Kenneth Clark

LOOKING FOR CIVILISATION

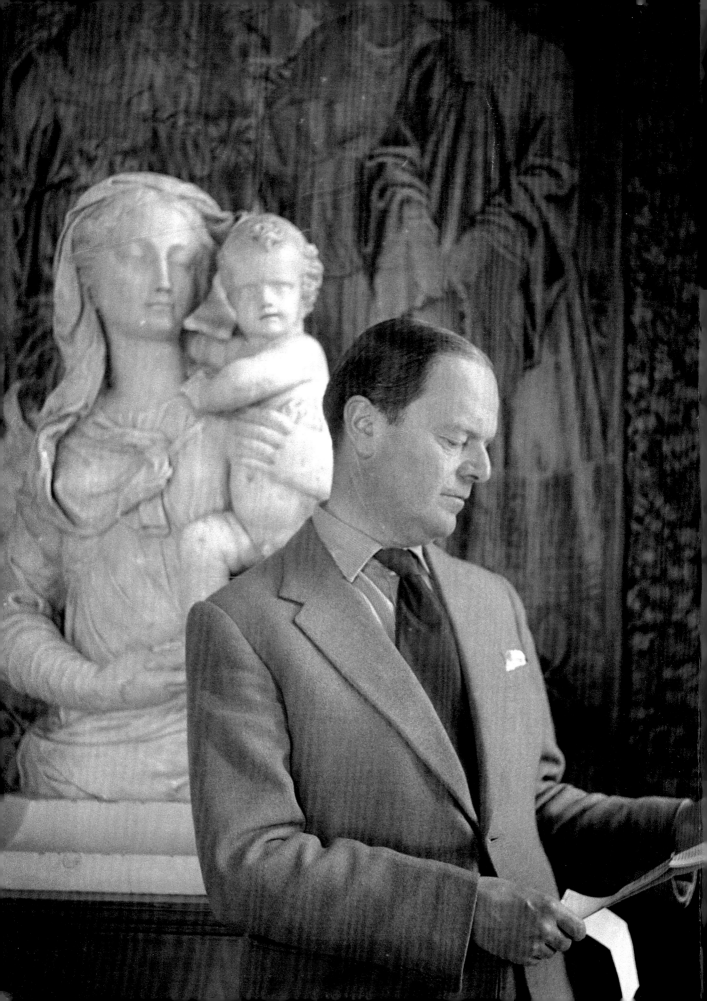

Kenneth Clark

LOOKING FOR CIVILISATION

Chris Stephens and John-Paul Stonard,
with David Alan Mellor, Peter T.J. Rumley and John Wyver

First published 2014 by order of the Tate Trustees by Tate Publishing, a division of Tate Enterprises Ltd, Millbank, London SW1P 4RG
www.tate.org.uk/publishing

on the occasion of the exhibition
Kenneth Clark: Looking for Civilisation
Tate Britain 19 May – 10 August 2014

The exhibition was made possible by the provision of insurance through the Government Indemnity Scheme. Tate Britain would like to thank HM Government for providing Government Indemnity and the Department for Culture, Media and Sport and Arts Council England for arranging the indemnity

A catalogue record for this book is available from the British Library
ISBN 978 1 84976 260 1

Distributed in the United States and Canada by ABRAMS, New York
Library of Congress Control Number applied for

Design by Nigel Soper
Colour reproduction by DL Imaging Ltd, London
Printed and bound in Spain by Grafos SA, Barcelona

Frontispiece:
CECIL BEATON
Kenneth Clark, Baron Clark 1955
Bromide print on white card mount
23.8 × 24.1
National Portrait Gallery, London

Director's Foreword:
GRAHAM SUTHERLAND
Kenneth Clark, Baron Clark
1963–4
Oil on canvas,
54.6 × 45.7
National Portrait Gallery, London

Front cover:
Kenneth Clark, as Director of the National Gallery, looking at works in wartime storage, 1942

Back cover:
PAUL CEZANNE
Bathers (Esquisse de baigneurs)
c.1900–2 (see pl.31)

Unless otherwise stated, images are reproduced courtesy of the Clark family.

Measurements of artworks are given in centimetres

Contents

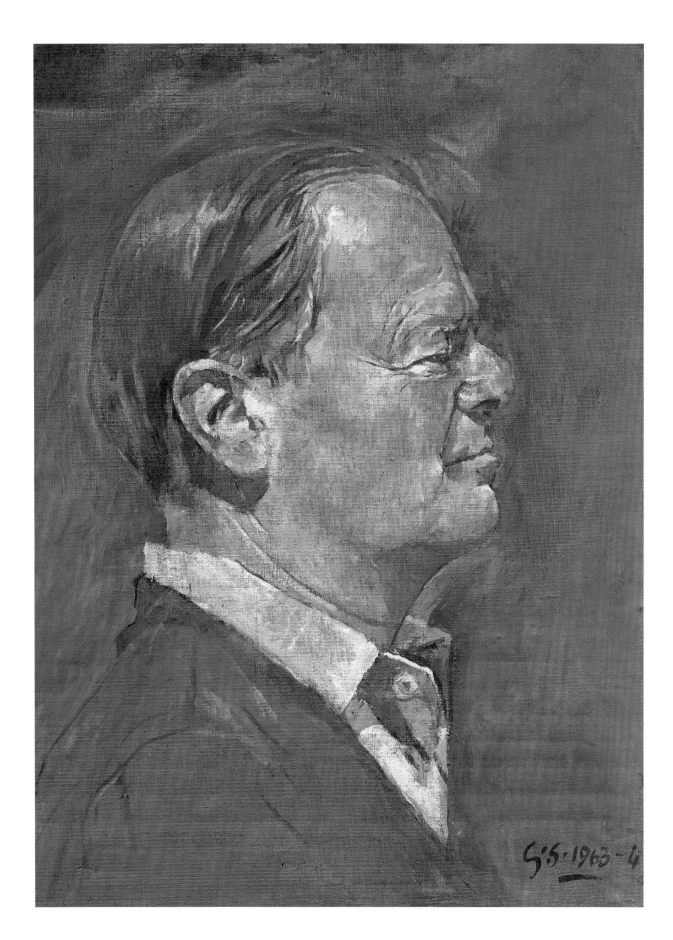

Director's Foreword

PENELOPE CURTIS, DIRECTOR, TATE BRITAIN

EVEN WHEN PEOPLE THINK they do not know the figure of Kenneth Clark, they will find, if they are interested in the visual culture of this country, that his impact is all around. Many people remember with admiration and even passion the effect of the TV series *Civilisation*. For them, these programmes, along with his writing, changed the way they thought about art and turned it into something with which they could truly engage. But even for those who never saw the programmes, and for whom the name means little, Clark is a figure whose influence is embedded in the art we see today.

Civilisation is the title of Clark's best known work, and it captures something of Clark's import, and of his own impetus. Like other cultural commentators of the mid-twentieth century, whether on the left or the right, Clark sought to hold on to what he saw as the tangible signs of a culture that had been threatened by the world wars with which he had grown up. His reaction was not only to save the past, but also to invest in the future, and to help create the artists who would help take us forward. Clark's work was both public and private, overt as well as clandestine, and the more one learns of him, the more one appreciates his involvement at every level. Only now, with biographical study beginning to supercede his inimitable autobiographies, and with the gradual absorption of his archive, is the fuller picture emerging.

Asking ourselves how 'Modern Art in Britain' would have been different without Clark is an interesting question. How would the careers of Henry Moore and Graham Sutherland have differed? Would abstraction have had a stronger hold here if Clark had approved? Would neo-Romanticism have had correspondingly less? His tastes shape ours; they both enlarge and constrain them, because his power of veto, of purchase and of patronage, was large.

It was fortuitous for me that my proposal to make an exhibition devoted to this cultural phenomenon was matched by the greater knowledge of Chris Stephens, and of John-Paul Stonard, who have worked together to turn an idea into reality. We were all delighted that Jane Clark and Colette Clark were ready to support the project, as was James Stourton, by then already deeply embedded in the Clark archives now largely held at the Tate. I must also thank the Murray family and the Linbury Trust for their support, along with the Exhibition Supporters Group. We are greatly indebted to all the many very generous lenders to the exhibition, and to the DCMS and the Arts Council who together provide the government indemnity for these works. The Tate has only rarely devoted an exhibition to a single figure who was not an artist; I hope that this venture helps to convince.

We all benefited from a colloquium organised by Nigel Llewellyn, which brought together those who had worked on various parts of Clark's career: his early writings, his administration of institutions, his involvement in committees, his broadcast work, his life. It is our hope that this exhibition and book succeed not only in capturing something of this eclectic synthesis, but also in illuminating it. Clark's love of art combined with the flair for interior design, the enthusiasm for mixing and matching, the erudition united with fearless popularisation, and his interest in the notion of key works, of artistic influence and of the zeitgeist, tell us much about what we look at now, and how, and why.

Introduction

CHRIS STEPHENS AND JOHN-PAUL STONARD

THIS BOOK IS PUBLISHED to coincide with the first exhibition devoted to Kenneth Clark (1903–1983), one of the leading figures in the British art world during the last century. Clark was many things in his professional life: scholar, educator, collector, patron, writer, administrator, broadcaster and impresario. In all of these capacities he remained dedicated to his central belief in the vital importance of art for human life.

At the heart of this exhibition is an examination of Clark's support for modern British artists. This support was provided first through his private activities and then, from 1939, through various state-funded initiatives. Clark not only supported a number of artists – from those of the Bloomsbury Group and their Euston Road School protégés to artists associated with wartime neo-romanticism (most importantly, Henry Moore, Graham Sutherland and John Piper) – but, by a variety of means, he also had a decisive influence on the dominant taste from the 1940s. The exhibition is not, however, restricted to Clark's influence on the British art of his time. It also sets out to create a much more boldly comprehensive portrait of Clark. Alongside collecting and patronage, Clark was a pioneering scholar, museum director, arts writer and broadcaster. Works that he acquired while Director of the National Gallery, such as Constable's *Sketch for 'Hadleigh Castle'* (fig.13), can be placed alongside the drawings of Leonardo (figs 9, 11) that he catalogued for the Royal Collection to tell one part of this story. His drive to introduce and explain art in ways that would be accessible to as wide an audience as possible extended from such landmark books as *One Hundred Details from Pictures in the National Gallery* (1938) to his ground-breaking work on television. Clark was a contradictory character; to some he appeared aloof and condescending, a man from the higher echelons of British society who managed to occupy the uncomfortable area where the establishment meets the artistic community; yet he was clearly driven by a profound belief in the democratic right of everybody to have access to culture.

It is this belief, above all else, which seems to recommend Clark as relevant to our present times. Some thirty years after his death, a moment has arrived when his career can be reassessed and discovered for a generation for whom he might well be a distant figure. His realisation of the importance of new technology for spreading knowledge and appreciation of the arts remains exemplary for our times. The elegance of his writing and the depth of his scholarship have lost none of their ability to beguile and inspire. Having argued for a revival of older forms of private patronage, and for the benefits that corporate sponsorship could bring, Clark also campaigned for sustained state support for artists and the arts, often in the face of resistance from Left and Right. Above all, perhaps, he realised that the best way to educate the general public about works of art was to make such an experience entertaining. To that end, with typical flair, he significantly changed the relationship between the National Gallery and its public. During the war he opened it for concerts that, famously, drew crowds of Londoners hungry for culture who queued to listen to the lunchtime concerts organised by Myra Hess; he was instrumental in the wartime exhibition programme 'Art for the People', and in the continuation of its spirit into the Arts Council of Great Britain after the war; and he became an early star of television, broadcasting about art at first on ATV and later on the BBC, including his legendary series

Fig.1
Kenneth Clark c.1941

Civilisation. Echoes of many of Clark's innovations can be found in the policies and practices of both museums and broadcasters in the twenty-first century.

The exhibition follows Clark's career up to the moment when he achieved international celebrity through *Civilisation*. The imperative not only to define but also to protect civilisation forms a thread running throughout Clark's life and work. 'What is civilisation?' he asks at the beginning of his thirteen episodes. 'I don't know. I can't define it in abstract terms – yet. But I think I can recognise it when I see it.'[1] He had recognised it when, aged seven, he first encountered the painted screens of Imperial Japan. His life was dedicated to the search for it, and an understanding of the objects it produced. As he noted at the very end of *Civilisation*, he witnessed its near destruction in the 1940s and dedicated himself to its protection, in Britain at least.

In one sense, Clark was very much a man of his times: his early success was not only a result of the freedom of inherited wealth and the best education but was also facilitated by the shortage of professional men as a result of the destruction of the First World War. The course of his patronage and also his scholarship mirrored the move of British society towards the social democracy of the 1940s and beyond. His pioneering role in mass broadcasting may be placed alongside that of other key figures of the time, such as Alistair Cooke and David Attenborough. Yet in the values and anxieties he expressed, and in his embrace of new audiences and new technologies, Clark stands as a figure of direct relevance and profound inspiration for the twenty-first century – and beyond.

––––––––––

This project would have been impossible without the generous support of Kenneth Clark's family. We are hugely indebted to Jane Clark and to Colette Clark, both of whom have been unstinting with information, advice and practical and moral support. We are also hugely grateful to Helena Clark and to Sam and Samantha Clark and Christopher Clark for their help. At an early stage we discovered that a similar project was under way at Brighton Museum and Art Gallery and, while we regret that the collaborative exhibition that we began to develop could not be realised, we are grateful to David Beevers and Nicola Colbey at Brighton for their support. As a consequence of that association we were fortunate to inherit Peter Rumley's immense knowledge of Clark and of Saltwood Castle, which has been extremely helpful and we thank him sincerely. As well as Peter, we were pleased to secure David Alan Mellor's knowledge of British visual culture of the mid-twentieth century for this publication. Most particularly, both the exhibition and catalogue have benefited immeasurably from John Wyver's unrivalled knowledge of the history of art on television and his past research on Clark in particular. We have been very fortunate that our project has coincided with the beginning of a new biography of Clark by James Stourton, and we have benefited immensely from James's generosity with his knowledge and advice. Though we have each worked on Kenneth Clark in a variety of ways and at different times over the last twenty years, it was Penelope Curtis who suggested he might be a suitable subject for an exhibition and we are grateful to her for the proposal.

We have benefited from many others' knowledge of Clark and have been struck by the generosity of so many who have been willing to share their expertise. The range of Clark's professional activities was so broad that we have relied on many others for their advice and guidance as we tried to identify, assess and understand all sorts of objects and works of art. We would like to thank for their various contributions to our research and their help with loans: Frédéric Armand-Delille, Madeleine Bessborough, Rosina Buckland, Caroline Campbell, Hugo Chapman, Jonathan Clark, Martin Clayton, Melanie Clore, Stephen Coppell, Stephane Cosman Connery, Kathleen Doyle, Ann Dumas, Anne Dunn, David Ekserdjian, Caroline Elam, Rupert Faulkner, Matthew Gale, Angelique Gaussen, Thomas Gibson, Izzy Goldman, Nicholas and Judith Goodison, Howard Grey, Maggie Hanbury, Paul Hills, James Holland-Hibbert, Diana Howard, Caryl and John Hubbard, Simon Hucker, David Fraser Jenkins, Bryan Keene, Richard Kendall, Catherine Lampert, Laura Lindsay, John Lowden, William Lucy, Francesco Manacorda, Lynda McLeod, Charlie Moffett, Danny Moynihan, John and Virginia Murray, David Nash, Francis Outred, Geoffrey Parton, John Pasmore, Nicholas Penny, Catherine Porteous, Lauren Porter, Marcella Pralormo, James Rawlin, Christopher Riopelle, Joseph Rishel, John and Anya Sainsbury, Nick Serota, Richard Shone, the family of Janet and Reynolds Stone, Letizia Treves and Jayne Warman.

We are, of course, extremely grateful to all of the lenders to the exhibition both public and private and, in particular, to Her Majesty the Queen. At Tate we have over a long period of time taxed various archivists past and present and thank them all. This catalogue has been managed by Miranda Harrison, and the pictures have been admirably assembled by Miriam Perez. We are grateful to both of them and to our copy-editor Matthew Taylor and designer Nigel Soper. Kiko Noda has made the practical arrangements for the loans, and we are, as always, humbled by the many diverse skills brought to bear on such a project from across the organisation. Along the way we were fortunate to have the assistance of Bojana Popovic, Olivia Bone and Alexandra Burstin as curatorial interns. Lorna Robertson has been a constant support to this project as with so many others. Finally, at different times the project has been kept on the straight and narrow by successive Assistant Curators, Jenny Powell, Benjamin Angwin and Inga Fraser. The bulk of the work falls to them, so thank you.

1 Looking for Civilisation

JOHN-PAUL STONARD

Art is a long word which stretches from millinery to religion.
— K. CLARK, introduction to *Praeterita: The Autobiography of John Ruskin*, London 1949, p.xxii

KENNETH CLARK DEVOTED HIS LIFE to exploring the 'long word', art. He wrote and lectured about it, collected it and commissioned it, hung it and discovered it in unlikely places. He made television programmes about it and changed many people's opinions about what it might be good for, or what indeed it might be. At an early age he tried, rather unsuccessfully, to make it. Hanging paintings, he later said, was a good enough substitute for making them. During the Second World War, as Director of the National Gallery in London, he was instrumental in protecting the collection from possible destruction in the Blitz, by sending the paintings to safe storage in Wales. In their absence he argued that the cultural life they represented was at least in part what the country was fighting for.

Nowadays, Clark is best known for the 1969 television documentary *Civilisation* (spelt with that all-important soft 's'). It was the culmination of his life in the arts, from his early career as a scholar and museum director through to his later years as a writer and broadcaster. When asked to make the television series, Clark later wrote that he was not entirely sure what civilisation was, but nevertheless 'felt confident that it was something which was worth defending, and something that was in danger'.[1] His view of art and civilisation changed, but he never lost sight of his fundamental belief in the importance of art as a vital element of civilised society, a source of salvation, even, and something worth fighting for.

In the first volume of his memoirs, *Another Part of the Wood*, Clark describes his upbringing and the origin of his interest in the arts. He was born in 1903, an only child, into considerable wealth. His father, Kenneth M. Clark, had inherited a vast fortune from family interests in the Scottish textile industry, and lived among the ranks of the idle rich. Many people in that golden age were richer, Clark famously observed, but few could have been

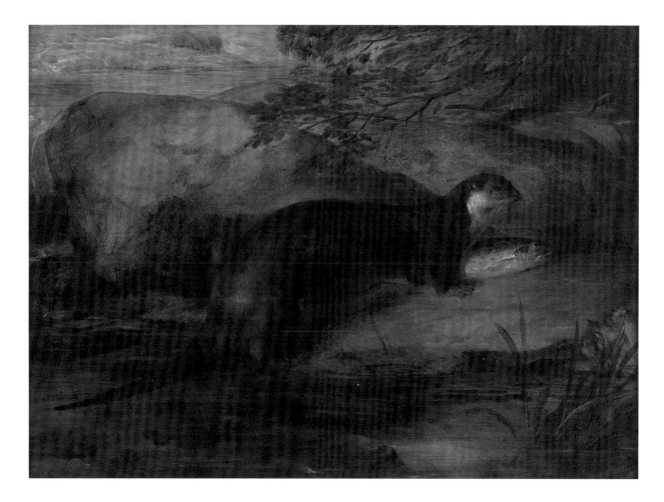

idler.[2] In addition to the large sporting estate of Sudbourne Hall in Suffolk, the family home where Clark grew up, his father owned 49,000 acres of the Ardnamurchan peninsular in Scotland, complete with castle and stags to shoot; hotels in Menton and Sospel, in the south of France, near Monte Carlo; houses in Perthshire and London; and numerous yachts, designed for cruising and racing, all given 'K' names – *Katoomba* (rebuilt twice), *Khama* and *Kariad*.

Despite this ostentatious lifestyle, Kenneth M. Clark was, according to his son, a 'genuine lover of paintings'. Sudbourne Hall was filled with works of art of varying quality, but including paintings by Edwin Landseer (fig.3), John Everett Millais, James Tissot and Tintoretto, as well as numerous *objets de luxe*.[3] A large, well-stocked library was furnished with six comfortable sofas and a pianola organ, operated by pedals, that could play

Rossini's *Stabat Mater* and Mendelssohn's *Elijah*. It was the perfect setting for cultivating an appreciation of art, and the perfect origin for an aesthete.

Even as a child, then, Clark lived in a very un-English manner: surrounded by art. His father's further activities as a patron meant he also came into contact with artists. In 1912 Clark senior commissioned a portrait of the nine-year-old Kenneth from the painter Charles Sims (fig.4). The finished work was exhibited at the Royal Academy and described in *The Times* as 'ingenious' – even if the figure was slightly awkward and outsize against the background.[4]

For his twelfth birthday Clark received an album of Japanese prints, including woodcuts drawings by Hokusai. He was already a precocious enthusiast for Japanese art, having been taken by his nanny to the 1910 Japan–British Exhibition, held in White City.

Fig.3
SIR EDWIN HENRY LANDSEER
The Otter c.1842
Oil on canvas
45.5 × 60.5
Private Collection

Fig.4
CHARLES SIMS
Portrait of Lord Clark
as a Young Boy C.1911
Oil on canvas
91.4 × 71.1
Private Collection

Among the gaudy displays of knick-knacks and 'Mikado' (Clark's word for Japanese kitsch) was a 'perfectly serious collection of Japanese art', he later recalled, including a room of sixteenth-century painted screens. Most impressive of all was a pair of six-panel screens decorated with floral motifs. This was almost certainly *Peonies and Plum-Blossom*, painted by Kaiho Yusho, on loan from Myoshinji, a Zen temple in north-west Kyoto.[5] 'I felt myself promoted into a different world', Clark wrote; 'I felt that these paintings had a harmony and finality quite outside my ordinary experience. In fact, I was conscious, for the first time in my life, as far as I can remember, that beauty is something timeless.'[6] As a schoolboy at Winchester College (1917–21) he was entranced by the collection of Japanese prints belonging to the art master, Alexander Macdonald, and was soon collecting Japanese prints himself, including two master prints by the

eighteenth-century *Ukiyo-e* master Kitagawa Utamaro (fig.5), as well as works by Okumura Masanobu, Hiroshige and Hokusai. Later in life he acquired a rare seventeenth-century Japanese screen, showing a landscape loosely based on the traditional subject of the 'Eight Views of the Xiao-Xiang River' – no match, however, for the national treasures he had seen at White City in 1910.

Japanese art presented a model of aesthetic experience, of visual and sensual enjoyment, that Clark was to carry with him throughout his life.[7] Many of his most evocative descriptions of Western art drew on his memories of Asian art. Leonardo's landscape drawings of around 1503, for example, he saw as having 'a Japanese fantasy and precision in the spacing of their accents'.[8] But in early life he readily found other models: Aubrey Beardsley's affinity with the graceful linear style of Japanese art was the basis for Clark's early passion for his work, at a time when Beardsley was relatively unfashionable (fig.6).[9] The work of the artist and *Punch* illustrator Charles Keene (pl.9) was another early passion, admired by Clark both for its draughtsmanship and for the subjects depicted; Clark copied drawings as a child, and collected them as a young man.

Clark was equally precocious when it came to intellectual influences. At Winchester he came across the thirty-nine volumes of the writings of John Ruskin in the school library. His later anthology of favourite excerpts from the nineteenth-century art critic's writings *Ruskin Today* (1964) is testament to his depth of reading over the years of these volumes. Ruskin's influence was, on the one hand, as a moralist, who believed in art as a means of social and personal betterment and, on the

Fig.5
KITAGAWA UTAMARO
*Hour of the Cock (6 pm),
Servant from a Samurai
Mansion* 1798–1804
Woodblock print
37.1 × 24.7
Victoria and Albert
Museum, London

other, as a stylist, whose writing often reached 'the point at which thought, feeling, and language are one, the point of incandescence which we call poetry'.[10]

It was thanks to the charismatic headmaster of Winchester College, Montague Rendall, that Clark first encountered the names of the two other great influences on his early career as a scholar and art enthusiast. Rendall had gathered together a study collection of prints after old-master paintings, and gave lectures on Italian Renaissance art, based, at least in part, on the writings of Roger Fry and Bernard Berenson. Both these figures came to play an important role in Clark's life and became personal friends.

Fry and Berenson were almost the same age (Berenson was born in 1865, Fry in 1866), and thus some forty years older than Clark. Although of contrasting personalities ('Roger made one feel far cleverer than one was. Mr. Berenson made one feel far stupider'), both were decisive for the evolution of Clark's concept of art.[11]

Clark first met Fry in 1923, after hearing him lecture in Oxford on Cézanne and Poussin.[12] At Winchester he had read Fry's enormously influential collection of essays *Vision and Design* (1920) and he knew of Fry's writings on Italian painting. But it was through his 'spellbinding' lecturing and profoundly engaging conversation that Fry was to have the strongest influence. As Clark wrote in the introduction to a posthumous collection of Fry's last lectures, Fry did as much as one man could do to change taste in England, by which Clark meant not only the introduction to modern French painting provided by Fry's post-impressionist exhibitions but also the furniture and design work produced by the Omega Workshops under his direction.[13] As a writer on art, it was Fry's belief in 'pure aesthetic sensation' and his ability to communicate this genuine experience that most swayed Clark, particularly in the case of Cézanne. Fry's short monograph on Cézanne (1927) was for Clark a 'masterpiece' of art criticism,[14] which contributed to the

Fig.6
AUBREY BEARDSLEY
The Black Cape 1907
Ink on paper
22.7 × 16.2
Victoria and Albert
Museum, London

Fig.7
JOHN RUSKIN
Study of a Window near Madonna dell'Orto, Venice c.1849–50
Ink and watercolour on paper
33.7 × 25.4
Private Collection

bold move of displaying Cézanne's *Montagne Sainte-Victoire* alongside Manet's *Bar aux Folies-Bergères* at the National Gallery in 1934, just after Clark became the Director. ('He lived to see a Cézanne in the National Gallery', Clark wrote; Fry died later that year.[15]) Even more remarkable was the extent of Clark's own collection of works by Cézanne, including major paintings such as *Le Château Noir* (pl.14). Travelling in France in December 1933, Clark had the notable good fortune of being offered numerous drawings and watercolours by Cézanne by a Paris dealer, on behalf of Cézanne's son (fig.8; pls 18, 46). As he wrote to the American writer Edith Wharton:

> There are about 10 pencil drawings of poor Madame C., and a dozen of himself; about 15 are very lovely watercolours of still life and landscape, and the rest landscape and composition studies of all dates. They really provide a new basis for understanding Cézanne as they show the working up of well known pictures, and include all the studies for the picture of an Orgy which created so much fuss. I must add for your peace of mind that there can be no question that they are genuine & that they cost me much less than a modest motor car.[16]

He would not have bought them without Fry's advocacy, and without having had the experience of looking at paintings with Fry: 'These moments remain in my mind like glimpses through a half-open door into a room full of beautiful pictures, which I shall not see again.'[17]

If Fry was a benign tutor, Berenson was, by contrast, an overbearing Olympian oracle. Clark first met the famous American scholar when invited to lunch at the Villa I Tatti, Berenson's home in the hills outside Florence, while travelling in Italy in 1925. It was during this visit that Berenson surprised Clark by inviting him to work on a new edition of his catalogue of the drawings of Florentine painters, first published in 1903. It was a

Fig.8
PAUL CÉZANNE
The Back of a Chair
1879–82
Watercolour, wash and
crayon on paper
17.5 × 11.5
Private Collection

landmark book in the history of Italian art, and Berenson's masterpiece. Clark later recalled: 'It was the most golden egg that the world of art had to offer, and I would be a goose to refuse it.'[18]

At the time Clark was finishing his first book, an account of the nineteenth-century architectural style Gothic revival. Written at the suggestion of Charles Bell (Keeper of Fine Arts at the Ashmolean Museum, Oxford, and a mentor of the young Clark after he arrived to read history at the university there in 1922), it was originally intended as a criticism of the Gothic revival, but turned out for the most part as an appreciation. Considering works of art not from an aesthetic position but as revealing 'something of the epochs which made them'[19] was a characteristic of the Germanic theories of art that Clark had read while at Oxford, particularly the works of the Austrian art historian Alois Riegl (which he confessed he found rather hard going). Although Riegl's concept of art as a 'revelation of a state of mind' was extremely influential on the young Clark, he was also wary of a too abstract approach, and conscious of the negative association of 'Germanic' theory. It was important to avoid 'producing but another of those *Geists* and *Formproblems* of this or that style in which the Germanic origin of the arts is so frequently emphasised'.[20]

The time Clark spent at I Tatti with Berenson was an education in a very different approach to art: that of connoisseurship. Having an 'eye' meant the ability to discern on the basis simply of looking at a work, who might have made it and when. A retentive visual memory was also essential, particularly considering the often poor quality of photographic reproduction at the time. Clark spent days with his wife, Jane, whom he married in early 1927, studying the paintings in the Uffizi, 'from which they always returned with some new discovery of discrimination', as Maurice Bowra, an Oxford friend who visited I Tatti, later wrote.[21] Clark's eye as a connoisseur was directed towards ends very different from those prescribed by the German theorists. Attribution was a gentleman's sport, and for Clark it seemed at the time 'the only game worth playing'.[22] Not, he was careful to add, for the money (which he did not need), but for the glory of having an eye and being right.

Clark's greatest achievement as a connoisseur remains, without doubt, his work on Leonardo da Vinci. His earliest published article on Leonardo, in the magazine *Life and Letters*, describes the dangers of assuming an 'entirely isolated, superhuman figure'.[23] His argument for a more historical, balanced view of Leonardo, a 'long' view, perhaps, was the basis for the monograph on which he began working at this moment.[24] At the same time (1928), he was offered the job of cataloguing the unrivalled collection of drawings by Leonardo in the Royal Collection at Windsor; an extraordinary break for a twenty-five-year-old with no formal qualification in art history, as Clark later recalled. His catalogue remains unsurpassed (if in a quite specialised genre), and many of his identifications, both attributions and de-attributions (figs 9, 10), as well as datings of the drawings, have stood the test of time – as have his many extraordinary descriptive passages. The 'swirling lines ... of force' of Leonardo's nine tiny deluge drawings (fig.11), he compares to Japanese prints of Ogata Korin and Hokusai, but also to Sienese art: 'all schools which reduce the world to

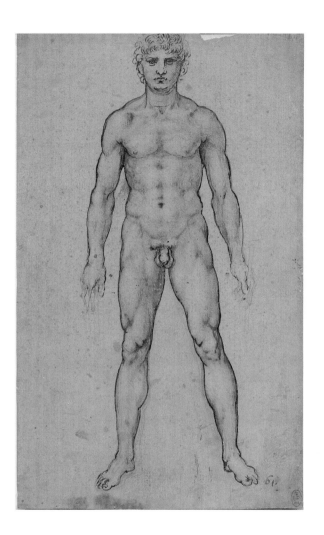

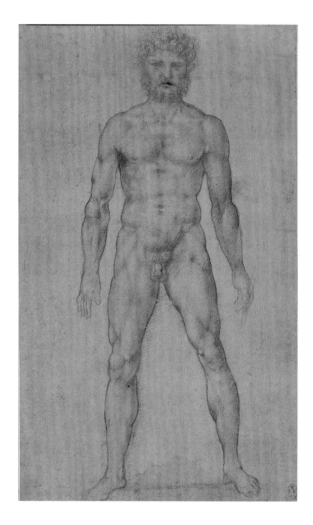

Fig.9
LEONARDO DA VINCI
*A Nude Man from the
Front* c.1504–6
Red chalk and pen and
ink on pale red prepared
paper
23.7 × 14.6
Royal Collection Trust

Fig.10
After LEONARDO DA VINCI
A Standing Male Nude
c.1504–6
Black and red chalk with
touches of pen and ink on
pale red prepared paper
25.8 × 15.3
Royal Collection Trust

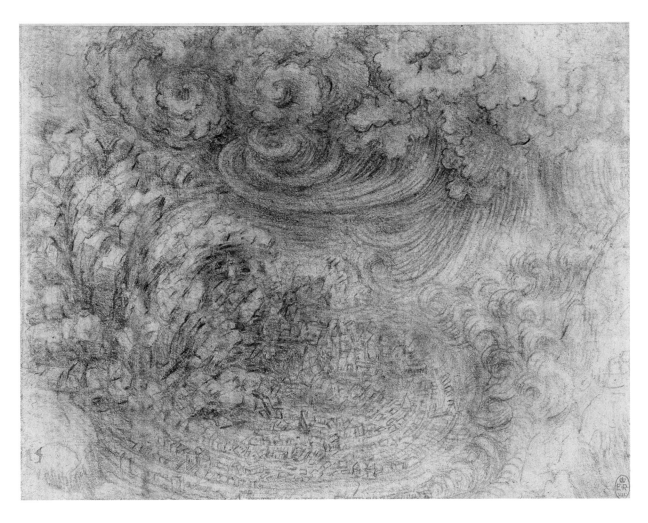

line'. It was as if these drawings contained in themselves the whole of the history of art, both Eastern and Western.

At the beginning of the 1930s, then, it seemed that Clark was set on the diligent and contemplative path of scholarship, combining the insights of a tradition of German art theory, the connoisseurial approach of Berenson and the critical enthusiasm of Roger Fry. Any hopes of a quiet, professorial life were overturned, however, by the offer of the job of Keeper of the Department of Fine Art at the Ashmolean Museum, which he accepted in 1931.[25] Two years later came the even more spectacular offer, considering Clark's age (thirty), to be Director of the National Gallery, a position he took up in January 1934. It was a tough decision, as he wrote to Edith Wharton, to exchange the 'vegetarianism of the vita contemplativa' for a 'carnivorous diet' of the life of action.[26]

Reading Clark's letters and appointment diaries from this moment reveals just how carnivorous his diet became: the years of the 'Great Clark Boom', as he put it, involved a vertiginous round of social and professional

engagements, compounded by his acceptance (again reluctantly, so he later held) of the post of Surveyor of the King's Pictures, just a matter of months after taking up the post at the National Gallery. The position of Surveyor involved regular trips to Windsor and care of the collection, principally at Hampton Court, but also at all the other royal palaces and residences.

Somehow, however, he managed to finish his Leonardo monograph. It was given as a complete set of lectures at Yale University in 1936 and was finally published in 1939.[27] Compared with his earlier writings, particularly the Windsor catalogue, the change in Clark's view of Leonardo demonstrated by the monograph is fascinating and instructive. By the time he came to deliver his lectures in Yale, he had realised that the true challenge was not so much to demythologise Leonardo as to view him as a whole, to see his art and scientific writings alongside one another, rather than as distinct entities. The 'long' notion of art he drew out from Leonardo – in the sense of seeing art as part of a wider world, to which it is related in a range of practical and metaphorical ways – was the basis for much of his later writing on art.

A crucial influence on this 'long' view of Leonardo came, indirectly, from the German cultural historian Aby Warburg. Clark was fortunate to attend one of Warburg's last, and most famous, lectures, delivered at the Bibliotheca Hertziana (the German art history research institute) in Rome in January 1929. 'Warburg was without doubt the most original thinker on art history of our time', Clark recalled, 'and entirely changed the course of art-historical studies.'[28] The virtue

of Warburg's cultural–historical approach was its 'reaction against the formalist or stylistic approach of [Giovanni] Morelli and Berenson' – it offered a way of moving beyond connoisseurship, and of seeing works in a much broader setting. Warburg's view of works of art as symbols, and his enquiry into the 'origin, meaning and transmission' of these symbols, fascinated Clark and influenced his subsequent work.

In January 1934, when the Warburg Institute was finally installed in London, Clark wrote to Fritz Saxl, the Director, that its presence was an 'incalculable gain to English scholarship'. He was in close and regular contact with Saxl, as well as with Gertrude Bing, Edgar Wind and, from 1937, the young Ernst Gombrich, recently arrived from Vienna.[29] One of Gombrich's first tasks on arriving in London was to identify (correctly) the subject of a group of four small paintings that Clark had purchased from a dealer in Vienna for the National Gallery, having identified them himself as by Giorgione. It was for Clark a bold move and, as it turned out, led to a public scandal (involving letters to *The Times* and questions in Parliament) when it emerged that the panels were in fact by Andrea Previtali, a lesser-known painter from Bergamo (fig.12). The attribution was made by the scholar George Martin Richter, and has not been challenged since.[30]

The importance of the Warburg Institute for Clark's work on Leonardo is borne out by numerous letters and visits from Clark to the Institute, with 'Leonardo problems', such as what was the significance of the head-dress in his drawings of Leda, and how much was his work as a scientist affected by his learning Latin late in life?[31] It was, besides, a symbol

Fig.12
ANDREA PREVITALI
Scenes from Tebaldeo's Eclogues 1505
Tempera with oil glazes on wood
19.7 × 18.4
National Gallery, London

Fig.13
JOHN CONSTABLE
*Sketch for 'Hadleigh
Castle'* c.1828–9
Oil on canvas
122.6 × 167.3
Tate

of the 'good' Germany: its staff were political refugees from Nazism, and upholders of a valuable scholarly tradition. In his work for the National Gallery, Clark inevitably became aware of the need to address a broad public, beyond the limited audience of scholars, and it was, perhaps paradoxically (considering the often recondite scholarship it produced), the iconographic approach of the Warburg that enabled him to see art in a much broader cultural setting, specifically in relation to literature. Clark was well aware of the particular importance of this connection for his English audience, who, as he wrote to Gombrich, 'are such a literary people that the best way of persuading them to take an interest in a picture is to find that it has its origin in a poem'.[32]

This shift to a concern with subject matter was certainly registered in the contemporary art that Clark began to support during the 1930s. In an article in the *Listener* in October 1935, Clark stated his firm belief that abstraction was a dead-end for painting.[33] His belief in the importance of figurative painting, and the regeneration of traditional iconography for contemporary art, can be seen in his support of the painters of the Euston Road School, although his strongest allegiance was to the poetic transformations of figures and landscapes in the work of Henry Moore, Graham Sutherland and Victor Pasmore. His advocacy was based both on friendship and on a sense of allegiance to English art, and the feeling that it required defending in the face of the fragmenting forces of modernism, and the natural indifference of his countrymen towards the visual arts. Writing and lecturing on John Constable in 1938, the centenary of his death, Clark followed the example of Clive Bell and Roger Fry in proposing Constable as the greatest

Fig.14
Probably REMBRANDT
VAN RIJN
Margaretha de Geer,
Wife of Jacob Trip 1661
Oil on canvas
75.3 × 63.8
National Gallery, London

English painter, and the only one who might respectably hold a place in the European tradition. It was surely also a matter of personal pride that Constable's great romantic painting *Hadleigh Castle* was purchased for the National Gallery during Clark's time as Director (fig.13).

The Second World War provided a vital focus for these questions of national tradition and an 'alternative' modernism, focused on the human figure rather than abstract form. Following a short period working for the Ministry of Information (where he was involved in making propaganda films), Clark returned to the National Gallery in 1941. He had already masterminded the removal of the collection and its storage in a disused quarry in Wales (and had done the same for many of the paintings in the Royal Collection). Popular demand led to the decision to bring back one painting for display for a month

on a regular basis. The first, in January 1942, was *Margaretha de Geer, Wife of Jacob Trip* 1661, then attributed to Rembrandt (fig.14).[34] These single displays became a vital focus for a spirit of culture in wartime London, when most museums and galleries were closed and, for the first two years at least, cultural life was bleak. Most famous as a rallying point were the series of daily concerts at the gallery, organised by the pianist Myra Hess from late 1939.[35]

Clark understood that war, however much it must be hated, was the symptom of a 'life-giving impulse', and that it might not only provide the inspiration for great works of art but also act as a counter to the fragmentation of modern art and life.[36] The works produced as a result both of the War Artists Advisory Committee, set up to ensure that artists would 'leave for posterity some record of the extraordinary events through which we are passing', and of Recording Britain, a project commissioning artists to record life on the home front, were testament to this view.[37] Clark was well aware of the pressing questions raised by these initiatives, not only about the role of the state as patron of the arts (which, on the whole, he thought was a good thing) but also about the broader question of art in a democratic society. On this point Clark stuck to the view that the arts were 'incurably aristocratic'.[38] Aesthetic decisions could neither be made by a committee nor devolved by popular consent to the 'average man'. Such a relinquishing of expertise would inevitably result in exchanging all the paintings in the National Gallery for 'pictures of blue-bell glades and scarlet cardinals carousing'.[39] In the age of a mass public for the arts, the task was rather to convince the 'average man' that it was worth making the

'strenuous' effort to understand art, and thus to reap the rewards himself.

In 1945 Clark resigned from the National Gallery to do just that: to devote himself to writing and lecturing. 'My overwhelming need was to communicate my feelings about works of art in words. I wanted to write, occasionally to lecture, indirectly to teach', he recalled.[40] It was during these years that he published some of his best books, notably *Landscape into Art* (1949), *Piero della Francesca* (1951) and *The Nude* (1956). His brilliant accounts of the evolution of landscape painting and of the evolution of the motif of the nude human figure in art are the results of an approach that placed works of art in the widest possible cultural setting without descending into trivial generalisations. *Landscape into Art*, for example, was informed by the long history of man's concept of nature, from antiquity to the present, encapsulated in penetrating categories, from the medieval landscape of symbols, through concepts of light, fantasy, ideals, naturalism and order. Clark introduces his chapter on the sense of natural light that first pervades the miniatures of Hubert van Eyck with one of his greatest formulations: 'Facts become art through love ... [and] this all embracing love is expressed by light.'[41]

Equally striking is Clark's distinction between 'naked' and 'nude', with which he opened a series of lectures given at the National Gallery in Washington, D.C. in 1953. (Clark's love of epigrams and pithy phrases might be traced to his time with Berenson, who in his youth 'listened night after night to the conversation of Oscar Wilde'.[42]) The lectures were published together a few years later as one of his most influential and controversial books, *The Nude*.[43] The subject is traced once again throughout the history of Western art, in this case reaching back to antiquity, and summed up in broad yet incisive categories; Apollo and Venus are the archetypes of the male and female body, which were later transformed into a variety of modes, summed up by the characteristics of energy, pathos and ecstasy, and an 'alternative convention' of Gothic northern art before the inevitable fragmentation of the modern age. Generalisations, yes, but piercing rather than sweeping. More than any other publication, *The Nude* showed the mark of Clark's transformative encounter with German art history, particularly that of Warburg. One of the chapters in *The Nude* (on the topic of 'pathos') he described in a letter to Gertrude Bing as 'entirely Warburgian' in approach.[44]

Clark was never again to write such a dense and scholarly book. His *Rembrandt and the Italian Renaissance* (1966) was the result more of enthusiasm than of deep scholarship; he admitted that he was no specialist in Dutch art.[45] He went on to make a series of television documentaries on Rembrandt, which in turn became a further book published in 1978 – this time expressly as a popular introduction.[46] But throughout the 1960s Clark focused his energy less on scholarship than on his new role as a public communicator, specifically in making television programmes about art (which were for the most part more televised lectures than documentaries), and also as a pioneering supporter of commercial television as the first chairman of the Independent Television Authority (ITA) from 1954. The questions that he tackled in these programmes were often of a general nature, rotating around matters of taste, as for example in the ATV series *Is Art Necessary?*, in which he asked questions

about everyday aesthetic judgement. For one of these programmes, *What is Good Taste?*, he raised the issue of good and bad taste by comparing two rooms, one decorated in the 'modern' style and the other in a style probably approximating to that of most of the viewers of the programme. In the end, he suggests, it is a matter of personal taste; although some personal tastes, he implies, may be better-informed than others.

What constituted civilisation was also, when it came to it, a matter of individual opinion. The subtitle of the 1969 television series, 'A Personal View', was evidently designed to ward off the charge that Clark was trying to dictate views of what civilisation entailed, *de haut en bas* (although this did not prevent the coining of the nickname 'Lord Clark of Civilisation'). Clark's notion of art as 'incurably aristocratic' nevertheless seeps through into his own manner. Yet, filtered through the medium of television, and thanks in large part to his collaboration with the producer and director Michael Gill, the lasting appeal of *Civilisation* is precisely Clark's ability to give universal relevance to his subject – to explain an often complex and distant notion of 'civilisation' in terms that the 'average man' can understand.

Clark claimed that his concept for the series was sketched on a napkin at lunch, shortly after David Attenborough, the Controller of BBC Two, raised the idea. Despite the appearance of spontaneity, the background to Clark's conception was a combination of scholarship and personal circumstances, art and history. In adopting the subtitle 'A Personal View', Clark may well have been recalling the subtitle the nineteenth-century Swiss art historian Jacob Burckhardt

had given to his classic book *The Civilisation of the Renaissance in Italy* (1860), '*eines blossen Versuches*' (suggesting a 'mere attempt'), noted by Clark in reviewing a new edition of the book, which he held in high regard, in January 1945.[47] Burckhardt remained a distant influence, however, and his book deals with a much shorter time span. Clark would also undoubtedly have read his friend Clive Bell's engaging, if minor, account in his *Civilization: An Essay* (1928). Bell proposes tolerance and liberality, good manners and taste, as the basic elements of civilisation, and to an extent sets the tone for Clark's own rather old-fashioned, liberal views, as he put it.[48]

A more interesting comparison can be made with Sigmund Freud's 1930 publication *Der Unbehagen in der Kultur* (*Civilisation and its Discontents*). For Freud, civilisation is not a reflection of achievement but a source of suffering. It regulates human relations and represses individual instincts. He warns against the view of civilisation as synonymous with 'perfecting', as an idealistic, unrealistic view.[49] Although we know that Clark read Freud's famous essay on Leonardo, there is no evidence that he read much else by Freud, including his account of civilisation, and he clearly distrusted psychoanalysis as a way of interpreting art. Yet the two men nevertheless agreed that the problem was one of the individual in conflict with an oppressive outer world, and to a degree they shared the view that aesthetic experience was a source of redemption. To this extent, they were equally pessimistic. Where were the artists now to stand up for individual genius, as Beethoven and Balzac did, Clark asks in the penultimate programme of *Civilisation*, standing alongside Rodin's full-length sculpture of Balzac, 'to

defy all those forces that threaten to impair our humanity: 'lies, tanks, tear-gas, ideologies, opinion polls, mechanisation, planners, computers – the whole lot'.[50] It is undoubtedly the most impassioned moment in the whole series (fig.15).

He could have added 'Marxism' to this list, and made no bones of his antipathy to it elsewhere. What he could not have added, however, was 'television' – which many in the 1960s and since have held to impair humanity. What did television mean for civilisation and, by extension, for the creative individual and works of art? Clearly the thirteen episodes of *Civilisation* were one form of answer. Nowadays, Clark suggested

in 1971, television is civilisation, 'the great democratic instrument', which has 'vastly increased people's understanding of human nature, literature and even history'. This he wrote in an article for the American magazine *Look* (adding, 'I still think *I Love Lucy* one of the best commercial programs ever put out in America'[51]). Four years later, in October 1975, Clark gave a more subtle account of the pros and cons of television as part of contemporary society. While the arguments against were not completely to be discounted (he describes Mary Whitehouse, a seasoned campaigner against obscenity on television, as 'one of the few people in this country with any moral courage'), they were outweighed by

Fig.15
Still taken from *Civilisation* (BBC 1969) with Kenneth Clark standing alongside Rodin's *Balzac*

the central benefit of television in broadening experience. Clark himself confessed: 'I have led a sheltered life, and it is only in the last few years, watching television, that I have begun to realise how other people live.' Television, in his view, was less a cause of social good or ill than a 'visible projection' of the state of the world, revealing both the breadth of the human and natural worlds and the 'spiritual and intellectual decline which has overtaken us in the last thirty years'.[52] Yet it was certainly no substitute for art, or religion, and 'can do nothing to give us spiritual comfort and enlightenment'.

After the war, Clark's interest in contemporary art waned; he could find little there to give him the kind of solace he needed. His discovery of the works of Sidney Nolan (pl.39) during a trip to Australia in 1949 was a rare moment of identification with a contemporary artist (one who had himself been inspired by Clark's *Landscape into Art*). Clark was able to see the importance, and even the genius (he mentioned it in private to Graham Sutherland) of a painter such as Francis Bacon, whose studio he visited around 1945, but was unable to incorporate Bacon into his world view.[53] Pop art was always a step too far for Clark: a visit with Jane to Andy Warhol's Factory in 1964 resulted in a sneezing fit and a swift therapeutic visit to the Frick Collection.[54]

Art and civilisation, in the twentieth century at least, had become different things. Clark's view of civilisation was based above all on an ethos of confidence, in society, laws, conventions, philosophy and reason; it was based on the power of individual genius to create masterpieces of art and literature. It was impossible for him to square this with the anxieties and dilemmas of modern art, the legacy of Cézanne's famous doubt and the general sense of uncertainty of man in the modern world. Even in Clark's 'long' view of art, there were certain forms of experimentation, and departures from tradition, that went too far; traditional genres and assumptions remained.

Kenneth Clark's notions of art and civilisation may have fallen out of favour in many circles. Masterpieces are as unfashionable, at least in scholarly circles, as the concept of divinely bestowed genius, although these are still the terms that define a popular understanding of art and artists: great women and men doing great things. What is a masterpiece? Clark posed the question in one of his final lectures, answering in terms that are by now familiar to anybody who knows something of his life and work. The long word 'art' was, after all these experiences, of greatest value as the shortest road to happiness (another unfashionable concept), and it was in the search for civilisation that Clark created his own version of the happiness and sense of satisfaction that art can give. What counts is to keep on looking. 'Whether pilgrims to Cythera will ever reach it is beside the point', he once wrote of Watteau's famous painting, 'They are going in search of it, as the first object of life.'[55]

2 Selected Works from the Collection of Kenneth Clark

CHRIS STEPHENS AND JOHN-PAUL STONARD

The following pages illustrate a selection of some of the major works that at one time belonged to Kenneth Clark, alongside lesser-known, yet equally fascinating, objects from his collection. Clark bought and sold numerous works of art during his lifetime, many of which were dispersed in a large sale after his death.

▶ **Pl.1**
AUGUSTE RENOIR
La Baigneuse Blonde 1882
Oil on canvas
90 × 63
Pinacoteca Agnelli, Turin

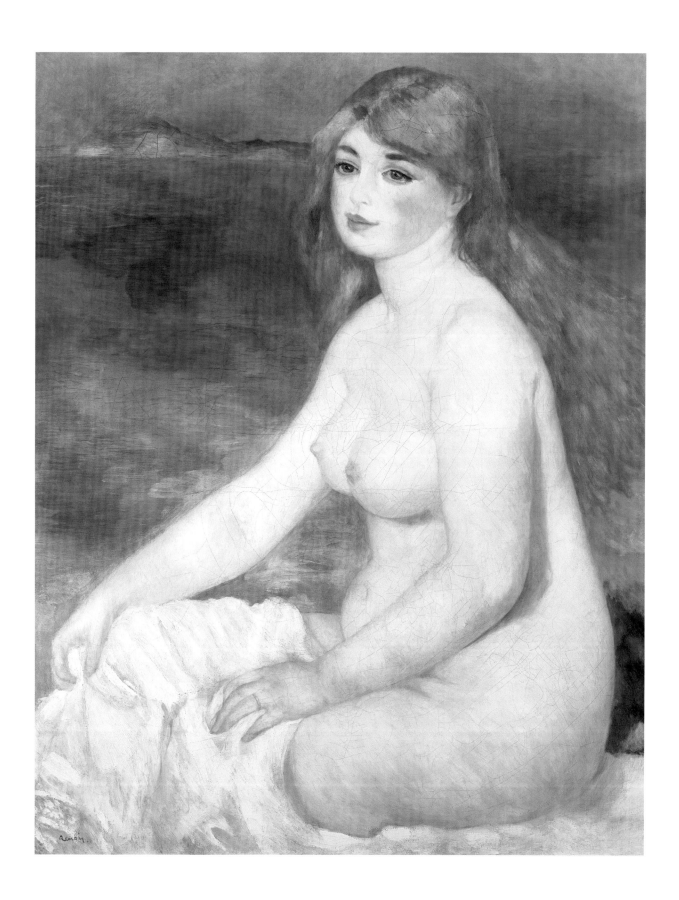

▲ **Pl.2**
SCHOOL OF KANO
TOUN MASUNOBU
Winter Landscape
17th century
Six-fold screen, ink
and gold on paper
170 × 336
Private Collection

▼ Pl.3
VICTOR PASMORE
The Wounded Bird 1944
Oil on canvas
51 × 76
Private Collection

◄ **Pl.4**
GIOVANNI BELLINI
The Virgin and Child
C.1470
Tempera and gilding
on panel
33.5 × 27.2
Ashmolean Museum,
Oxford

▶ **Pl.5**
GIOVANNI MARTINI
DA UDINE
*Trompe l'Oeil with
Two Quails and a Lute*
C.1515–20
Ink and watercolour
on paper with collage
43 × 32
Private Collection

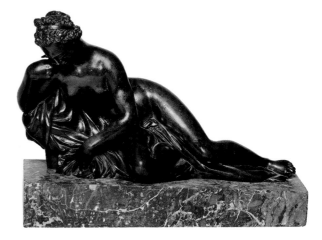

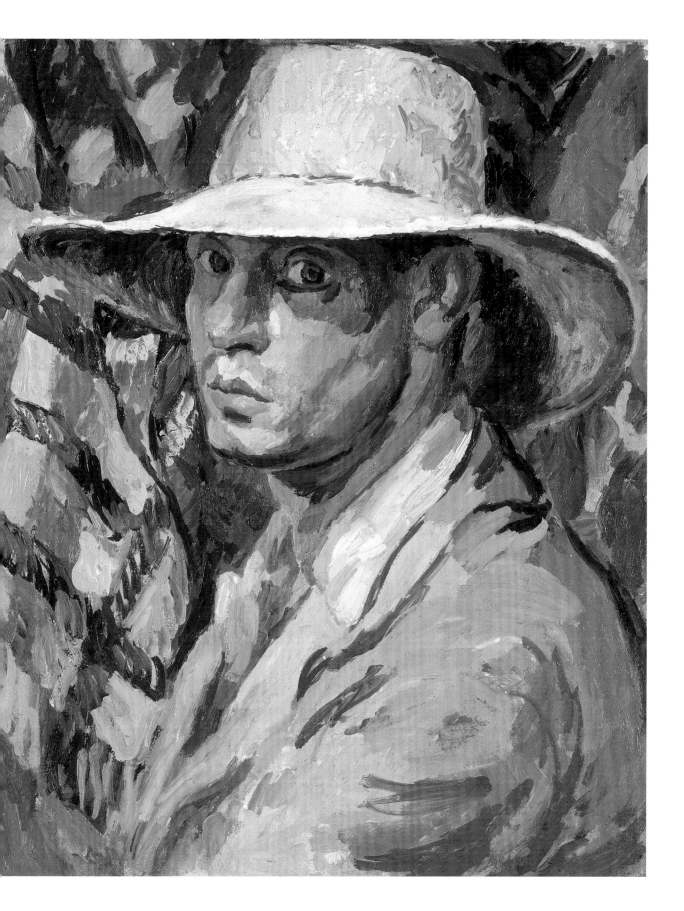

◀ **Pl.9**
CHARLES KEENE
Collection of eighty-six
drawings in a bound book
Late 19th century
50 × 35 × 2.5
Private Collection

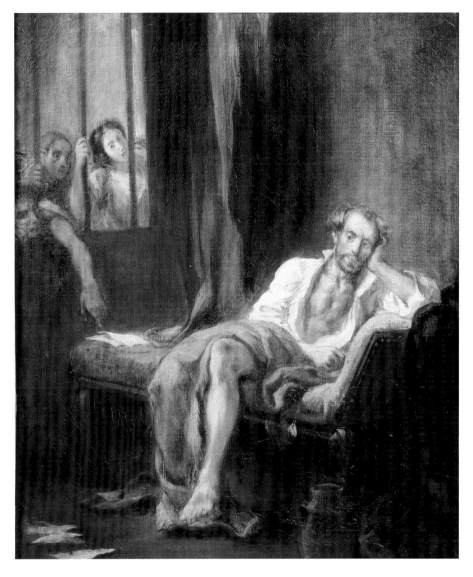

▶ **Pl.10**
EUGÈNE DELACROIX
*Tasso in the Hospital of
St Anna, Ferrara* 1839
Oil on canvas
60 × 50
Oskar Reinhart Collection

▶ **Pl.11**
RAPHAEL
Portrait of Valerio Belli
c.1517
Oil on wod
c.10 diameter
Private Collection

▼ **Pl.12**
Circle of GIUSTO LE COURT
Madonna and Child c.1660
Marble
98 × 76 × 36.5
Private Collection

▶ **Pl.13**
DAVID JONES
Petra im Rosenhag 1931
Watercolour, gouache and
pencil on paper
100 × 77.5
National Museum Wales

► **Pl.14**
PAUL CÉZANNE
Le Château Noir c.1904
Oil on canvas
69.2 × 82.7
Private Collection

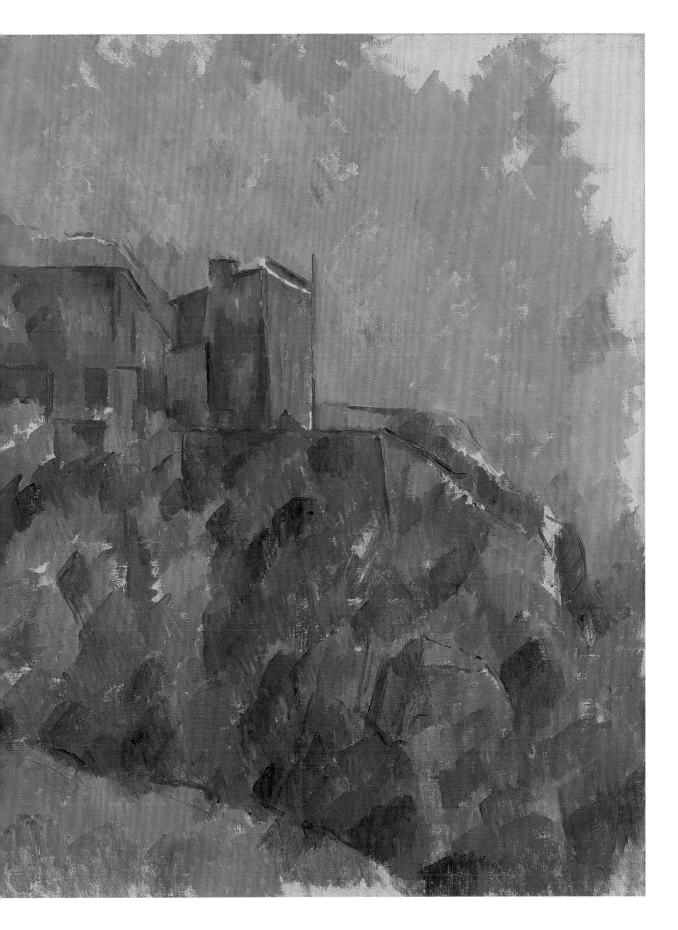

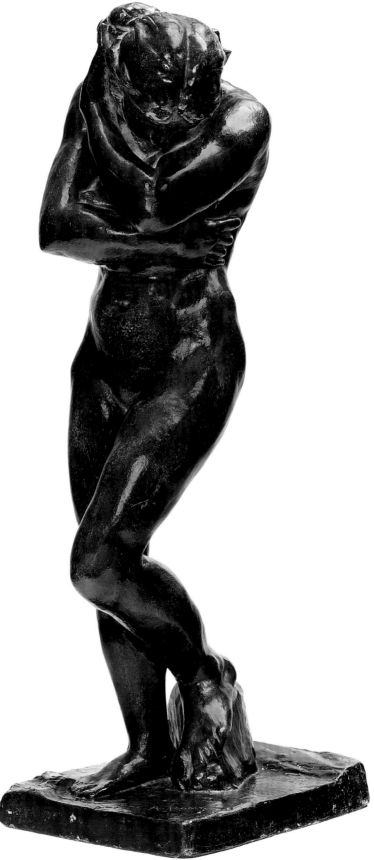

▶ **Pl.15**
AUGUSTE RODIN
Eve 1881
Bronze
76 × 23 × 29
Private Collection

▶ **Pl.16**
HENRY MOORE
*Two Women: Drawing
for Sculpture Combining
Wood and Metal* 1939
Bodycolour over graphite,
charcoal and coloured
chalks on paper
44.9 × 37.7
British Museum

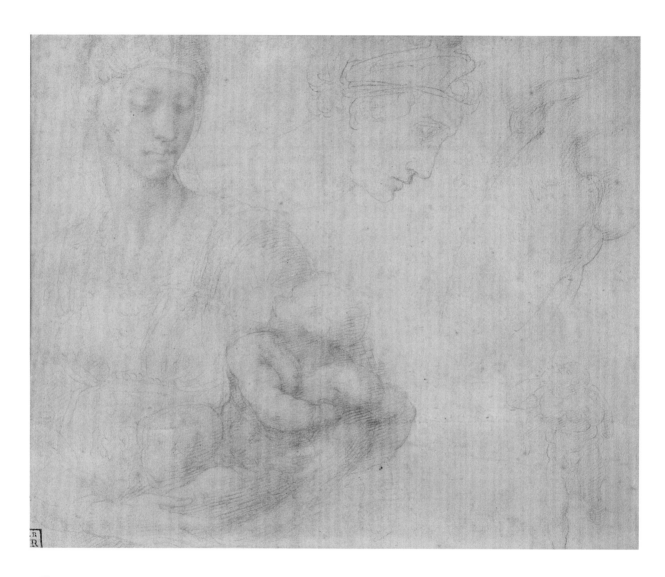

▲ **Pl.17**
Follower of
MICHELANGELO
Sheet of Figure Studies,
with the Madonna and
Child 16th century
Black chalk on paper
21 × 26.5
Private Collection

▲ **Pl.18**
PAUL CÉZANNE
The Young Paul Asleep
1878–80
Pencil on paper
34 × 45.5
Private Collection

Pl.19
Circle of JACOPO
CARUCCI, KNOWN AS
PONTORMO
Madonna and Child
C.1520
Oil on panel
73.5 × 53.5
Cartwright Hall Art
Gallery, Bradford

▶ **Pl.20**
*David Playing a Psaltery
Beneath Christ in
Mandorla with Cherubim
and Serphim, Lombardy,
Italy* 1440–50
Single leaf manuscript
20 × 20
Morgan Library and
Museum, New York

▶ **Pl.21**
Attributed to GIORGIONE
*A Winged Putto Gathering
Fruit from a Tree*
c.1500
Fresco fragment,
transferred to linen
144 × 81 × 11
Private Collection

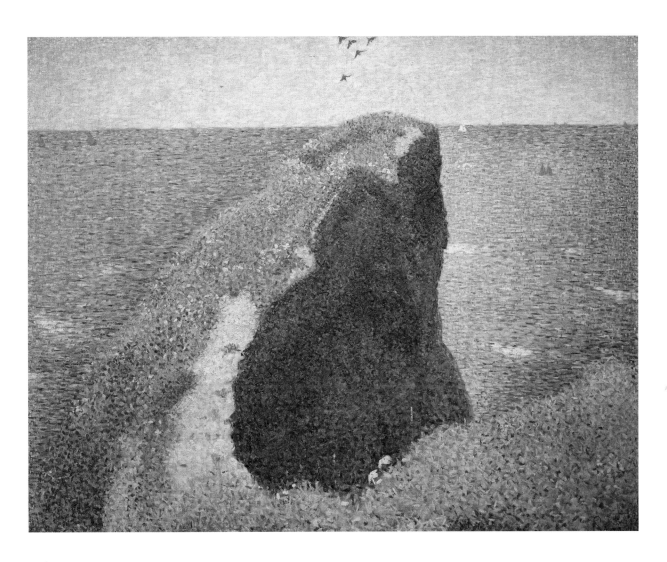

▲ **Pl.22**
GEORGES SEURAT
Le Bec du Hoc,
Grandcamp 1885
Oil on canvas
64.8 × 81.6
Tate

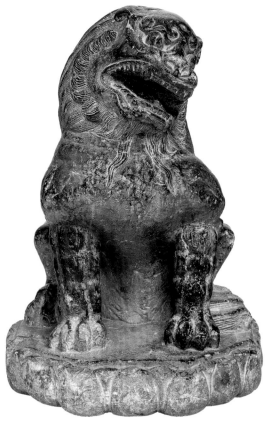

▶ **Pl.23**
Tang Dynasty Lion
AD 618–907
Black stone
40 × 28 × 27.5
Private Collection

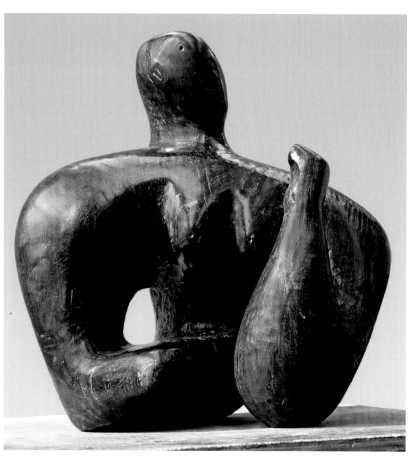

◀ **Pl.24**
HENRY MOORE
Composition 1932
Dark African wood
40.6 × 38.1 × 26.7
Private Collection

▶ **Pl.25**
HENRY MOORE
Standing Female Nude
1925–35
Pen and black ink, black
wash and coloured chalks
on buff paper
42.3 × 25.2
British Museum

▶ **Pl.26**
Table Fountain Group:
Orpheus Playing his Lyre
Urbino 1561
Tin-glazed earthenware
(maiolica)
48 × 44 × 34
Private Collection

▶ **Pl.27**
VANESSA BELL
Portrait of Angelica as a
Russian Princess 1928
Oil on canvas
59 × 39
Private Collection

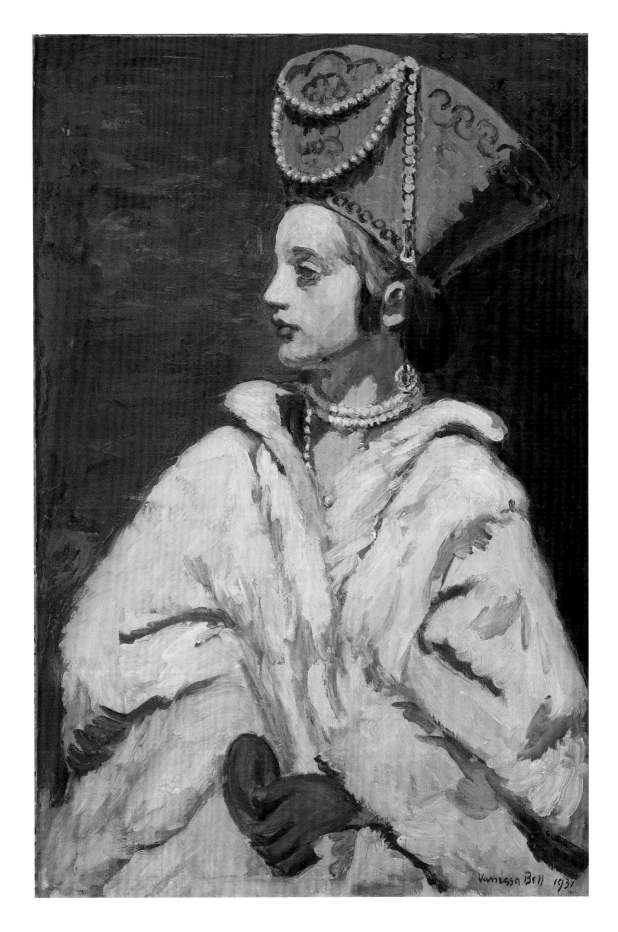

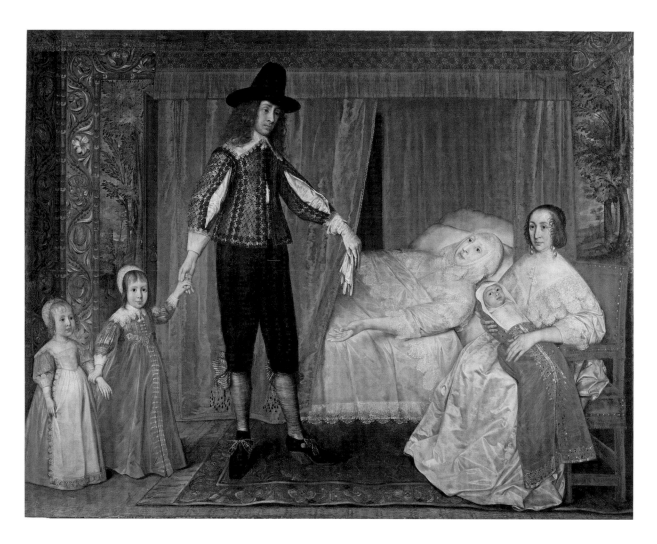

DAVID DES GRANGES
The Saltonstall Family
c.1636–7
Oil on canvas
214 × 276.2
Tate

Pl.29
Group of 3 figures:

▼ *An allegory of vigilance*
France c.1600
Ivory
17 × 6 × 5

▶ *Charity*
Italy 17th century
Gilt bronze
33 × 15 × 10

▶ ▶ *Venus and Cupid*
Venice c.1600
Bronze
22.5 × 6 × 6
Private Collection

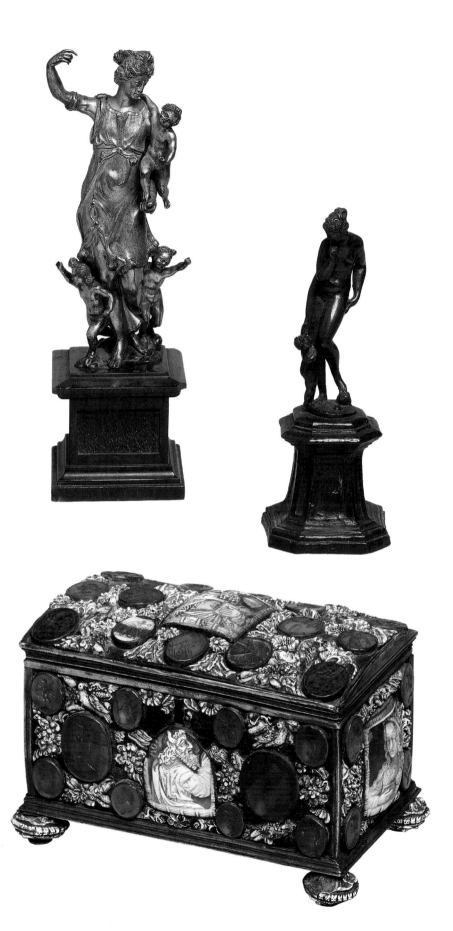

▶ **Pl.30**
Augsburg Silver Gilt and Enamel Casket 17th and 18th centuries
Silver gilt and enamel set with agate intaglios and mother of pearl cameo portraits
9 × 12 × 8
Private Collection

▼ **Pl.31**
PAUL CÉZANNE
*Bathers (Esquisse de
baigneurs)* c.1900–2
Oil on canvas
20.5 × 33.4
Private Collection

▶ **Pl.32**
LUCCA DELLA ROBBIA
Christ Before Pilate
15th century
White-glazed maiolica
with blue pigment
33 × 58
Private Collection

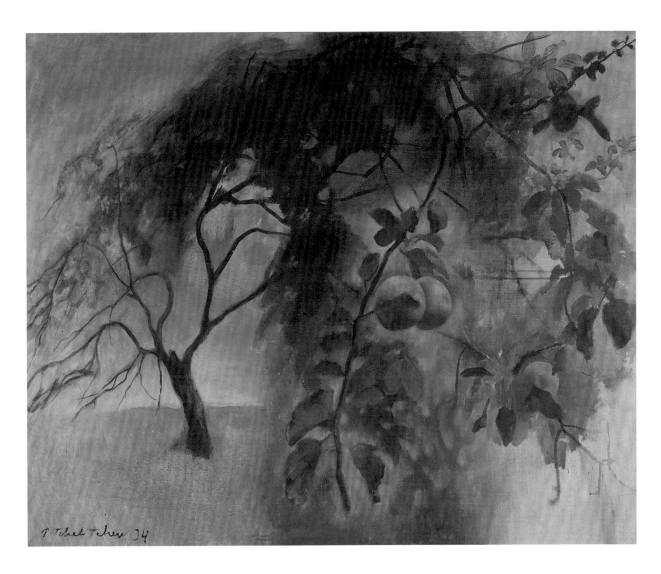

▲ **Pl.33**
PAVEL TCHELITCHEW
Apple Tree 1931
Oil on canvas
78 × 100
Private Collection

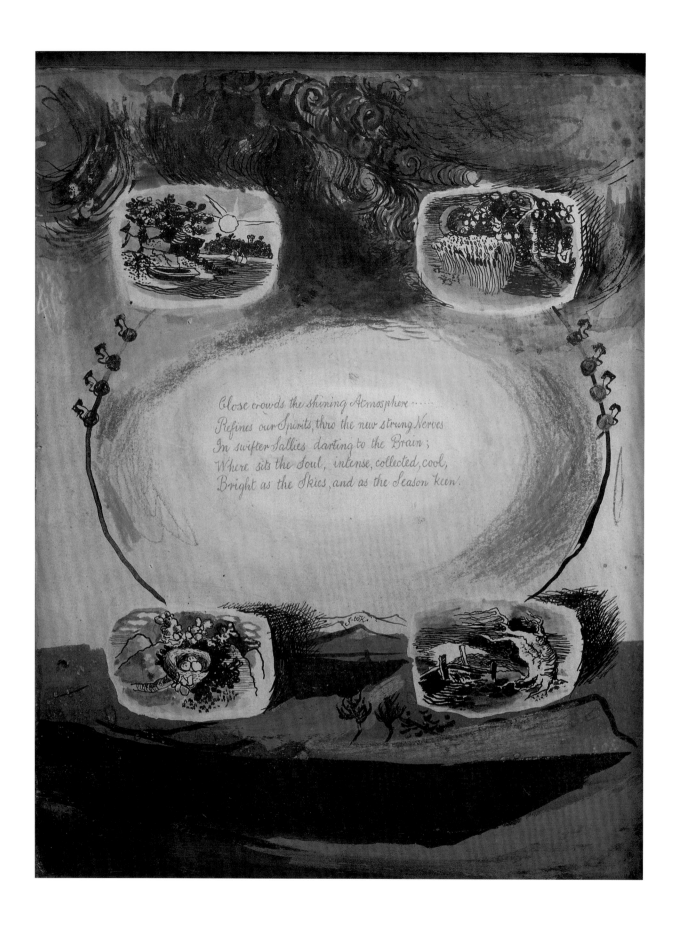

Close crowds the shining Atmosphere
Refines our Spirits, thro the new strung Nerves
In swifter Sallies darting to the Brain;
Where sits the Soul, intense, collected, cool,
Bright as the Skies, and as the Season keen.

◀ **Pl.34**
GRAHAM SUTHERLAND
*Design for the cover of
'Landscape Into Art'* 1940
Watercolour and ink on paper
41 × 34.5
Private Collection

▲ **Pl.35**
GRAHAM BELL
Brunswick Square, London
1940
Oil on canvas
34.7 × 39.8
Museums Sheffield

SELECTED WORKS FROM THE COLLECTION OF KENNETH CLARK **61**

▲ **Pl.36**
HENRY MOORE
Head 1930
Ironstone
7 × 7 × 3
Private Collection

▶ **Pl.37**
SAMUEL PALMER
*Cornfield by Moonlight,
with the Evening Star*
c.1830
Watercolour and gouache
with brown ink
19.7 × 25.8
British Museum

▼ **Pl.38**
JOHN PIPER
Gordale Scar 1943
Oil on canvas
76.2 × 61
Private Collection

▶ **Pl.39**
SIDNEY NOLAN
Central Australia 1950
Oil on canvas
121 × 90
University of York

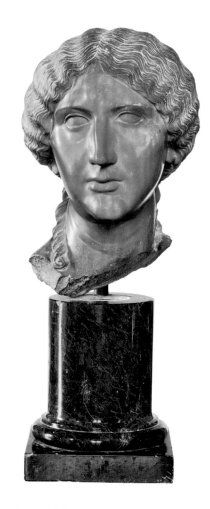

▶ **Pl.40**
Portrait Head of a
Roman Empress: probably
Agrippina the Elder
AD 1st century
Greywacke (greenschist)
54 × 23 × 26
Private Collection

▶ **Pl.42**
JOSHUA REYNOLDS
Portrait of Marie Countess
of Schaumburg-Lippe
C.1759
Oil on canvas
49 × 40
Private Collection

▶ **Pl.41**
THOMAS
GAINSBOROUGH
A Peasant Family Going to
Market 1771–4
Chalk and wash on paper
41.4 × 53.8
Gainsborough's House,
Sudbury, Suffolk

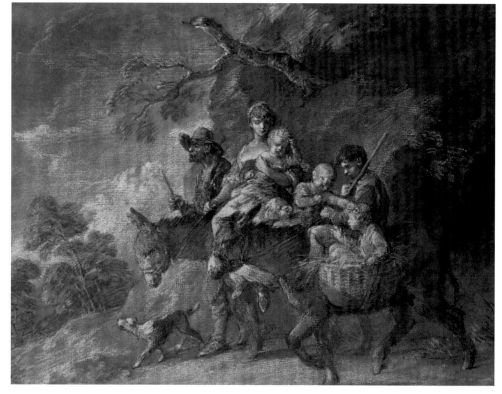

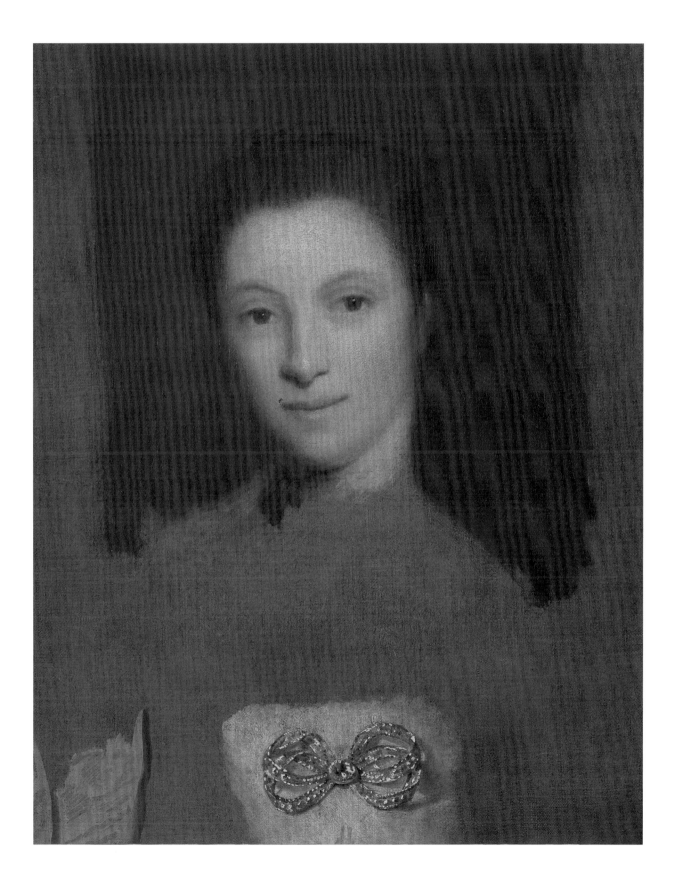

▶ **Pl.43**
BOW FACTORY
*Pair of White Busts of
Mongolians* c.1750
Porcelain ware
25.5 × 10.7 × 8.4 (male)
28.5 × 12.5 × 9.5 (female)
Pallant House Gallery,
Chichester

▶ **Pl.44**
Follower of ADAM
ELSHEIMER
Tobias and the Angel
after 1613
Oil on panel
9.5 × 12.5
Private Collection

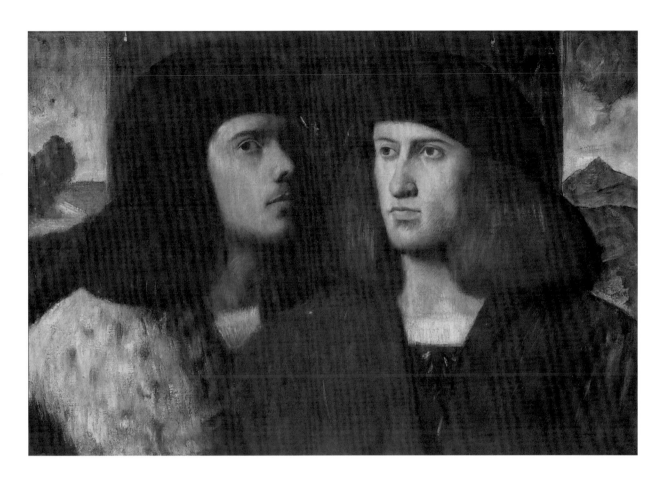

▲ **Pl.45**
EDGAR DEGAS
Two Heads of Men,
after Giovanni Cariani
(formerly attributed to
Gentile Bellini)
c.1854
Oil on canvas
40 × 60
Private Collection

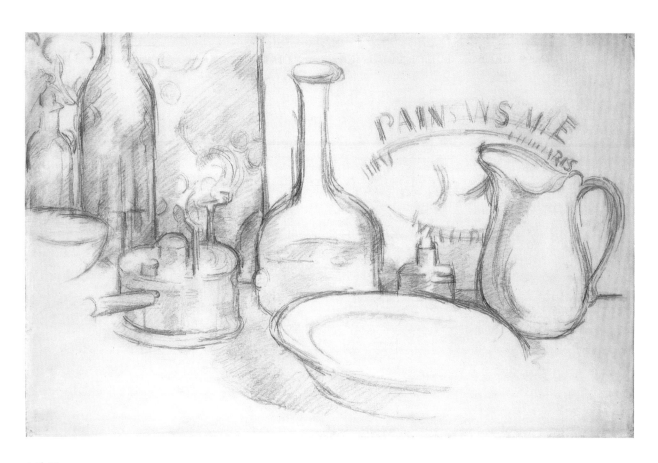

▲ **Pl.46**
PAUL CÉZANNE
*Nature Morte: 'Pain Sans
Mie' (Still Life with Spirit
Lamp)* c.1887–90
Pencil on paper
31.8 × 49.2
Private Collection

▼ **Pl.47**
GEORGES SEURAT
The Forest at Pontaubert 1881
Oil on canvas
79.1 × 62.5
Metropolitan Museum of Art,
New York

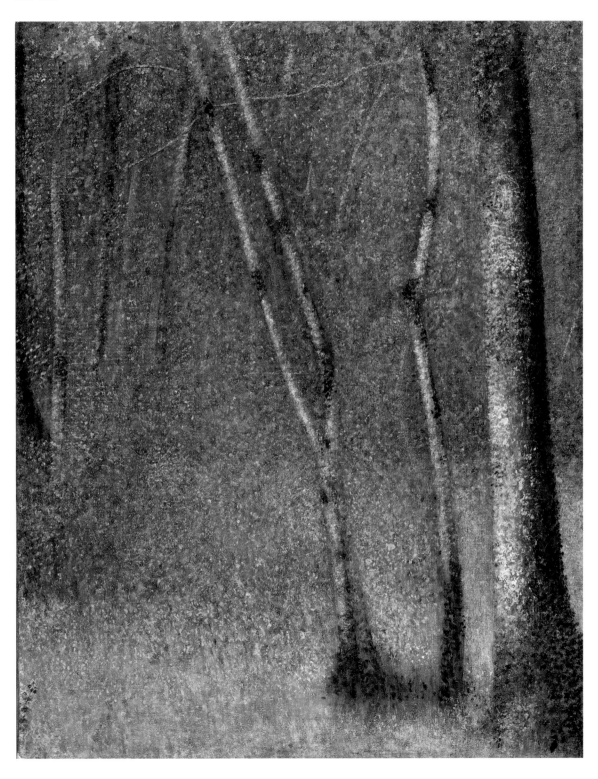

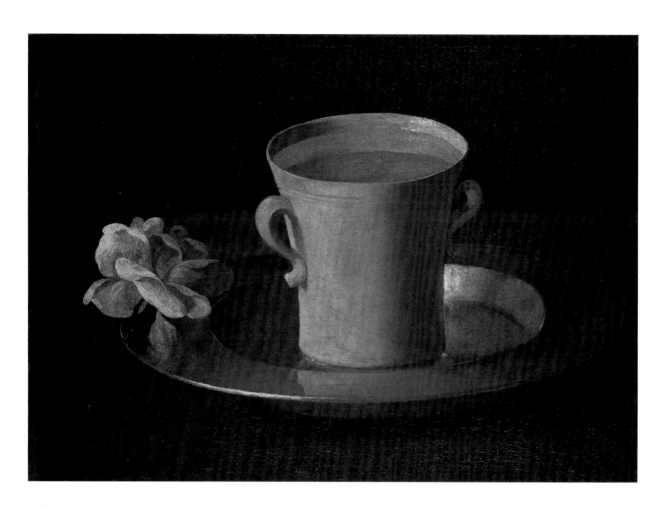

▲ **Pl.48**
FRANCISCO DE ZURBARÁN
A Cup of Water and a Rose
c.1630
Oil on canvas
21.2 × 30.1
National Gallery, London

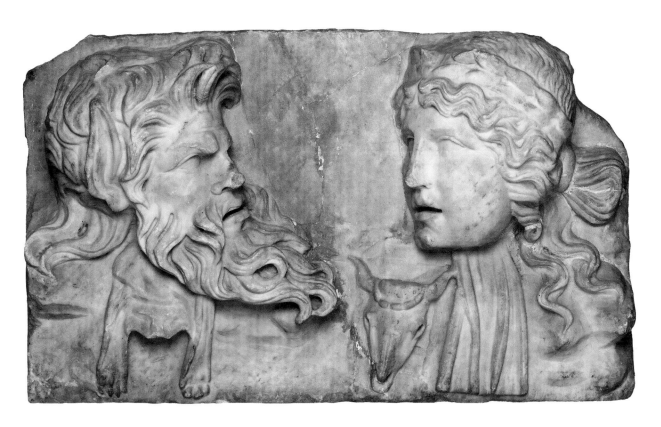

▲ **Pl.49**
Hadrianic Panel of Two Masks AD 125
Marble
31 × 48 × 10
Private Collection

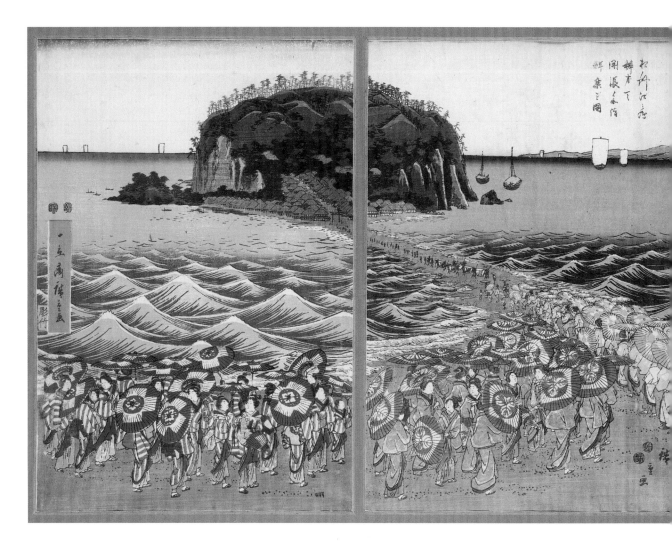

▲ **Pl.50**
UTAGAWA HIROSHIGE
*Pilgrims Visiting the Shrine
of Benten at Enoshima in
Sagami Province* c.1850
Woodblock print, triptych
55.9 × 91.4
Private Collection

▼ **Pl.51**
LUCIAN FREUD
Balcony Still Life 1951
Oil on copper
14.5 × 19.5
Private Collection

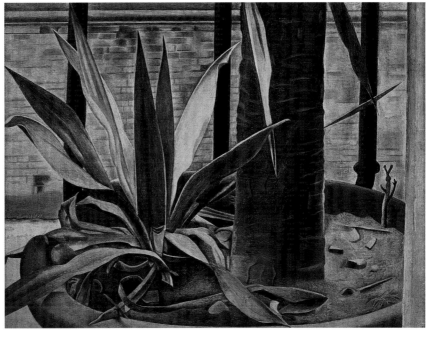

▲ **Pl.52**
JOSEPH MALLORD
WILLIAM TURNER
Seascape: Folkestone
c.1845
Oil on canvas
88.3 × 117.5
Private Collection

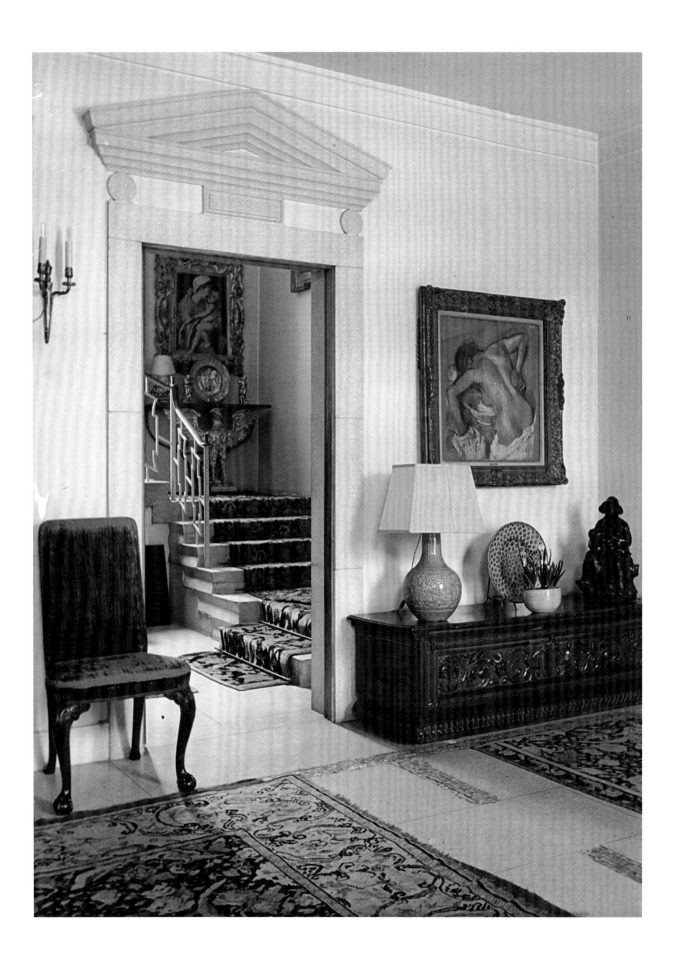

3 Patron and Collector

CHRIS STEPHENS

THOUGH HE OFTEN RESISTED the label for himself, Kenneth Clark identified two kinds of collector: 'those who aim at completing a series, and those who long to possess things that have bewitched them'.[1] His own collection included some major works of art, but it was nonetheless domestic and driven by personal taste more than strategy. Alongside significant paintings, it included numerous drawings and other smaller works. He feared he had, perhaps, too many sculptures – in particular Renaissance bronzes and a few small carvings – and these were nearly all small enough to stand on a side-table or bookcase. The collection was not restricted to paintings, drawings and sculptures, however: Clark was a great lover of china and amassed huge amounts of Sèvres porcelain, majolica from Italy and beyond, and Chinese, Japanese and Islamic ceramics, including two monumental Yung Chen period (1723–35) porcelain pagodas often erroneously supposed to have been bought by the Prince Regent for the Brighton Pavilion. The furniture was fine, betraying a penchant for Japonaiserie and including numerous pieces by Sheraton, Chippendale and others. Objets d'art and bijouterie were common, mixing with the sculptures on every surface: Renaissance medals by Pisanello (pl.11) and others, medieval ivories (pl.29), a jewel- and stone-encrusted seventeenth-century casket (pl.30), a sixteenth-century Scottish coco-de-mer cup, coins and copious amounts of jewellery, including numerous eighteenth- and nineteenth-century English brooches and bracelets, and rings ranging from third-century Roman, fourth-century Syrian and fifth-century Coptic to recent commissions from Alexander Calder. There were antiquities from Egypt, Greece and Rome, Coptic textiles and oddities such as a pair of narwhal tusks. 'It is a strange accumulation', Clark reflected in 1947, with 'examples of almost every kind of artefact and almost every epoch, from early Egyptian times onwards. There are no Flemish or German primitives …

that really seems to be the only form of artistic expression which is missing.'[2]

Much of Clark's collection – most of which should, rightly, be seen as both his and his wife Jane's – was acquired during the 1920s and early 1930s. This was the period when they were establishing the marital home, travelling freely, and when art and antiques could be bought relatively cheaply as a result of the slump. In fact, by his own account Clark's collecting had begun in childhood. Clark's father – despite his reputation for racing yachts, cards, drink and cigars – had built a sizeable collection of paintings by such fashionable artists of the time as John Everett Millais and William Quiller Orchardson, and earlier painters such as David Wilkie and Edwin Henry Landseer (fig.3).[3] The young Clark was encouraged in his prodigious interest in art: for example, his collection of original Japanese prints by Hokusai and others started with a twelfth–birthday

present, and he acquired original works of art throughout his teenage years.

Clark generally bought opportunistically. One exception was an extraordinary collection of about 150 medieval and Renaissance illuminated miniatures that he bought around 1930. These were the residue of a collection assembled in an album by the nineteenth-century Scottish collector James Dennistoun. There seems later to have been a row about the price paid, and Clark explained that while he might have paid too little for the German miniatures, which were the gems of the collection, he probably paid too much for the Italian ones. By the early 1970s, Clark had sold and given away a number, but still had over a hundred and the original album.[4]

Photographs of the Clarks's homes are rare, but a series of Upper Terrace House, Hampstead, from 1947 (figs 16–18) show one or two of the Dennistoun miniatures displayed framed on bookcases alongside a

Fig.17
Upper Terrace House interior, 1947
Felix H. Man

Fig.18
Upper Terrace House interior, 1947
Felix H. Man

small roundel by Raphael – a portrait of the artist's friend Valerio Belli. These photographs show how the works on display in the main rooms of the house were mostly paintings and drawings from the Italian Renaissance and late nineteenth-century France. Clark had six oils by Paul Cézanne (pls 14, 31), two important Seurats (pls 22, 47), landscapes by Pissarro and Sisley, a nude pastel, drawings and bronzes by Degas and a bronze *Mother and Child*, several drawings and two oils by Renoir (pls 1, 6), including *La Baigneuse Blonde*, which Clark considered the painter's masterpiece and in which, it seems, he delighted more than anything.[5] Most remarkable was the acquisition in 1933 of about fifty drawings and watercolours by Cézanne that Clark had happened upon at the Parisian gallery of Paul Guillaume, who was selling them on behalf of the artist's son (fig.8, pls 18, 46).

In the library of Upper Terrace House hung a Madonna and Child by Giovanni Bellini (pl.4); another, by Rosso Fiorentino (pl.19), hung on the stairs. Clark had some early Sienese pictures, echoing acquisitions he made for the National Gallery, and a number of Venetian objects, including a fresco fragment (pl.21) from the exterior of the Fondaco dei Tedeschi, attributed to Giorgione and once in the collection of John Ruskin. An oil painting of a rather grotesque head has been identified as a copy of Michelangelo's drawing of Cleopatra by Giorgio Vasari or a follower; Clark believed the Madonna and Child on the left-hand side of a sheet of studies to be from the hand of Michelangelo. Drawings were a special passion for Clark; an undated typed guide to the pictures in the house records the display in the White Sitting Room including 'old master drawings by Solario, Correggio,

Allori, Rosso, Guido Reni, Raffaelino, Carli, etc.'; elsewhere one might find a beautiful watercolour by Giovanni da Udine (pl.5) and a grand portrait by Tintoretto which Clark later used to demonstrate the sort of museum work that sits uncomfortably in a private house.[6] The pictures ranged more widely: he continued to buy Japanese prints; he had drawings by Rubens, Murillo, Delacroix and Géricault, and a number by Millet; a Corot had been one of his first purchases and, because they were out of fashion, he collected paintings by such Barbizon painters as Théodore Rousseau and Charles-François Daubigny. He also had paintings by Delacroix (pl.10), 'Le Douanier' Rousseau and Toulouse-Lautrec, and, moving into the twentieth century, several paintings and drawings by Matisse, a drawing by Picasso, a major 1913 collage by Juan Gris (he regretted the lack of Braque) and a number of works by Georges Rouault.[7]

There were numerous works by contemporary British artists. This was, in fact, the greater part of Clark's picture collection. He had some earlier British works: he had a number of his father's Victorian and Edwardian paintings (Orchardson's *Venetian Lagoon* is visible in a bedroom, fig.17), though of the Pre-Raphaelites he had only one drawing: a portrait of Elizabeth Siddal by Rossetti. Somewhat unexpected is the large seventeenth-century *Saltonstall Family* by David Des Granges (pl.28). He had an unfinished Reynolds (also once Ruskin's, pl.42), a Gainsborough oil and several drawings, including the major *Peasant Family on the Way to Market* (pl.41), at least ten Constables, all small except one bought on the advice of Lucian Freud and later considered to be unreliably

Fig.19
HENRY MOORE
Madonna and Child 1943
Terracotta
19 × 15 × 15
Daniel Katz Gallery,
London

attributed (a modest array for an artist whom Clark regarded as the pinnacle of English landscape painting, though he did have a cast of Constable's death mask), watercolours by Girtin, Cozens, Cotman and Turner, and in the early 1950s he acquired probably the most important painting he owned, Turner's *Seascape: Folkestone* (pl.52), a magnificent late work which was, Clark wrote, 'his only consolation' for the Renoir that he had sold.[8] If the Turner and the Renoir nude were Clark's most important paintings, the most influential may have been Samuel Palmer's *Cornfield by Moonlight, with the Evening Star* (pl.37), not only one of the artist's masterpieces but one echoes of which can be seen in the work of numerous British artists of the 1940s.

In the 1930s and 1940s Clark was widely known as one of the most active collectors, if not *the* most active, of contemporary British art. Looking back at his collecting, Clark recalled seeing Henry Moore's first solo show in 1928: 'I began to buy his drawings immediately. I am glad to say that I have been doing so ever since and now have over forty (pls 16, 25; figs 21, 36). At a slightly later date I had the same good fortune with Graham Sutherland (pl.34; fig.29), Victor Pasmore, David Jones (pl.13) and John Piper (pl.38).'[9] In fact, his collecting of the British art of his time ranged far wider than those five artists, and his involvement was much broader and deeper than simply acquiring work. For Clark, the making of art was an essential ingredient of civilisation, and he sought to encourage and facilitate its production and its reception. The idea of civilisation that runs through Clark's career was also, one discerns, embodied in a certain way of life. In any living collection, he wrote, the works of younger artists should comfortably take their place among the works of the past. But the house was not just a conglomeration of works mixing with surprising harmony; it was itself an artefact. In 1947 he wrote of his home at Upper Terrace House:

This house represents a desperate rear-guard action. Under the influence of the prevailing moral ideas England has had to destroy one of the most perfect of all English works of art, the great house. It was the essence of these houses that they were alive, that their pictures, furniture, carpets, tapestry, had grown into the house and represented the habits and affections of generations of civilised men and women. To strip

one of these houses and preserve it as a museum or a lunatic asylum is to destroy it. However, the fact remains that in a few years time hardly one of these houses will be lived in. Soon the peculiar beauty they created will be as remote, as impossible to imagine, as the palace of a Byzantine emperor.[10]

Defiantly dismissing the prospect of life 'in a prefabricated cell with bare walls, plastic furniture and filing cabinets for government forms', Clark committed 'to preserve some token of our former surroundings, as a last modest assertion of the belief that life is more agreeable when the objects which surround us have been made with love and made to please'.[11] The English country house, Clark concluded, had achieved on a grand scale what could be found in many a home – 'in the back parlour of a village post office, but not in the apartment of a millionaire' – the character that derives from contents that have all 'aroused the same passion of desire'. 'The question is will it be possible to maintain this modest level of civilisation in the future?'[12]

――――――――

Among the objects of desire that Clark had amassed in the mid-1930s was a white relief by Ben Nicholson (fig.20). Clark had bought it in late 1934, soon after the artist had started making such works.[13] Yet, within a few days of Nicholson opening an exhibition of white reliefs – possibly the high-water mark of British modernism – Clark expressed his concerns about abstract art.[14] Considering 'The Future of Painting', he sought to explain why the 'art of painting' had become 'not so much difficult as impossible'. Acknowledging

that academic values and the 'belated impressionists' had had their day, Clark went on with a critique of the two 'advanced' schools laying claim to the future: 'cubists' (for which read 'abstract') and, adopting Herbert Read's term, 'super-realists'. He noted that while advanced art before the First World War – which was 'civilised, traditional and free' – was 'essentially a French movement', 'post-War movements in the arts, with their belief in violence and superstition, have been essentially German'. In the case of the abstract and surrealist movements he observed 'their extreme reliance on theory' and the 'diversity of these theories'. They were like Germanic Protestantism, as opposed to 'the catholic understanding that allowed Degas to study Sir Thomas Lawrence as well as Ingres'.

Taking each 'dissenting sect' in turn, Clark argued that:

> abstract art, in anything like a pure form, has the fatal defect of purity. Without a pinch of earth the artist soon contracts spiritual beri-beri and dies of exhaustion. The whole cubist movement has revealed the poverty of human invention when forced to spin a web from its own guts.

'Geometric' as opposed to 'organic' art is dismissed, though Clark admits: 'There are some admirable Negro textiles which', he adds, 'the supporters of the geometric style can weigh against Giotto, Donatello, Michelangelo and Chartres Cathedral'. He was more tolerant of the surrealists because they conformed to the tradition that 'a strongly held image must precede a work of art', and their exploitation of the unconscious

Fig.20
BEN NICHOLSON
1934 (white relief – AS)
1934
Painted wood relief
70.5. × 47.5 × 3
Annely Juda Fine Art,
London / Mitchell Innes
& Nash, New York

could be justified by 'the ubiquitous influence of psychoanalytic theory'.

Society's future, Clark mused, was likely to rest with fascist thugs and the proletariat but certainly not with 'the clique of elaborate middle-aged persons who are the chief supporters of abstract art'. 'Cubism and Super-realism', he ended, 'are the end of a period of self-consciousness, inbreeding and exhaustion'; perhaps, he concluded, there was little prospect for painting in the immediate future. Citing the impact of photography on painting's traditional imitative function, he wondered whether any good style would come in his lifetime, offering late sixteenth-century Italy, the age of Shakespeare and the late Roman period as 'slack periods' in the history of art. 'No new style will grow out of a

preoccupation with art for its own sake. It can only arise from a new interest in subject-matter. We need a new myth in which the symbols are inherently pictorial.' For Clark, good art had to relate, or be comprehensible, to a large part of society and, by extension, to relate in its imagery to things those people understood.

The position was hardly unique. What is unusual is that, having expressed such a pessimistic view of future developments, Clark seems to have set out to do something about it through his own patronage. In the later 1930s one can discern a change in his involvement with contemporary art. Clark believed that the arcane remoteness from common experience that he saw in advanced art stemmed from an absence of patronage. For painting to flourish it had to be 'necessary and popular'.[15] In the absence of collectors or patrons, he believed, artists had become increasingly introspective and their work divorced from everyday experience, or the material world. Reviewing an exhibition of Shell posters in the autumn of 1934, Clark observed that 'as rich people have grown fewer and more ignorant, so art has declined', and he praised Shell-Mex BP Ltd for providing 'just the kind of patronage which the modern world and the modern artist needs: a patronage which no single rich man could provide'.[16] He nevertheless seems to have set out to try to provide such a patronage himself, first through private means and later through state bodies. The result was the establishment of a particular kind of modernism as the dominant art in Britain in the 1940s: an art that was not realist but which related to the material, natural world, an art consciously developed with reference to the art of the past, often to British artistic tradition, and an art which found its 'myth' in nature

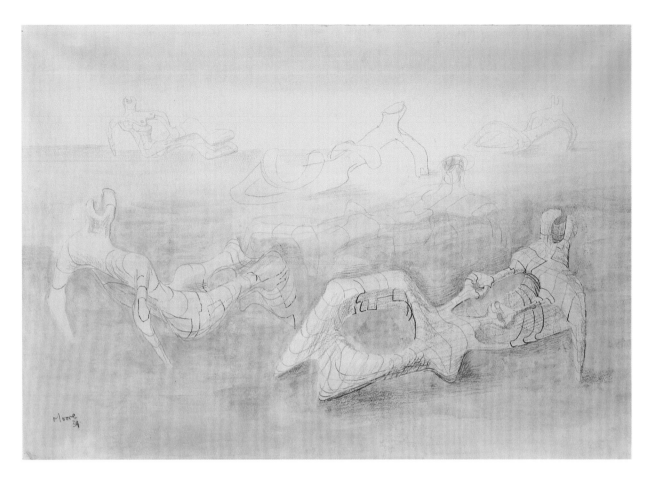

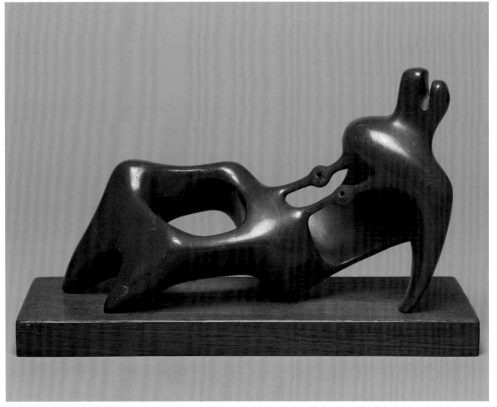

Fig.21
HENRY MOORE
*Ideas for Metal Sculpture:
Studies for Reclining
Figures; Abstract Forms*
1939
Coloured chalks on paper
38 × 55.5
British Museum

Fig.22
HENRY MOORE
Reclining Figure 1939
Lead
18 × 29.5 × 10.5
Private Collection

Fig.23
MAN RAY
Solarised Portrait of Lady Clark 1934
Vintage print
23.5 × 18
Private Collection

Chamberlain and Winston Churchill, senior bureaucrats and members of the royal family from the King down. Clark himself described a period when 'we were asked everywhere, and almost everyone of note came to lunch or dine with us': it was 'the Great Clark Boom'.[17]

From early on Clark had not only bought works of art but had also commissioned things from artists. He had got to know the Bloomsbury painters through Roger Fry, whom he had met while at Oxford. He would own numerous works by Duncan Grant and Vanessa Bell (pls 8, 27; fig.32), and both painted portraits of Jane Clark; before them Clark had commissioned the venerable Philip Wilson Steer to do the same, resulting in 'one of the worst portraits ever painted'.[18] Photographs of Jane, presumably made in Paris, by Man Ray may also have been commissions (fig.23). The Clarks commissioned numerous domestic items: Bernard Leach made tiles to decorate a fireplace, some of the interiors at their home in Portland Place were by Marion Dorn, and Grant and Bell made a number of things: a painted screen, a rug designed by Grant and, most significantly of all, a large dinner service the forty-odd plates of which were each hand-painted with portraits of famous women of history (figs 24, 25). The act of commissioning was a recurring aspect of Clark's involvement with artists and reflected his idea of intelligent patronage.

Clark supported a range of contemporary artists through a variety of means. As well as buying and commissioning works of fine and decorative art, he served as an advocate for certain artists and types of art; he acted as a broker, introducing artists to other collectors, commercial galleries and public collections,

– the bedrock of British cultural identity in Clark's nationally defined view of culture – and in the Second World War.

If ever there had been a 'single rich man' able to nurture contemporary British art, that man was surely Kenneth Clark. He certainly had the financial capital for such a venture. He was, in addition, uniquely socially positioned to enact and facilitate a range of different forms of brokerage. One might imagine him sitting at a key nexus, offering aesthetic opinion to the political and social elite, and providing the art world access to the establishment. This situation was not just the result of his position as Director of the National Gallery and Surveyor of the King's Pictures, which was itself a symptom of his social position as well as his clear aptitude for such work. Somehow he seemed to know not only the leading writers, musicians and artists of two generations but also politicians as widely arrayed as Ramsay MacDonald, Neville

facilitating acquisitions and helping works into particular collections; and, despite claiming the contrary, he advised artists not only on the practical aspects of their work but also on the style and development of their art, gently steering them in one direction or away from another. There are instances of him owning work by artists he did not especially like. Clark therefore exerted a considerable – unique – influence over British art. Of course, he did not do this in a vacuum. The crisis in patronage that he diagnosed was part of a wider economic crisis in the cultural field, and his commissions fitted a broader pattern of alternative strategies to which artists had to turn.[19] Nor was he alone in collecting and supporting those artists he singled out for special attention. Nevertheless, his intervention was especially significant because of his unique ability to exercise his patronage as both a private and a public activity, something that would reach its high point during the war, when he was able to use public money to support and steer artists. As we shall see, his influence may in time have been resented not only by those beyond its reach but even by some of those boosted by his support.

As if responding to the anxieties he had expressed in the *Listener*, Clark started supporting artists in a more committed and concerted fashion than simply commissions and purchases. Broadly, his patronage was in support of two forms of representational modernism: the understated post-Cézannean work of the Euston Road painters – William Coldstream, Graham Bell, Claude Rogers and Victor Pasmore – and what would become known as the neo-romanticism of Moore, Piper and Sutherland.

Following an introduction from his Bloomsbury friends, Clark was intimately involved with the new school on the Euston Road from the start. In 1937 he anonymously funded the first prospectus, and he wrote the introduction for the major exhibition of the group's work at the Ashmolean Museum in Oxford in 1941. Coldstream and Bell circulated their polemical pamphlet 'A Plan for Artists' in the spring of 1937. It echoed Clark's thinking on patronage as the two authors, both of whom had been being making films for John Grierson rather than painting, argued that there was a link between the economic pressures on the artist and the discrediting of 'ordinary realistic painting'. They called for ten people each to guarantee an artist's bank overdraft for a year, at the end of which works would be sold and the income used to clear the debt. Clark responded enthusiastically, provided funds and drew in such wealthy friends as Samuel Courtauld. He clearly went further, as the three leading figures in the school – Coldstream, Bell and Pasmore – each seem to have received a regular stipend from Clark.[20]

Coldstream certainly received regular cheques, and Clark acquired successive paintings and brokered other sales, notably to the wealthy Canadian Massey Foundation.[21] In addition, he mediated in several commissions for portraits and one for a country house interior, and even commissioned a landscape himself (fig.26). Clark held the belief that 'it needs two people to make a picture: one to commission it and the other to carry it out … The ideal patron doesn't simply pay an artist for his work. He is a man with enough critical understanding to see the direction in which the artist ought to go.'[22] Unsurprisingly, he saw the best

Fig.26
WILLIAM COLDSTREAM
On the Map 1937
Oil on canvas
50.8 × 50.8
Tate

example of such patronage in fifteenth-century Italy.

Clark also arranged a landscape commission for Graham Bell (fig.27; actually the same view as Coldstream's), and also provided him with a stipend. After enlistment in the RAF Bell wrote to Clark suggesting he cease payment as he was no longer painting.[23] Pasmore was, in effect, a Sunday painter until Clark paid him a salary to release him from working in the offices of the London County Council. In March 1940 Pasmore wrote to Clark, 'as regards the "Red Table", if you would like it for yourself, don't buy it because it belongs to you under our little agreement' (fig.28; see also pl.3, fig.33), and a little later he told Jane Clark that he was concerned about his 'monthly cheque', saying, 'I should hate to lose it.'[24] Several paintings are discussed in correspondence before their completion, suggesting that they were either commissioned or at least bought in advance. Such was their 'little arrangement' that, when Pasmore seemed about to be called up, he

Fig.27
GRAHAM BELL
Suffolk Landscape with Train 1937
Oil on canvas
71 × 91.5
Private Collection

wrote to Clark: 'It seems that our partnership has been brought to an end now. It is very sad as I have enjoyed painting for you.'[25] At the end of the war Clark helped him buy a house in Blackheath – a debt that was only paid off at the beginning of the 1960s.

The Euston Road project reached its denouement with a survey exhibition of its members' work at the Ashmolean Museum, Oxford, in 1941. Clark lent several works and provided an introduction, giving the show an important public seal of approval. He was keen to emphasise that, though the Euston Road painters continued the tradition of painting based on close observation typified by the landscapes of Constable and Cézanne, the artists would never subscribe to anything as crude as social realism. Interestingly, a few years later, when Bell's widow reviewed Clark's draft for a posthumous introduction to the painter's work, the one comment she made was that he should have made reference to the fact that all of Bell's art stemmed from his Left-wing politics.[26] The extent of Clark's

Fig.28
VICTOR PASMORE
The Red Tablecloth 1936
Oil on canvas
60.5 × 73
Private Collection

involvement in the school was reflected in Pasmore's comment: 'I must thank you myself and on behalf of the others for your great support of the Euston Road exhibition at Oxford and I do hope you are satisfied with our selection and arrangement. We are delighted you regard yourself a member of the school as surely you are.'[27]

Though recognising in Pasmore 'one of the two or three most talented English painters of this century', Clark's enthusiasm for Euston Road painting was qualified.[28] In contrast, he described his first encounter with Graham Sutherland's art in epiphanic terms and credited Sutherland with 'showing me a way out of the virtuous fog of Bloomsbury art'. The terms with which Clark would recall this encounter are illuminating. Sutherland's work was, he wrote, 'contemporary and original', with a 'visionary intensity ... which ... seemed to place him in the same tradition of lyrical art as Blake, Turner and Samuel Palmer'. In contrast, not only did the Euston Roaders not 'excite' him, but Clark 'felt fairly certain that spatial construction and careful realisation were not the natural inheritance of English painting'.[29] There is a clue here to the key criteria by which Clark assessed the importance of contemporary British artists: their contemporaneity and invention, technical proficiency and a relationship to national traditions. So, in the last years of the 1930s, Clark very clearly put more of his resources into the developing new romanticism in British art,

Fig.29
GRAHAM SUTHERLAND
*Sun Setting Between Two
Hills* 1938
Watercolour on paper
26.5 × 36
Private Collection

of which Graham Sutherland was the leading light and to which would be added Henry Moore and John Piper, David Jones and such younger followers as Robert Colquhoun, John Craxton and Lucian Freud.

Clark first met Sutherland at, or as a result of, the Shell poster exhibition and acquired work straight after, if not before, their meeting, but it was in 1936 that regular contact was established. By that time Clark was showing Sutherland's work to others, securing his old friend Colin Anderson as another major patron (as he would be for Moore and others), and by the end of the year Clark had successfully introduced Sutherland to Rosenberg and Helft, the new London branch of Picasso's Paris dealer. From

that point on, artist and patron built a tight bond. Clark bought numerous works (pl.34, fig. 29). Sutherland's regular income from teaching probably meant a stipend was not necessary, but by October 1938 he wanted to give Clark a painting as a mark of gratitude. When war broke out and Sutherland's job was immediately suspended, Clark assured him he would look after him and straightaway sent money to tide him over. As with Pasmore, he provided funds to allow Sutherland to buy a house and the security that went with it.

Clark claimed to have collected Henry Moore's drawings from the time of his first solo exhibition at the Warren Gallery in 1928, but he only engaged directly with him shortly after befriending Sutherland. Interestingly,

until the 'Family Group' sculptures of the mid-1940s, Clark owned only a few small sculptures by Moore, as compared to dozens of works on paper. He seems never to have needed to support Moore financially. However, as soon as the obstructive J.B. Manson had been replaced as Director of the Tate Gallery by John Rothenstein, Clark worked behind the scenes and used his position as buyer for the Contemporary Art Society to ensure that *Recumbent Figure* (fig.30) was secured for the gallery in 1939. It seems to have been in that year that Clark met John Piper, and, though Piper, Moore and Sutherland had not previously been associated with each other, he probably consciously contributed to the tendency for them increasingly to be seen as the leading protagonists of a new disposition.

For Sutherland, Clark had brokered an arrangement with a leading avant-garde gallery; for Moore, he had brokered the acquisition of a key work for the national collection; for Piper, he secured a major commission. As Surveyor of the King's Pictures, Clark was close to the Queen and able to position Piper when it was suggested that a visual record should be made of Windsor Castle in case of enemy bombing (fig.31). Clark was very well aware of Piper's fascination with the romantic subject of ruins (he owned several, including Piper's painting of the burnt façade of Seaton Delaval) and put him forward for this important job. Piper was initially asked to make fifteen studies but hoped that the commission might extend to over a hundred; in the end, twenty-six were produced and, while insisting that they were impressed by the works, the royal household clearly felt that they did not meet their requirements as visual records.[30]

Consciously and explicitly in the minds of both Clark and Piper was the precedent

Fig.30
HENRY MOORE
Recumbent Figure 1938
Green Hornton stone
88.9 × 132.7 × 73.7
Tate

Fig.31
JOHN PIPER
The Round Tower from the Roof of St George's Chapel
C.1941–2
Watercolour on paper
37.4 × 51.1
Royal Collection Trust

of a series of watercolours of Windsor made by Paul Sandby in the late eighteenth century. It was not uncommon for Piper to invoke such art-historical associations, as is demonstrated by the Cotman-esque style of the watercolours he made for Recording Britain, and his painting of *Gordale Scar* (pl.38), a characteristically romantic, natural site painted by Turner, James Ward and others. Clark seems to have had a minor obsession with art that made such art-historical references. A study of his collection reveals an unusual number of artists' reinterpretations of art of the past. His Cézanne drawings included a number of studies after Delacroix and others, and he had Cézanne's oil after Delacroix's *Barque of Dante* and a Degas after Giovanni Bellini (pl.45).[31] Among contemporary artists, he had work by Sutherland after El Greco, Lawrence Gowing after Goya, Renato Guttuso after Delacroix, Duncan Grant

after Zurbarán (fig.32) and so on. Extending this phenomenon, there seems little doubt that Clark's collection had a direct impact on his artist friends: during the war Piper asked to come by to look at works by Palmer and by Sutherland, and echoes of Palmer's *Cornfield by Moonlight, with the Evening Star* (pl.37) recur in the work of several artists, including, surprisingly, in Pasmore's *Evening Star* (fig.33); the influence of Cézanne's composition and technique on Graham Bell was surely encouraged by having several major paintings so close to hand, and later Henry Moore acknowledged that the lower part of his *Two-Piece Reclining Figure No.1* 1959 was based on Clark's Seurat *Le Bec du Hoc* (pl.22). Clark encouraged such retrospective study: it seems, for example, that he commissioned Pasmore to paint *The Wave*, explicitly inspired by Courbet's treatment of the same subject. Conversely, Pasmore acknowledged the

influence of Clark's Renoir (pl.1) nude when he said that he had painted a series of nudes of his wife, Wendy, pregnant as a reaction against 'the sloppy sentiment' of the Renoir.[32]

Pasmore's 'smack at' Clark's Renoir hints at, perhaps, a tension that seems occasionally to have arisen from the patron–artist relationship.[33] Clark stated his belief that 'the ideal patron ... helps to give the artist his direction', which could be by advice as well as commission. For example, in February 1938 Clark wrote to Sutherland that he had arranged his show at Rosenberg and Helft, enclosing a cheque, and adding almost as an aside, 'the Surrealist show in Paris is really degrading – a squalid entertainment pack'.[34] That Sutherland got the message may be suggested by a letter from him to Clark later in the year: 'I always count myself the most fortunate painter in history! Please try to know how alive we always are to your interest and help. And this, of course, does make me regret any development in my work of the kind we discussed; for I do value immensely your criticism and I act on it where possible.'[35]

Sutherland presumably had Clark in mind when he wrote to Colin Anderson:

I do thank you for being literally the only one of my earliest supporters who follows what I am trying to do as I try to do it, naturally, and without the slightest prompting on my part. You never seem shocked, never worried as to whether my work is erotic or not or different or not ... nor do you think my work is always like Samuel Palmer or maddeningly like Picasso.[36]

In light of this, one might speculate that Sutherland's later description of Clark as a kind of 'Renaissance prince' might bear a hint of irony, echoed in Moore's observation that the Clarks's patronage was 'rather like being helped by the Ford Foundation'.[37]

As we have seen, if Clark valued contemporary art that was in productive dialogue with the past, he subscribed even more enthusiastically to nationally defined ideas of cultural production. Within this framework, he defined British art by two key factors: the fact that the British are a poetic people, and the weather. It seems to be upon this basis, as well as his preference for observation over romantic imagination, that he

Fig.32
DUNCAN GRANT
After Zurbarán c.1928
Oil on canvas
62 × 15.3
Private Collection

Fig.33
VICTOR PASMORE
Evening Star 1945–7
Oil on canvas
76 × 101.5
Private Collection

judged Constable to be the greatest of British painters. It also steered his admiration for the art of Sutherland, Piper and Moore, an art that was contemporary and, in his terms, native. National traditions and heritage became anxiously protected with the anticipation of attack, and Clark was best placed to ensure that artists might address such concerns.

With the outbreak of war Clark joined the Ministry of Information and from that position proposed and chaired the War Artists Advisory Committee (WAAC), his stated aim being to keep as many artists as possible out of the conflict and to record not just the events of the war but also what it felt like. So Clark was able to embed his artistic values in public policy and to put into practice his idea of creative patronage. To an extraordinary degree he became the gatekeeper for government commissions. He was, he noted, the only

person to sit on both committees that drew up lists of artists to be exempted from call-up before the war.[38] As well as the WAAC, Clark proposed the Recording Britain project, and it was he who determined that all the works should be in watercolour – the quintessential medium for English topography.

Clark repeatedly stated that an artist's most valuable contribution to the war effort was to keep working as a riposte to the threat to civilisation. It seems apparent, however, that he also recognised an opportunity to steer art away from the esoteric excesses of the 1930s. A few months after the beginning of the war, Herbert Read warned Ben Nicholson and Barbara Hepworth, now living in St Ives:

Sir Clark is very busy. But don't place too much hope on him. I was present at a lunch the other day at which he gave it as

Fig.34
GRAHAM SUTHERLAND
A Foundry: Hot Metal has been Poured into a Mould and Inflammable Gas is Rising 1941–2
Crayon and gouache on paper
91.8 × 109.2
Tate

his opinion – that abstract art, functional architecture '& all that sort of thing' was dead, & a damned good job too ... We are in for a revival of 'the picture with a story'. Nice clean healthy nature, the Coldstream Guards forming fours behind their Fuhrer ... all we represent & have fought for is threatened by the most appalling reaction.[39]

After the war, Clark was able to reflect that the WAAC had made artists' work more accessible. Moore's wartime pictures (fig.36), for example, showed a 'more explicit humanity' than earlier work.[40] Similarly, 'Before the war Sutherland's vision was so personal that few people could see nature through his eyes; his pictures of ruins, though no less personal, are more understandable, for the emotions they express are part of the general consciousness.'[41]

The artists Clark valued were kept away from danger and poverty; they were encouraged by their commissions to make an art that was more popularly accessible; and, in addition, the works were made far more visible to far more people than could have been imagined before the war. Through the great popularity of the exhibitions of war art that occupied the denuded rooms of the National Gallery and their national tours, and through reproduction, the war artists – and most especially Moore, Piper and Sutherland – were promoted not just among the usual circles of cognoscenti but to a wider audience than normally looked at contemporary art. While Clark noted with satisfaction that those three had become 'famous', it was possible for his friend, the painter and critic Robin Ironside, to write that Nicholson's painting was 'a more isolated phenomenon' than before the war.[42]

This public dominance was further secured through the Penguin Modern Painters series of books. Good-quality but affordable, these focused on contemporary British artists, and the line-up, determined by Clark as series editor, prioritised the artists he favoured. In particular, it is noteworthy that Moore was one of the first painters to be addressed, even though he was until then considered a sculptor, and that Nicholson's volume was not published until 1948.[43] At the same time, Clark secured the public visibility of his preferred artists through his gift of over 100 paintings to the Contemporary Art Society to be distributed to regional galleries in the UK, and through his involvement as a buyer for such Commonwealth organisations as the National Gallery of Victoria and the Art Gallery of South Australia.[44] In that way, a certain kind of contemporary British art became accessible in collections from Aberdeen to Adelaide.

Clark was a great populariser and was astutely aware of the value of other media for promotion. This is a theme that runs through his career, from his time at the National Gallery to his work on television. Clark's popularism was double-faceted: he sought to make art physically accessible to as many as possible through its dissemination in reproduction and in itself; in addition, he used his position as patron to support, promote and encourage an art that was understandable. As well as being part of a national tradition, such an art, for Clark, needed to derive from nature. Writing of John Constable, he argued that 'we can, and we must, accept nature as the material means through which pictorial emotion can be expressed. Indeed, it is only by studying nature with humility that we can discover our own emotions and learn to recreate them as shape and colour.'[45]

While he acknowledged, in 1938, that abstract art was descended from work that was dedicated to nature – the paintings of Cézanne – without the nourishment of nature it had 'become exceedingly thin and empty'. 'The history of art is not at all like a stream', he wrote, but 'like a series of harvests some of which are self-sown, so that the crop gets progressively poorer'.[46] The natural environment and national identity were, for Clark, intertwined, and it was this that drew him to the one new artist whose cause he adopted after the war, Sidney Nolan. He saw in Nolan's imagery of the Outback landscape and of Australian mythology an expression of an essential Australian-ness.[47]

Art based on nature, innovative and aware of art history, and true to native traditions was what Clark sought in contemporary practice and what he acquired for himself. The war – and nature – provided artists with the 'myth' they had lacked previously and enabled Clark to promote and publicise the art he most valued through various organs of the state. He was intimately involved in discussions that saw the wartime Council for the Encouragement of Music and the Arts develop into the Arts Council, whose first chairman, John Maynard Keynes, would be succeeded by Clark and which perpetuated the ethos of 'Art for the People' that had become established during the war. More particularly, Clark had successfully helped to secure in the public realm the artists who he believed best suited his criteria of success. In so doing, he had encouraged an ongoing retreat from international modernism to a more historically rooted image of modern national identity. As he observed in an essay of 1942, 'English painting is becoming a great deal more English.'[48]

4 Second World War

DAVID ALAN MELLOR

ORIGINATING IN 1939 under the chairmanship of Kenneth Clark, the War Artists Advisory Committee (WAAC) was a major component in a process of mirroring and memorialising that became, after the summer of 1940, a struggle for national survival.[1] It lay under the direction of the Ministry of Information (MoI) and aimed primarily to record pictorially the war at home and abroad. Clark, like John Maynard Keynes, his colleague at the Council for the Encouragement of Music and the Arts (CEMA), belonged to an elite network within the MoI of liberal administrators: aesthetes and arts managers (Clark himself), public relations chiefs such as Jack Beddington (who ran the Crown Film Unit) and cultural welfare advocates such as W.E. Williams, of the British Institute for Adult Education (BIAE).

In his choice of War Artists, Clark championed a certain tradition of popular but ennobled figuration, a strategy manifest in Henry Moore's grand but dilapidated Blitz sleepers (fig.36), freighted with antique pathos (which, for some, redeemed the artist's earlier, less popular abstractions).[2] Another type of classical heroism can be seen in the hyper-idealised illusionism of a painter such as Eric Kennington. Panoramic war landscapes became a dominant staple of WAAC production; skyscapes too, in the paintings of Paul Nash and Richard Eurich, were an omnipresent wartime genre. But such panoramas, when constructed from a more abstracted and technocratised point of view, as in Nash's last painting for the WAAC, *Battle of Germany* 1944 (fig.45), would push Clark to the limit of his tolerance for modernist abstraction. He was aware of how crucial popular legibility was for 'National Publicity', and by 1943 was reconciled with populist positions, despite his traditionalist outlook.[3] Such a visual populism was crucial to his choice in 1939 of Eric Kennington as a War Artist; the Secretary of the WAAC reported that he 'was selected by the committee … because

Fig.35
JOHN PIPER
Coventry Cathedral, 15 November, 1940 1940
Oil on plywood
76.2 × 63.4
Manchester City Galleries

Fig.36
HENRY MOORE
Pink and Green Sleepers
1941
Graphite, ink, gouache
and wax on paper
38.1 × 55.9
Tate

his style of drawing readily lent itself to reproduction in the form of picture postcards … and in other forms'.[4]

Running concurrently with the WAAC was another project conjured up by Clark to document the face of the nation under siege, Recording Britain, funded by the Pilgrim Trust. The prospect of a catastrophic Nazi bombing campaign and economic disaster fuelled Clark's cultural pessimism and his urgent mandating of a 'Scheme for Recording Changing Aspects of Britain'. In early December 1939 he outlined four topographic categories in need of pictorial documentation: 'A: Fine tracts of landscape which are likely to be spoiled by building developments … B. Towns and villages where old buildings are about to be pulled down … C. Parish Churches – many of these are in a bad state of repair and will fall down or be ruined by bad restoration … D. Country Houses and their Parks – these will be largely abandoned after the war and will either fall into disrepair or be converted

into lunatic sanatoria … [such records] cannot be rendered by photography.'[5]

Within the year Clark would concede that photography was an effective instrument to catalogue Britain's threatened heritage. In November 1940, with the Blitz at its height, he spoke at the Royal Institute of British Architects, advocating another compilation scheme to compose a national archive of 'graphic, photographic and other records of buildings of merit, whatever their date, which have been damaged or are in great danger of damage by warfare'.[6] A few months after this hastily convened conference the National Buildings Record (NBR) was established, with Clark on its Council of Management; with this, as with so many state and public initiatives in the very early 1940s, Clark functioned as an energetic broker and administrator for the production and elaboration of such bodies of national visual records that were to be made in the face of *Blitzkrieg* apocalypse. Harold Nicolson, Clark's colleague at the MoI, wrote

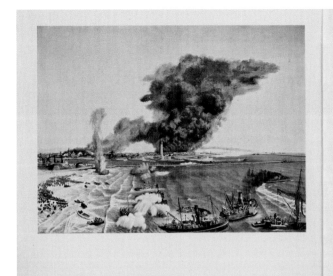

RICHARD EURICH. *The Withdrawal from Dunkerque.* 1940.

This painting of the most celebrated event of this war shows troops being ferried from the beaches to the drifter and the sidewheel naval tug in the right foreground. At the far right a destroyer is departing. At the extreme left motor trucks have been lined up to form a small subsidiary pier. Across the center may be seen the jetty from which many troops were rescued.

Eurich was born in 1903 at Bradford. He studied art at the Bradford Art School and at the Slade School. An amateur yachtsman, he has specialized in naval subjects.　　　　　　　(Oil on canvas, 30½ x 40 inches)

BRITAIN AT WAR

EDITED BY MONROE WHEELER. TEXT BY T. S. ELIOT, HERBERT READ, E. J. CARTER AND CARLOS DYER

THE MUSEUM OF MODERN ART, NEW YORK

Fig.37
RICHARD EURICH
The Withdrawal from Dunkirque, June 1940
1940
Frontispiece in *Britain at War*, MoMA exhibition catalogue, 1941

in 1944 of the effect of the NBR gathering this array: 'We shall thus obtain something which we have never had before in so complete a form – namely an illustrated catalogue of all our national treasures …. [providing an] outstanding public service.'[7]

Raw recordings by still and cine-photography guaranteed the documentary accuracy of WAAC paintings and drawings. Newsreel reportage of the evacuation of Dunkirk in May 1940, under a vast black pall of petro-chemical smoke, became a vital supplement to Richard Eurich as he rushed to prepare his cycloramic painting *The Withdrawal from Dunkirque, June 1940* (fig.37), displayed three months later at the National Gallery. Its apocalyptic photo-realism was balanced by his wish for art-historical reference, as he wrote: 'It seems to me that the traditional sea-painting of Van der Velde and Turner should be carried on to enrich and record our heritage.'[8] Eurich's painting became the lead picture at the WAAC

exhibition *Britain at War,* which opened in New York at the Museum of Modern Art (MOMA) in May 1941, promoting a frisson of a latter-day spectacular deliverance of the Israelites across the Dead Sea.

In that same New York exhibition, Bill Brandt's surrealistic photographs of tube shelterers mirrored the imaginative 'recording' of Henry Moore's drawings of the same subject. The commissioning of Moore's shelter drawings was related to other propaganda initiatives in the sphere of film and photography: Clark, it has been suggested, 'must have approved the parallel commission to Brandt'.[9] Brandt's photographs and Moore's drawings therefore shared the same wall at MOMA as testimonies, to American eyes, of the epic of the Blitz made into a romantic melodrama. More factualist, record-based photography helped create what Clark was now calling a 'New Humanism', in the expansion of the photographic archives of the Warburg Institute, on the Board of which he served.[10]

Fig.38
KENNETH ROWNTREE
The Bell Ringers' Chamber,
SS Peter & Paul Church,
Clare, Suffolk C.1940–2
Watercolour and
bodycolour on paper
30 × 47.5
Victoria and Albert
Museum

When the Warburg's Librarian was killed by a Luftwaffe bomb, Clark wrote with profound pessimism, 'It begins to look as if everything and everyone who symbolised the humanities will be wiped out before the war is over.'[11]

Recording Britain was specifically conceived as a bulwark against just such cultural obliteration, but also as a way of opening the door to more popular types of imagery. The employment of modernist figurative artists such as Barbara Jones and Kenneth Rowntree had the effect of deflecting the project away from the depiction of grand, established buildings towards a more vernacular range of pub interiors, fairgrounds and (as had been the case with the USA's Farm Security Agency documentary artists, such as Ben Shahn and Walker Evans) a graphic listing of written and painted signs.[12] Such imagery had the capacity to address a much broader audience, and suggested the eclipse of the Royal Watercolour Society's tradition by a kind of dry and figurative modernism – deadpan, *faux-naïf*, flat and itemising – exemplified by Rowntree (fig.38). In 1942 and 1943 Clark began to sense an indigenous 'primitivist' sensibility in the visual languages of the English inn sign; he canvassed friends and contacts 'looking

for old signs which were good primitive works of art'.[13] The deadpan mode was even, Clark thought, a style to which the WAAC could aspire, as he wrote to Sir Ronald Storrs in 1941: 'we want our war records to be … a little dull and naïve'.[14]

In his April 1941 Home Service radio broadcast 'The Weather in Our Souls', Clark elevated the British weather into a lyrical signifier of national culture, habit and ideology.[15] He argued for a cultural exceptionalism based on a particular kind of tonality in painting, both fugitive and theatrical. Cloudiness, broken weather and dullness had fortunately inoculated the British against the cultural and political extremism that flourished elsewhere: 'the atmosphere is quite different on the Continent … people there do literally see things in a different light – a hard, steady and unchanging light which allows them to develop hard, steady unchanging hatreds'.[16] Clark's 'stable' of favoured WAAC artists responded to this climate-based allegory; 'I was very moved by …. "The Weather in our Souls"', John Piper wrote.[17] Clark's views were buttressed by his viewing of Paul Nash's painting *Battle of Britain* (fig.39) when it arrived at the

National Gallery six months later. The surface of Nash's painting is marked by clouds and the condensation vapour trails from combatant aircraft over London. Alongside the romantic merit of free flight in this cloudy 'RAF pastoral',[18] Clark also recognised whimsy and nonsense as being among the paramount British cultural forces: 'On the word of nonsense one immediately thinks of Turner, because Turner is as full of nonsense as Shelley.'[19] Nash exemplified a systematic shift of surrealism into the realm of English whimsy. Some time in 1943 he recalled an auditory hallucination while gardening: 'when I heard "Last night heavy and medium hellebore bombed the mountains of the Moon"'.[20] In this mix, natural plant life and the intensification of RAF Bomber Command's offensive against Germany became fantastically juxtaposed and relocated to a fabulous place, altogether out of this world.

The National Gallery was the administrative locus of the WAAC. Emptied of its huge patrimony of old masters, Clark and the MoI had set up exhibitions of war pictures, publications, press views and an international outreach. As E.M.O'R. Dickey wrote to Nash, 'We reckon to open a new roomful of pictures about once every two months.'[21] The reinvention of the National Gallery as the heart of a modern, mobilised, cultured and democratic community can be seen in Humphrey Jennings's documentary film on the visual and aural signs of national identity, *Listen to Britain* (1942). Representatives of the national community, male and female, are shown alongside two of the Gallery's most celebrated paintings, Uccello's *Rout of San Romano* and Gainsborough's portrait of his daughters chasing a butterfly. Painting

had become mobilised as a component of British heritage, which was also rough and contingent: these paintings were actually life-size photographic reproductions, fixed to the gallery walls. We enter to hear a lunchtime concert and to gaze on the empty walls and frames of the Spanish Room; we leave it behind to be lyrically lifted through the pillars of the portico to a montage of British military–industrial iconography and the manufacturing of weapons, then to sublime chimneys and gas towers and are then raised up into the sky, in a closing image which gives an aerial view of the British countryside framed by a gap in the clouds – a vision of Clark's patchy 'Weather in Our Souls', a spectacle of aerial and national ascension complementing Nash's *Battle of Britain*, which the visitors to the Gallery would have seen in pride of place.

The participation of artists in the situation of total war may have gone some way to changing popular prejudices about art. 'Art is not "cissy"', asserted Clark to an audience of Civil Defence workers in January 1942.[22] Belief in the popular participation in art was an impulse he shared with John Maynard Keynes and Bill Williams, the heads of CEMA and the BIAE, but many dissented. Complaints flowed in: 'in my opinion the pictures, in the main, now exhibited at the National Gallery are almost insulting to those of us who have memories. It is quite understandable that the best are evacuated for safety but this appears insufficient reason to give us coloured morbidity in their place.'[23] In April 1941 Clark feared a conservative backlash when *The Times* ran a gloating article, 'The Eclipse of the Highbrow'. Writing to Edward Wadsworth, he recalled the negative reception of modernism during the First World War as indicative of

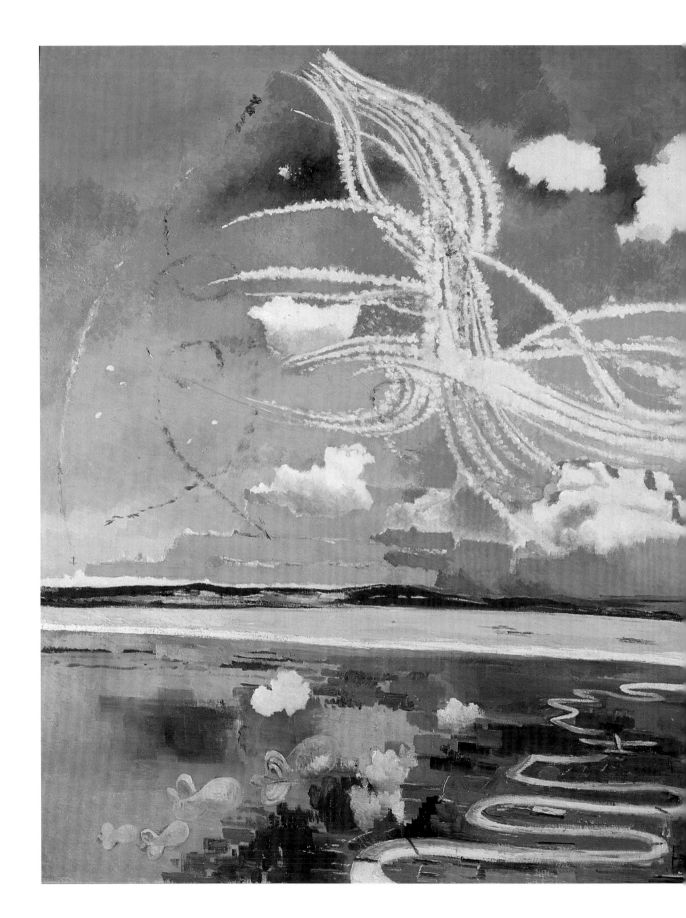

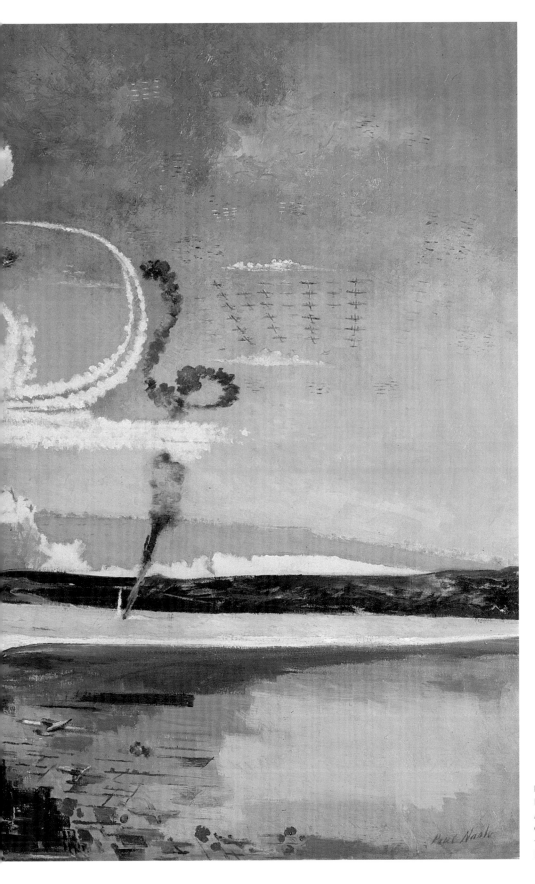

Fig.39
PAUL NASH
Battle of Britain 1941
Oil on canvas
122.6 × 183.5
Imperial War Museums

'the spate of philistinism and hypocrisy which always seems to accompany a war'.[24] *The Times* returned to the attack in March 1944, aided by a cabal of Royal Academicians,[25] who claimed that CEMA, which toured WAAC paintings across the UK, was 'a subversive movement which, with its several 'isms has been attempting to undermine the traditional glories of painting and sculpture'. A distinct lack of quality was alleged to be found in touring shows of reproductions of paintings, often originating from the Warburg Institute.[26] Nash, echoed by Keynes, contested the matter, writing that the original signatories were propounding views 'disquietingly similar to the Nazis' suppression of so-called "decadent art" before the war'.[27]

For such conservatives, the hidden bogey was the wholesale intervention of a re-fashioned, 'war-socialist' British state in the field of the visual arts. By 1942–3 this administrative dynamic, led by Clark, had gained momentum. On 11 May 1943 he announced that the War Artists scheme was the first instalment in state patronage of art:

> Before the war … the State did not spend a penny in buying works of art by living painters … Now a very large sum of money is available to keep alive modern English painting. This State patronage has not only kept alive painting but has created a new school of painting … What the State is doing for art and artists is really a revolution parallel to those going on in many walks of life … I hope it will continue after the war.[28]

That spring of 1943 saw Clark putting his weight behind an MoI film promoting the WAAC as a demonstration of the new accord between artists and a wider public: Jill Craigie's *Out of Chaos* (1944). The film showed Henry Moore as a recorder of the national struggle, the national *agon*, making sketches for his 'Tube Shelter' drawings. E.M.O'R. Dickey, the artist's 'handler' at the WAAC, had noted that Moore was 'not unwilling to be photographed. I should think it might be useful propaganda for the work of the miners.'[29] Moore's ascetic gravity, his 'Yorkshireness', was presented to the viewers as the sign of a new kind of post-bohemian artist. Here was a model of civic responsibility, the English artist as priestly figure, divining the war and meshed in social values. At the close of Craigie's film a female voice-over extends the value of art into an 'art of living'. A cross-section of the public has been assembled, viewing WAAC paintings in one of the National Gallery's rooms. An attendant interrupts to tell the critic Eric Newton, who is standing by, that 'an old lady' had made a complaint about Moore's drawings: 'they're positively disgusting, an insult to the human form; if I had my way I'd rip them off their frames'. Newton is unabashed and replies that 'everything new is attacked'. The spectators are impressed. Prefacing the film, Clark appears informally, sitting on his desk, a benign, youthful patrician, a guiding spirit, articulating the new compact between art and wartime society, enabled by governmental bureaucratic means, so that the artists' paintings could 'convey the feel of the war more than a photograph can do … [to] make images on the popular mind'.[30]

Royal patronage emerged as one aspect of this new harmony between artists and the British public, based on the High Tory ideal of

Fig.40

that appeared repeatedly in Piper's paintings of the Blitz, from Coventry Cathedral (fig.35) to the House of Commons.

Clark brokered the detailed conditions of the Windsor commission with the Queen, and relayed them to Piper in August 1941.[31] This renovation of tradition not only fused 'modern art' with the symbolic head of the British state but also outflanked conservative cultural positions. As Raymond Mortimer observed, it was an exemplary rebuke to the 'proud philistinism [of] our governing class'.[32]

The bond with royalty was also to be found in Clark's schemes for decorating British restaurants. The British Restaurant was – at Churchill's command – a re-branding of the emergency 'Community Feeding Centres' which had been established to cope with the difficulties of feeding masses of citizens during the stresses of the Blitz. Eric Newton, a reliable spokesman for the new order of state intervention in art, lauded the scheme to hang paintings on the walls of these communal restaurants as an extension of the walls of the National Gallery into public life. In a broadcast on the BBC's Forces Network in October 1942, he drew attention to 'the fact that the King has graciously promised to lend pictures from the Royal Collection to the scheme'.[33] Murals were painted in some British Restaurants, and in 1943 Clark nominated the painter Mary Kessell to decorate the YMCA hostel in the former Westminster Hospital with the Old Testament narrative of Judith and the Israelites at the mercy of the Assyrians and their extraordinary deliverance (fig.42). This fraught and crowded episode of decisive (Jewish) communitarianism was chosen for one of London's new communal institutions

a covenant between monarch and subjects. That King George VI and Queen Elizabeth had stayed and were bombed in Buckingham Palace during the Blitz gave rise to the idea of a broader community of endurance living under a sympathetic monarchy. Clark's role in commissioning John Piper to paint a series of watercolours of Windsor Castle (fig.31), which arose from his Recording Britain paintings, shows his understanding of the potential of this new relationship. Similar architecture became a semi-heraldic badge of a war-battered Britain on the covers of the MoI series of publications *War Pictures by British Artists* (fig.40), which featured a compressed cyclorama of land, air and sea conflict circling around a Gothic ruin. It was a stylised counterpart to the charred tracery

Fig.41
MARY KESSELL
Refugees: '... pray ye that your fight be not in the winter...' Matt XXIV 20
1945
Oil on canvas
50.8 × 70.9
Imperial War Museums

Fig.42
Mary Kessel murals at Royal Westminster Hospital, June 1943

Fig.43
ERIC KENNINGTON
*Able Seaman Povey of
HMS Hardy* 1940
Postcard

owing to the topicality of 'recent accounts of the suffering of the Jews in Europe'.[34] Piper designed a mural for the British Restaurant at Merton, Surrey, of a Gothic ruin with crescent moon and stars.[35] In Dagenham, Clark eulogised the decorations of the canteen servicing the Ford Motor Co. A local newspaper reported that he believed such restaurants 'should be utilized for the refreshment and sustaining of the spirit as well as the body. That was why [I] attached very great importance to the idea of decorating the civic restaurants that were springing up in their boroughs.'[36] The task of coordinating the decorations was given to Jane Clark, who ensured that the government agenda to promote national efficiency was encoded in pictorial decoration. R.A. Butler, President of the Board of Trade, argued that 'the circulation of art exhibitions and the provision of pictures in British Restaurants … [helped] counter war fatigue or boredom'.[37] A 'browned-off' body of workers required remedies and recreation, and the alleviating decoration of the British Restaurants, it was officially thought, could 'combine the brightening up with a saving of electricity'.[38]

The uncontested paragon for patriotic populism, who by 1942 was well embedded in the programme of state patronage, was the artist Eric Kennington. A veteran artist from the First World War, Kennington was one of the first to be recruited to the WAAC. He was included in the first National Gallery exhibition of WAAC works in the summer of 1940, with pastel portraits of sailors involved in recent heroic actions, such as *Able Seaman Povey of HMS Hardy*, which became a popular postcard (fig.43). His hyper-masculine, heroic portraits of British servicemen had an enthusiastic following, but some, including several art critics, were not persuaded, detecting in his rhetoric a sort of authoritarian sublime. Raymond Mortimer identified a disturbing formal trait: 'the violence of Mr. Kennington's style is as hysterical as the eloquence of Hitler'.[39] Kennington's 'hot' and lurid pastels lent the Battle of Britain an early Hollywood air, which gave new gloss and currency to this combat epic. Although Clark had recognised the value of Kennington's work, the artist left the WAAC for the War Office's public relations team, as he felt that his portraits were not being disseminated widely enough. On his own initiative he had drawn a portrait of the gravely disfigured pilot-hero Richard Hillary, author of a proto-existentialist novel of the air war, *The Last Enemy*. After Hillary was killed, in early 1943, Kennington made the pastel drawing *The Heart of England* (fig.44), an extraordinary allegory of Hillary's love of England in the mode of Hans Eworth's 1550 portrait of Sir John Luttrell. The neo-romantic tenor of Kennington's image can be compared with the opening sequence of Michael Powell and Emeric Pressburger's Technicolor fantasia of the afterlife of an

Fig.44
ERIC KENNINGTON
The Heart of England 1943
Pastel on paper
40 x 50 cm
Private Collection

RAF bomber pilot, *A Matter of Life and Death* (1946). Although it was neither commissioned nor purchased by the WAAC, Clark realised it was impossible to defy the myth of Hillary's legend, and hung the pastel drawing for six months in the National Gallery.

When it came to Paul Nash's painting dealing with a similarly lofty aerial and metaphysical view, however, Clark was drastically out of sympathy. The mechanisms of surveillance – radar, reconnaissance photography and film – had informed the paintings of Richard Eurich, but Eurich had treated his subjects conventionally, as distanced battle scenes. In contrast, with its sources in combat photographs of the great bombing campaign which had begun in 1942, Nash's *Battle of Germany* 1944 (fig.45) resembled a late Cézanne which had been catastrophically militarised: an abstract image of high-altitude strategic bombing and photo-reconnaissance.[40] At one level

it recalled Ben Nicholson's colour patch compositions of the early 1920s; at another it corresponded to contemporary war journalism describing the bomber's point of view.[41] A *Picture Post* feature, 'The Battle of Germany: From the Heavens', was subtitled 'A celestial view of a grim scene … war is resolved into a series of formal patterns … the meaning is not always clear'.[42] Nash audaciously addressed the subject from a formalist perspective. It was, perhaps, the most comprehensively modernist painting he had ever made. Clark wrote to him in a state of obvious unhappiness at his own bafflement before the painting: 'I must send you a word about your picture, although I'm afraid it isn't the word I should like to send. For, alas, I can't understand it … I can only tell you, truthfully my own feelings in front of it, which are apologetic bewilderment and incomprehension.'[43] Here, in its passing resemblance to Nicholson, was a perturbing

Fig.45
PAUL NASH
Battle of Germany 1944
Oil on canvas
121.9 × 182.8
Imperial War Museums

artefact, a painting full of floating discs and flattened, overlapping spaces. A year before, Clark wrote to the collector Jim Ede about a proposed Penguin monograph on Ben Nicholson: 'I must warn you that I cannot have a preponderance of white squares and circles among the illustrations, as I cannot understand them and I am bound to assume that pictures which I cannot understand will also mystify the average man.'[44] The WAAC's entire position, as formulated by Clark, was staked upon the needs of visual records that might be legible to the 'average man'; that such popular spectatorship might suffer 'bewilderment' at a time of national emergency was inconceivable.

'The danger is that the State will take over everything … the effects of State control are already apparent in art … War-Artists are not art', wrote Cyril Connolly at the end

of the war.[45] That his fears were not realised was for the most part due to Clark's activities. Under his guidance the WAAC painters had trodden largely conventional paths in picture-making, fulfilling the government brief to use traditional formats in recording the events of the war. It was a conservative, if popular, policy, encouraging the deployment of seventeenth-century sea battles, ruin genres and heroic martial portraiture. At a slightly earlier moment in his relationship with Nash, Clark had written to the painter describing a type of mythical figuration that was at once traditional but was also born of the sombre facts – the events of contemporary warfare: 'you have discovered a new form of allegorical painting. It is impossible to paint great events without allegory … and you have discovered a way of making symbols out of the events themselves.'[46]

5 Saltwood

PETER T.J. RUMLEY

Nothing could be seen of the castle hill, it was hidden in mist and darkness, and not even the faintest gleam of light indicated the great castle was there. For a long time K. stood on the wooden bridge leading from the main road to the village, looking up into the apparent emptiness.
— FRANZ KAFKA, *The Castle*, trans. J.R. Williams, Ware 2009, p.3

Fig.46
ROBIN IRONSIDE
Saltwood Castle C.1955
Ink and watercolour
on paper
22.9 × 13.3
Private Collection

To AN OUTSIDER Saltwood Castle remains remote, mysterious and difficult to find. Its light grey ragstone walls, monumental towers and deep dry moat are hidden by trees, which disconnects it from the village of Saltwood. Kenneth Clark and his wife, Jane, first visited the castle in the early 1950s, and in 1953 they bought it as their family home. Clark and Saltwood became synonymous in the public eye, a connection accentuated through television, interviews and photographs taken at the castle over thirty years.

The castle stands high above the historic Cinque Port of Hythe. Originally, the defensive site was an Anglo-Saxon stronghold and, although the ownership swung between Church and Crown, most of its life the castle has been a private residence; in fact, a residence for the archbishops of Canterbury until the Dissolution of the Monasteries, when it passed into a series of private owners.[1] For the castle, once surrounded by a park, is a fortified palace, with its architecture stressing symbolic authority over the landscape through medieval lordly display, built to be seen from both the land and the sea, to astound and subjugate a feudal order.[2] By tradition it was from Saltwood that four knights set out to murder Thomas Becket on 29 December 1170. The castle is essentially the vestige of the palace of Archbishop William Courtenay (c.1342–1396). It was Courtenay who, no doubt, employed the king's mason, Henry Yevele (c.1320–1400), then working on the great Gothic nave of Canterbury Cathedral, to design the colossal inner bailey gatehouse twin towers: the towers that J.M.W. Turner so eloquently painted c.1795 (fig.47).[3]

To Clark, entering Saltwood for the first time must have been like walking through the pages of his 1928 book *The Gothic Revival: An Essay in the History of Taste*. Not only was the castle a somewhat ruined Gothic medieval masterpiece, but in 1882 William Deedes had employed the little-known architect Frederick Beeston to submit plans to reconstruct the

gatehouse as part of a growing Gothic revival craze in restoring and romancing ruined medieval castles.[4] Saltwood had suffered a series of earthquakes in 1580, 1692 and 1755, which had rendered the castle a ruin, but, like so many ruinous antiquities, it had been turned into a tenanted farmhouse. On 21 August 1925, with growing financial pressures, Herbert Deedes signed a conveyance of the castle over to a local estate agent, Frederick Butler, and two other local residents, Richard Price and Frederick Coleman, who had formed a syndicate of three equal shares each.[5] Hoping to make a profit out of the purchase, the syndicate sold the castle a year later on 8 November 1926, to Reginald and Iva Lawson, for £10,750. The grandson of Lionel Lawson, one of the founders of the *Daily Telegraph*, Reginald used his wealth to add a first floor to the service wing to the gatehouse. The rest of Courtenay's medieval structures and curtain walls remained ruinous. In 1929 Lawson had purchased another castle, Herstmonceux, Sussex, to add to his collection; but on 17 December 1930, aged thirty-eight, Lawson was found shot in the grounds of Saltwood Castle. It is believed he was shooting pigeons. The inquest's verdict

Fig.47
JOSEPH MALLORD
WILLIAM TURNER
Saltwood Castle, Kent
c.1795
Watercolour and graphite
on paper
14.4 × 20.3
Ashmolean Museum,
University of Oxford

was death by misadventure. However, ten days earlier he had killed a nine-year-old boy in a motoring accident, which played much on his mind.[6] Lawson was a great shooting sportsman and gave many shooting parties. He was a serious antiquarian and packed the castle with medieval artefacts and furniture, which Kenneth Clark was later to purchase.

Earlier, through a common interest in castle restoration, the Lawsons had met Martin and Katrina Conway. Lord Conway had spent much of his wealthy American wife's fortune on restoring the ruinous Allington Castle, near Maidstone.[7] Conway, a politician, adventurer, mountaineer, archaeologist and art historian (an expert on Giorgione and early Flemish artists after whom the Conway Photographic Library at the Courtauld Institute of Art is named), became a widower in 1933 and, the following year, married Iva Lawson of Saltwood Castle. Now Lady Conway, Iva, with Martin, embarked on a second major restoration of Saltwood's ruined curtain walls, towers and Courtenay's Great Hall above the extant medieval vaulted undercroft, which would become Kenneth Clark's celebrated library. Iva even had her face carved into one of the Great Hall window corbels. The Conways employed the architect Philip Tilden, who had also remodelled Garsington Manor for the Morrells, Chartwell for Sir Winston Churchill and Port Lympne for Sir Philip Sassoon. The rebuilding of the Great Hall was Tilden's first project at Saltwood, followed by the towers and the curtain walls, using both traditional and modern materials: ragstone for the outer facing and steel girders and concrete elsewhere. This was followed by opening the blanked-out windows of the 'Knight's Hall' and inserting tracery.[8]

Lord Conway died in 1936, and all restoration ceased. Lady Conway remained at the castle throughout the Second World War; with increasing old age she put the castle up for sale with its contents in May 1950. According to Clark's unreliable autobiography, he purchased it on a whim in the summer of 1953. En route to Venice with his family, he was stranded at the Grand Hotel, Folkestone, owing to a French railway strike. During their stay they learned that Saltwood Castle was again for sale and immediately took a taxi to view the property. Correspondence with Lady Conway, however, indicates the Clarks were discussing the castle sale for more than a year before her death on 14 March 1953.[9]

The south coast of Kent was not an unusual choice for the Clarks to seek a country house, for they had known the area before the war, having taken a lease on Bellevue, Lympne, overlooking Romney Marsh, from their friend Sir Philip Sassoon. There they had been visited by Henry and Irene Moore (who lived close by), Graham and Kathleen Sutherland, Graham Bell and Anne Olivier Popham (later married to Quentin Bell), and other friends. Having grown out of Upper Terrace House, Hampstead (figs 16–18), the Clarks began searching for a more substantial home for his expanding collection and library. They were seduced both by the romantic Gothic architecture of the castle and by its contents. Rare Flemish tapestries hung everywhere; Persian carpets covered the floor; oak coffers, trestle tables, armour, settles, four-poster beds, paintings and fine antiques filled the rooms. But there was one feature that attracted Clark more than any other: the separate Great Hall for his library and the adjoining tower for his study, where he would

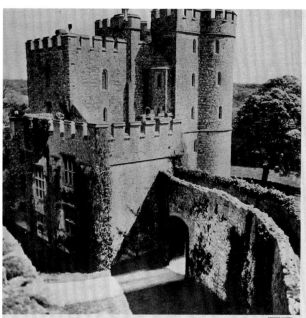

At last commercial television has reached this country and the shape it has taken is largely due to the ITA, under its chairman Sir Kenneth Clark. The country home of Sir Kenneth and Lady Clark is described here, by Loelia, Duchess of Westminster

ON THE EDGE of a valley to the north of Hythe stands Saltwood Castle, for 300 years little more than a series of ruins, guarded by the massive drum towers of the 14th-century gatehouse. In 1880 this gatehouse was restored to serve as a country residence. Further reconstruction has been carried out since by successive owners, and the late Lady Conway in particular spent a great deal on modernizing the castle. Medieval discomforts were eliminated by the installation of electric light and central heating. For the past two years it has been the home of Sir Kenneth and Lady Clark.

The castle, once residence of the Archbishops of Canterbury, is approached from the village by a short drive under the ruined bailey gate. The huge gatehouse and ramparts enclose a square inner courtyard, which at one time contained all the principal buildings and is now a vast expanse of smooth, green lawn. All but one of these buildings remain crumbling ruins. The exception is the great high room, once the Archbishop's Hall of Audience, which Sir Kenneth has turned into a library to house his many thousands of books. Below this is the undercroft, or vault, its entrance guarded by 18th-century Gothic revival figures representing two of the famous Archbishops who lived there – St. Thomas à Becket and Archbishop Courtenay. From the ramparts between here and the gatehouse you can look out over the bailey, across the Channel to the coast of France. On the far side of the courtyard is the beautiful yew tree planted by Richard II; above, rising from the lower tower is a television aerial.

The castle, thought to occupy a Roman site, has a history full of incident. The murder of Thomas à Becket was planned there on December 29, 1170, and carried out the next day in Canterbury Cathedral. Most of our Sovereigns from Edward II to Elizabeth I stayed at the castle for short periods during their reigns, and in 1540 it so aroused the envy of King Henry VIII that Thomas Cranmer, the last Archbishop of Canterbury to live at Saltwood, "presented" it to him. The last royal visitor was Queen Elizabeth who dined there with Sir Walter Raleigh. Soon after this the earthquake of 1580 reduced much of the castle to ruins.

The gatehouse with its flanking towers was added to the original castle by Archbishop Courtenay in the 14th century. The entrance

ANTHONY DENNEY

Saltwood Castle

GUARDING THE UNDERCROFT: ST. THOMAS À BECKET AND ARCHBISHOP COURTENAY

SUTHERLAND AND MOORE PRESIDE OVER THE ENTRANCE HALL

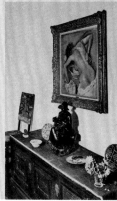

A DEGAS PASTEL HANGS OVER RENOIR'S BRONZE "MATERNITE"

80

write with pen and paper upon his knee. Tilden's magnificent complex of rooms was set across the Inner Bailey, away from the staff and daily interruptions of the main gatehouse residence.

Clark immediately secured an overdraft of £30,000 with the Clydesdale Bank to cover the purchase of the castle for £13,000 and the contents for £15,000. The loan was to be repaid with the sale of Upper Terrace House and Old Palace Yard, Richmond, a house Clark had purchased some twenty-three years earlier, while cataloguing the Leonardo drawings (figs 9–11) at Windsor Castle. These houses sold for £27,250 and £7,750 respectively. An option to purchase the tenanted Grange Farm and

some 200 acres was not taken up.[10] The Clarks moved into Saltwood Castle in January 1954, giving it the sobriquet 'Salters'. During the purchase of Saltwood, Clark also became the proprietor of a set, or flat, in Albany, Piccadilly – B5, which became his London base.

Although the castle sale was not completed until 10 December 1953, Clark auctioned most of the contents in a sale starting on 8 December. A marquee was set up on the Inner Bailey lawn, and over the four-day sale the proceeds amounted to £8,520.[11] Clark kept back from the sale choice works of art such as the fourteenth-century Spinello Aretino altarpiece (which remains above the Great Hall fireplace), a number of tapestries,

Figs 48 and 49
Article on Saltwood Castle, *House and Garden*, October 1955
Private Collection

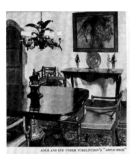

ADAM AND EVE UNDER TCHELITCHEV'S "APPLE-TREE"

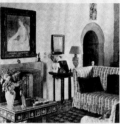

THE FABULOUS RENOIR IN THE DRAWING-ROOM

A VENETIAN MARBLE MADONNA AND CHILD

Saltwood Castle *continued*

to it is divided into an inner and outer passage by a flight of steps and a gateway, parts of which date from the 12th century. Courtenay's extension forms the outer passage and is a continuation of the vaulting of the earlier gatehouse. On either side of the entrance a low doorway opens into the guardrooms in the base of the towers. These are hexagonal in shape with domed groined ceilings; one is now used as an office by Lady Clark.

A good many plans would be necessary to show accurately the position of the many rooms. The varying levels are linked by narrow stone corridors and short flights of steps. In all of the rooms are displayed the paintings, sculpture, tapestries, and objets d'art which form Sir Kenneth's famous collection. Sir Kenneth—Director of the National Gallery for 11 years and now Chairman of the Arts Council—and Lady Clark have been collecting for the past 25 years, and their treasures range from 4th-century embroidery to 20th-century abstract painting. Many are the envy of museums all over the world but Sir Kenneth's is no museum collection, for it reflects not only very great knowledge, but a personal taste of great catholicity, which can love the art of the past and present, east and west equally.

In the entrance hall a Henry Moore figure stands on a 16th-century Italian table. On the walls hang two fine Sutherland *grisailles*, painted by the artist specially for Saltwood. In a corridor a Renoir sculpture stands beneath a Degas painting. In the dining-room a black and white patterned wallpaper covers the ancient stone, and makes the setting for the Regency furniture. The Louis Phillippe chandelier over the dining table is a design of white arum lilies and morning glories, topped by large pale leaves. On the wall hangs Tchelitchev's painting of an apple tree; on the table beneath it are 16th-century bronze figures of Adam and Eve. In the timber-ceilinged drawing-room the windows look inwards to the courtyard and outwards to France, and from it a door opens directly on to the ramparts. On one side of the room a 17th-century Japanese screen hangs on the plastered wall; nearby is a Degas copy of the Bellini portrait-heads in the Louvre. In one corner there is a Queen Anne secretaire, black and gold outside, green and gold in; to the right of it, in a blocked-up doorway, hangs an early Matisse. Outside the small library, Sutherland's "Crucifixion" hangs near a Renaissance tapestry. Throughout the castle runs this same freedom of grouping, this deliberate and dramatic contrasting of old and new.

As a setting for these treasures, the mediaeval background of Saltwood Castle is a far cry from Sir Kenneth and Lady Clark's previous home, a Georgian house in Hampstead, but the background of wrought masonry and uneven plaster seems to emphasise the intrinsic and fundamental qualities of craftsmanship in the works of their collection. Neither regrets the move. They are tremendously busy people and here, after a full week in town, they can relax in the utter peace of the Castle and its grounds. Here, too, Lady Clark can pursue her gardening with the added delight of an occasional find of Roman glass or pottery.

MAILLOL'S SKETCH FOR THE MEMORIAL TO CÉZANNE STANDS BELOW CÉZANNE'S "BATHERS"; CENTRE, A TINTORETTO; RIGHT, A ROUAULT "CHRIST"

ANOTHER CORNER OF THE LIVING-ROOM; THE SCREEN IS JAPANESE, THE PAINTING BY DEGAS AFTER BELLINI

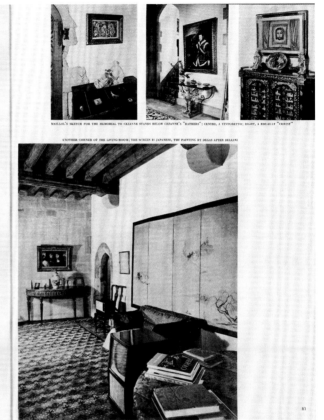

carpets and other antiques to dress the castle. Added to this was his own collection of contemporary art by the artists whose careers he so carefully nurtured: Henry Moore, Graham Sutherland, Victor Pasmore, John Piper, Sidney Nolan, Graham Bell and many more. These, along with his Ben Nicholson, Vanessa Bell and Duncan Grant pictures, hung next to works by Ruskin, Cézanne, Degas, Rodin, Turner's S*eascape, Folkestone* (pl.52) or Clark's cherished possession, Renoir's entrancing *La Baigneuse Blonde* (pl.1; fig.49). Curtains and bedspreads designed by John Piper added further decoration, as did carpets and ceramics by Duncan Grant and pieces by Marion Dorn. It

was a perfect eclectic marriage of ancient and modern. Oak bookcases were specially made by the Hythe Cabinet Works for Tilden's Great Hall, itself lit by tall, slender Gothic windows, to house his library of some 12,000 books and to match the massive oak roof trusses springing from the carved corbels. It remains one of the great rooms of Britain.

Clark's study was a small room off the library, and it was here that he wrote many of his popular and engaging books, including *Moments of Vision, Rembrandt and the Italian Renaissance*, his Oxford Slade lectures and his autobiography. The closing sequence of *Civilisation* showed Clark moving from his study into the Great Hall and finally touching

Fig.50

Kenneth Clark in
his library, Saltwood
Castle c.1968

Henry Moore's sculpture as a parting caress (fig.56).

For the next twenty-five or so years Saltwood became a social and cultural sanctuary for Clark's old friends. E.M. Foster came for the summer, Maurice Bowra and John Sparrow for Christmas. The constant string of weekend visitors included Eddie Sackville-West, William Walton, Laurence Olivier, Vivien Leigh, Ninette de Valois, Julian Huxley, Irene Worth, King Olav V of Norway, Colin Anderson, John Betjeman, the Moores, the Pipers and the Pasmores, Reynolds and Janet Stone, Yehudi Menuhin and John Berger, among many more. Following the castle's history of royal visitors, the Queen Mother stayed the night of 28 June 1957, having planted a tree in the grounds. The whole of Saltwood village turned out to greet her. The Queen Mother was on her way to unveil the Dunkirk Memorial commemorating the evacuation of the British Expeditionary Force in 1940.[12] She wrote to the Clarks from Salisbury, Rhodesia (now Harare, Zimbabwe), on 1 July 1957:

> It was a most delightful experience staying with you, and I loved every moment of that enchanted night at Saltwood. From the first thrill of suddenly coming upon the castle so splendidly amongst the deep green of the trees, to the wonderful and romantic walls, the perfect cocktail party (everyone nice and no noise!!) the delicious dinner and the pleasure of seeing such lovely pictures and objects in such a setting. All very exquisite and enjoyable and I am deeply grateful to you both for such a pleasure.[13]

With growing old age Clark had to deal with succession and handed the castle over to his eldest son and his wife, Alan and Jane Clark, in July 1971. Kenneth and his wife, Jane, moved into the Garden House, a new bungalow on the site of the castle's kitchen garden across the moat from his study. With Jane Clark's increasing ill health, few friends visited. Following her death in 1976, Clark married Nolwen de Janzé Rice. Clark died in 1983, leaving to his daughter Colette the Garden House, which Alan and Jane Clark eventually acquired, Nolwen having moved into the White House, Saltwood. Clark's funeral service was held in May 1983 at Hythe parish church, with those old friends attending that could. He was buried in the parish church at Saltwood as a confirmed Anglican. A memorial service was held in St James's, Piccadilly, in 1983, with John Pope-Hennessy delivering the eulogy and Yehudi Menuhin performing.[14]

Although Kenneth Clark had been a member of the Society for the Protection of Ancient Buildings since 1932, no further aggressive restoration of the castle had taken place since Tilden until Jane Clark, the widow of Alan, commenced a programme of approved conservation, which continues without grant aid.

6 Television

JOHN WYVER

O**N THE EVE OF THE FINAL EPISODE** of Kenneth Clark's television documentary *Civilisation: A Personal View* (1969), *The Times* ran a laudatory leader headlined 'How Like an Angel'. The scripts had been 'serious, sustained and scholarly', the films 'imaginative and always excellently directed'. 'The BBC has shown what can be done', the encomium continued, 'when the sights are set high and kept high'.[1] Four years earlier, Clark's personal views were being aired by the corporation's commercial rival, ATV. Marking the tenth anniversary of independent television in autumn 1965, the quarterly magazine *Contrast* asked television critics 'to nominate the six ITV programmes which they had found most memorable or significant'.[2] In the poll, ahead of *World in Action* (Granada, 1963–98), *Armchair Theatre* (ABC TV/Thames, 1956–74) and *Coronation Street* (Granada, from 1960), the top slot was taken by 'the Sir Kenneth Clark lectures'.

By 1965 Clark had broadcast at least thirty-six lectures made with the ITV contractor ATV. These were initiated in 1958 with a series of eleven discussions of abstract topics under the title *Is Art Necessary?* Later came more conventional lectures on *Five Revolutionary Painters* (1959) and *Landscape into Art* (1961), and three-part series on *Rembrandt* (1962), *Michelangelo* (1963) and *Discovering Japanese Art* (1963). 'His memorable performances', wrote an anonymous correspondent for *The Times* in 1964, 'have brought an unexpected lustre of culture to independent television.'[3] Many of these programmes survive, although their achievement was eclipsed by the success of *Civilisation*, resulting in their invisibility for some five decades. Yet in his autobiography Clark notes that the 'programmes I did for ATV were probably more widely seen by the British people than *Civilisation* and had more influence in England'.[4]

Viewed today, the programmes retain an immediacy and an interest thanks in part to Clark's evolving talent as a presenter,

Fig.51
Kenneth Clark filming
Out of Chaos (Two
Cities Films 1944)

combining diffidence with passion, refined composure with a quiet urgency, and bold assertions with occasional expressions of doubt. In the early recordings he appears uncertain about phrasing and delivery, about where to look and how to move, but by the time of a recording made in a Picasso retrospective at the Tate Gallery in 1960, he is able to conduct the cameras on a tour of the exhibition with assurance and facility. Celebrating the 'simply superb' final programme in the 1963 *Michelangelo* series, Maurice Wiggin wrote that Clark 'had acquired a new relaxed affability, without in the least losing his towering authority'.[5] And, indeed, a significant part of the pleasure we take from Clark on screen derives from the effortless confidence of his judgements. 'Gauguin was about as sympathetic as Stalin', he is happy to tell us, and of Picasso's canvas that he calls 'The young ladies of Avignon', he says, 'as a work of art I don't think it's a complete success'.[6]

Beyond their stated subjects, the programmes are also richly suggestive about their author's beliefs and understandings – including those about the modern medium that he was endeavouring to master. Clark's on-screen lectures are among the earliest attempts to engage television with the visual arts. As such, they betray the struggles involved in bringing the two media together, just as they trace a path towards the format realised in spectacular fashion in *Civilisation*. In an opening statement to the *Five Revolutionary Painters* programme on Goya, Clark acknowledges in one of many self-reflective musings that television is 'a queer way of looking at pictures'.[7] Yet across the decade before *Civilisation* the man and the small screen became ever more comfortable with the compromises involved in placing a canvas before a camera.

More generally, the programmes express a tension between protecting the values of an elite and patrician culture and the impetus

Fig.52
Production still of *Sight and Sound* (BBC 1939) The BBC television quiz programme was broadcast from Alexandra Palace on 26 February 1939, with a team of artists (Duncan Grant, Brynhild Parker, Barnett Freedman, Nicolas Bentley) and a team of poets (W.J. Turner, Stephen Spender, Winifred Holmes, George Barker)

towards democratising knowledge about and access to the arts. Conflicting demands are apparent even in the earliest record of Kenneth Clark's encounters with television. As Director of the National Gallery he was invited in early 1937 to the BBC studios at Alexandra Palace. He reported back to the trustees that he thought they 'would agree that the process would be of immense importance in popularising the Gallery if ever it attained the necessary degree of proficiency'.[8] Despite his minuted disappointment that 'the results [of showing paintings on the screen] were feeble in the extreme', he was happy to make an on-screen appearance later that year describing, using reproductions in the studio, Florentine paintings from the Gallery's collection.[9]

Following a brief period as Director of the Film Division in the Ministry of Information at the beginning of the Second World War,[10] Clark's most substantial relationship with the moving image came when he was appointed chairman of the new Independent Television Authority (ITA) in 1954. Concerned both to establish an effective and appropriate challenge to the television monopoly of the BBC and to 'prevent the vulgarity of commercialism from having things all its own way',[11] he was seen as an effective influence on the new service, even as he emerged as a more combative figure than had been anticipated by the Conservative government that appointed him.

To his regret, in 1957 his three-year ITA contract was not renewed. At the dinner to mark his departure his services were swiftly solicited by Val Parnell and Lew Grade of ATV, one of the initial quartet of ITV companies. ATV had close connections with many of the key players in Britain's light entertainment industry, including the theatre chain Moss Empires Ltd and the leading talent agency the Grade Organisation. The consortium could make successful popular programmes, but it was far less secure about fulfilling contractual obligations to meet the 1954 Television Act's strictures to produce a service 'of high quality' with 'a proper balance' in the subject matter of programmes.[12] Who better to help them fulfil these public service obligations than the former chairman of the ITA, who had been responsible for interpreting the Act and for ensuring that the new service was used in what Clark had called a 'civilising and life-enhancing manner'?[13]

In his memoirs Clark suggests that he was engaged by ATV solely as a presenter. In fact, he was offered an initial one-year contract (which was renewed several times) 'to act as our general consultant counsellor and friend in the realm of general television programming … to give us your opinion as to the proportion of our total programme output which should be devoted to programmes of a more serious nature, for instance, the arts … and generally to advise us on a proper balance of overall programme subject and content'.[14] The fee for the year was to be £2,500. In addition, for £200 per programme, he was engaged to conceive between ten and fifteen programmes 'with which you would agree to be directly connected', although he would not necessarily appear on screen.[15] ATV also purchased a television set for him at a cost of £53 13s 4d. Years later, Kenneth Clark spoke of the pleasure he derived from watching 'a lot of television'. 'I enjoy plays about detectives and policemen', he admitted in a lecture to the Royal Institution; 'It was a good day when

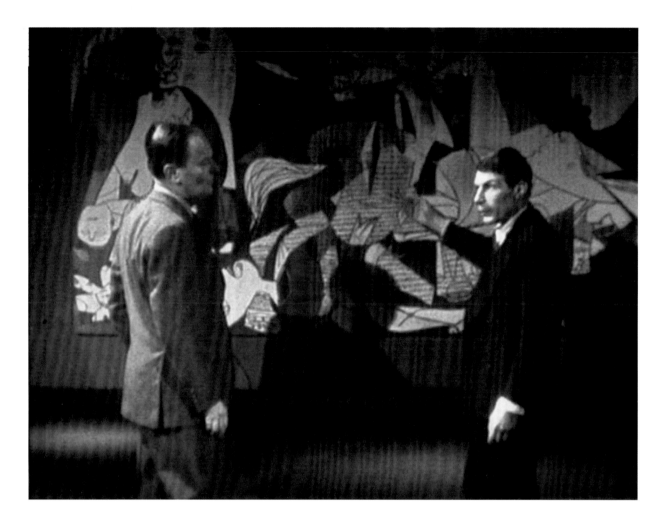

Z Cars began to use the English tradition of documentary film for police stories.'[16]

The archival record of Clark's nine-year relationship with ATV indicates that for much of the time his work as consultant and counsellor was fulfilled by an occasional lunch or letter. By contrast, the possibility of making programmes was soon occupying a significant element of his attention. A first series was announced, in which Clark 'and distinguished experts will approach a wide range of cultural subjects with an adventurous spirit which goes beyond television's traditional treatment of the arts'.[17] Under the title *Is Art Necessary?* the subjects were to include 'Is opera absurd?', 'Need we talk?, an investigation of the power of gesture' and 'Is your cornice necessary?, an appraisal of the extent to which architecture has impoverished itself by cutting out unnecessary ornateness'.[18]

'This was quite a reasonable plan', Clark wrote later, 'but it didn't work. It left out of account one all-important factor: the concentrated character of television.' The first programme, *Isn't He Beautiful?* had too many guests (including a breeder of shire horses, the potter Bernard Leach and the sculptor Reg Butler), too diffuse a focus (at one point Clark and Butler ranked wild animals, including giraffes and crocodiles, on a scale of beauty) and far too little structure. In later broadcasts the guests were dispensed with – although not before the third programme, in which John Berger made an appearance (fig.53),[19] – and the subject matter was narrowed to the visual arts. The format was simplified into a television version of art history's traditional slide lecture.

The programmes were almost exclusively made in the studio, first as live transmissions,

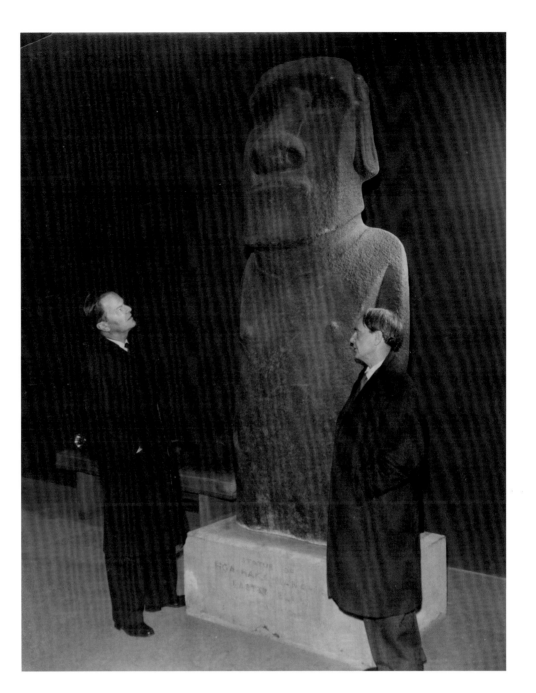

Fig.54
Still of Kenneth Clark and Henry Moore exploring the British Museum at night from *Is Art Necessary? Encounters in the Dark* (ATV 1958)

then as electronic recordings with minimal editing. Occasional sequences were recorded away from the studio on 16 mm film, and the second programme was shot entirely in the British Museum over two nights, with Clark and Henry Moore looking at ancient sculptures by torchlight (fig.54).[20] Paintings were initially introduced as large photographic reproductions physically present on easels alongside Clark, and only later were the images simply edited against

his words in the manner that has since been standard in arts documentaries.

Among other topics, the programmes explore Clark's views on art forgery, portraiture, questions of value both aesthetic and financial, and the question of whether art can be democratic. The most vivid moments are when expressions of his personal beliefs break through his detached dialectic. 'One must say', begins one of these credos, 'that art gives us, those of us who appreciate it,

a peculiar happiness that nothing else can give. I know it sounds ridiculous to those who don't feel it, but there it is.'[21] Such elitism runs throughout the programmes and takes perhaps its most uncompromising form in *Can Art Be Democratic?* in which Clark asserts that 'very few people will give the thought, the attention and the concentration, the sympathy to enter into a work of art' and so be able to make a true judgement about it.[22]

There is hope in Clark's world, however, for the less fortunate, or rather the less committed, for

> when they do feel the impact of a great work of art, as in Handel's 'Messiah', or a Beethoven symphony, or perhaps in that film of *Henry V*, or in an Ibsen play, then they realise it is something extraordinary, a wonderful new experience and they want – they want to feel it often and more intensely.

Most importantly, the minority have an absolute obligation to the majority, and he formulates this responsibility rhetorically in *What is Good Taste?* 'Can more people', he asks, 'be persuaded to use their eyes, to love what they see, to discriminate between their sensations and to recognise them as part of a harmonious whole?'[23] Although he evades any definitive answer, this is what he understands as his mission in this medium.

Clark's eleventh ATV programme, in April 1959, assembled museum casts and artworks from his personal collection to reflect on *What is Sculpture?* But he recognised that his abstract musings – in this case on Donatello, Rodin and Henry Moore – were failing to connect with viewers. The producer, Michael

Fig.55
Stills from *What is Sculpture?*
(ATV 1959)

Redington, recalled Clark's admission that the programmes were not working. 'What we want to do is to tell stories. That's what people like, isn't it? A narrative ... There are five painters, only five, no more. But I will tell those five stories, and let's see how we go.'[24]

Clark began his first programme in the 1959 series *Five Revolutionary Painters*, on Goya, by confiding to the viewer, 'I don't know how this is going to come off.' He listed the inadequacies of his medium for the study of paintings: 'It distorts the shapes, of course you can't give the colour or the finer touches, and then we expect the television picture to move – a still on television always looks to me dead, like a waxwork.' Yet the television camera could do 'the most extraordinary things – the lens can come right up close to a head ... with a vividness, isolate ... in a way that the eye can't do'.[25] Some paintings, however, worked better than others, as he recognised in the later programme on Caravaggio, whose works 'don't come out very well on television ... They lack the sharp definition which enables the camera to make discoveries.'[26]

The enthusiasm with which *Five Revolutionary Painters* was received took Clark by surprise. Writing to thank his executive producer, Robert Heller, for his fulsome praise, Clark admitted that, 'it is extraordinary that in the same day Covent Garden porters and waiters in the Ritz Hotel, as well as the more highbrow members of society like chemists or booksellers, should all speak approvingly of my programmes ... Now we must see what else we can do to extend the medium and bridge the gap between the brows.'[27]

Emboldened by the success of the series, Kenneth Clark suggested to ATV the series that became *Great Temples of the World*.

He also began to formulate ideas for a new fortnightly arts magazine programme for ITV, responding to the success of the BBC's *Monitor*, first broadcast in February 1958. The result was *Shapes and Sounds*, from October that year, but problems arose with the first programme, recorded as an outside broadcast from the Earls Court Motor Show. Technical inadequacies and the fact that the brand names of some specific manufacturers were given more prominence than others meant that the show appears not to have been broadcast. The following month, Clark wrote resignedly to Val Parnell, 'I am not easy in my mind about recommending or devising other programmes. They never seem to turn out as well as I had hoped and if I were to try to make them all that I want I would have to give up my whole life to the job which I cannot do.'[28] He subsequently reined in his involvement with ATV and kept his energy for presenting his own scripts. Yet the relationship would still yield five further series of lectures, as well as a number of single documentaries.

Despite the inadequacies of the medium for showing paintings, the televised lecture format was by now successfully established. As Robert Heller suggested, Clark's idea for a series on great temples might offer a new direction. 'I think that after the landscape cycle, and perhaps one other', Heller wrote, 'you will have exhausted the effective use of photographic blow-ups of pictures and sculpture. The next logical step would be for you to move to where the objects are, to a setting, and an atmosphere.'[29]

Picasso: Sir Kenneth Clark at the Tate Gallery (1960) was one step towards 'a setting, and an atmosphere', but the decisive move was to go to Venice with the ATV film

cameraman Warwick Ashton. *Great Temples of the World: San Marco, Venice* was broadcast in December 1964, accompanied by a *TV Times* article authored by Clark in which he seems to anticipate his masterwork by more than four years: 'I have long had a fancy that a good series of television programmes could be made by examining the great buildings of the world and seeing what they tell us of the civilisation that produced them. It is a way of putting abstract ideas into visual terms, which is the essence of television.'[30]

Location shooting, however, brought its own frustrations, as Clark noted in his presentation of a second *Great Temples* programme a year later. Standing outside Chartres Cathedral, he explained to his audience, 'I will now go in and look at the interior insofar as it's possible to do so ... the interior of Chartres is extremely dark even to the human eye, and I'm afraid almost impossibly dark to the camera's eye.' Once inside, and looking up at the stained glass, he returned to the theme: 'When talking about art on television one's always having to make excuses for the medium, but never more so than now, because in the windows of Chartres Cathedral colour is everything.'[31]

Broadcast less than five years later, programme two of *Civilisation* culminates in a glorious sequence hymning the beauties of Chartres Cathedral. The interiors have a spacious lightness, the deep blues of the stained glass leap from the screen. The medium no longer needs to be excused, and there is a soaring confidence about the camerawork, the editing and the balance of music and narration that makes them more than a match for the conviction of Clark's ideas. Between the two trips to Chartres had

come the documentary *The Royal Palaces of Britain*, which Clark wrote and presented as a rare co-production between BBC and ITV.[32]

Although the final stages of the film's production were unhappy, not least because the Queen and Prince Philip expressed their displeasure at a preview, *Royal Palaces* was shot in glowing colour on 35 mm film by a team significantly more skilled than any Clark had worked with before and with a much more substantial budget. The 35 mm film facilitated a far greater level of detail in the images than he had been able to work with previously, the brilliant colour was revelatory, and with the budget came location lamps that could illuminate the furthest recesses of a palace ballroom or, in the later series, a Gothic vault and the voluminous rooms of the Vatican. The cinematographer A.A. 'Tubby' Englander filmed both *Royal Palaces* and *Civilisation*, and thanks to him the apologetic self-reflectivity of the ATV lectures was banished.

The technology, introduced for the BBC's first colour transmissions from July 1967, complemented the screen persona that had been honed over the previous decade. Both helped deliver the intellectual framework of the new series. The thirteen fifty-minute episodes of *Civilisation: A Personal View* trace a story of European culture from the barbarian conquest of the Roman world through to the troubled present of the 1960s.[33] The visual arts and architecture are privileged in a format that combines the art history lecture with a Grand Tour travelogue. Literature, philosophy and music also feature, but all of the most memorable sequences have a painting, a statue or a building as their focus. There is no space for Spain and Portugal, or for contradictory ideas within

Fig.56
Still with Kenneth Clark touching Henry Moore sculpture from *Civilisation* (BBC 1969)

a unitary line of thought. In this history of Clark's heroes, foremost among whom are Leonardo, Michelangelo and Rembrandt, the images are frequently spectacular and the narration consistently stimulating. Both the fundamentals and the details of the analysis, however, were to be challenged across the next four decades by numerous new currents of art histories, including in John Berger's four-part BBC television series *Ways of Seeing* three years later.[34]

As the series unfolds, a profound uncertainty on Clark's part about the future emerges, a sense of fragility that was heightened by the production filming in Paris during the student protests of May 1968. 'Rioting was going on all around us', the producer Michael Gill recalled, 'riot police were standing just off-camera, fifty-strong; I was gassed.'[35] Yet there was still hope, as Clark signals in the final shot of the series, when he

lightly touches the talisman of a small Henry Moore sculpture as he passes through the library of his home at Saltwood Castle (fig.56).

The BBC's public service mission meant that there was no longer the apparent contradiction between an assured defence of the value of the high arts and the interests of a commercial company like ATV that was bringing it to the screen. Clark had nonetheless learned many lessons from Lew Grade and his colleagues, as he suggested in the final sentence of a speech in Washington, D.C., following the triumph of *Civilisation* in the United States. 'I would like to think that these programmes have done two things', he said; 'they have made people feel that they are part of a great human achievement, and be proud of it, and they have made them feel humble in thinking of the great men and women of the past. Also, I'd like to think that they are entertaining.'[36]

Notes

INTRODUCTION

1. K. Clark, *Civilisation: A Personal View*, London 1969, p.1.

1. LOOKING FOR CIVILISATION

1. K. Clark, 'Looking for Civilisation', unpublished typescript, Tate Archive 8812.2.2.174.

2. K. Clark, *Another Part of the Wood: A Self-Portrait*, London 1974, p.1.

3. Kenneth M. Clark's paintings were sold at two auctions: one in his lifetime, at Christie's, on 22 February 1918, 'owing to his giving up his residence, Sudbourne Hall, Suffolk', which contained fifteen drawings and fifty-nine paintings, and a further smaller sale at Christie's on 25 April 1947, with sixteen drawings and eleven paintings.

4. 'Mr Sims' portrait of Kenneth, son of K.M. Clark ... is an ingenious work. The child is sailing a boat, and his action is represented with great vivacity; but his figure is awkwardly combined with the landscape of the background so that he looks too large for the composition.' ('The Royal Academy. Third Notice: Portraits and Landscapes', *The Times*, 17 May 1912. The painting remains in the Clark family collection.)

5. *An Illustrated Catalogue of Japanese Old Fine Arts, etc.*, exh. cat., Japan–British Exhibition, White City, London, 1910, p.9 no.58. Illustration no.48. Clark may also have been referring to a six-panel screen depicting flowers painted by Ogata Korin, from the collection of the University Art Museum, Tokyo.

6. K. Clark, 'Discovering Japanese Art. 1. The Shadow of China', unpublished typescript, Tate Archive 8812.2.2.450.

7. The three television programmes that he made in 1963, *Discovering Japanese Art*, were an account of his own visit to Japan the previous year.

8. K. Clark, *Leonardo da Vinci*, London 1993 [1939], p.177.

9. K. Clark, *The Best of Aubrey Beardsley*, London 1978, p.11. Clark compares Beardsley's drawing *The Black Cape* to Japanese art: 'The way in which her figure stands alone, displaying her astonishing garment, was probably inspired by a Japanese print. Similar isolated figures appear in the prints of Kiyonaga's followers, in particular Sharaku and Chōki, although Beardsley is more likely to have seen the ubiquitous Kunisada' (p.82).

10. K. Clark, *Ruskin Today*, London 1964, p.xvi.

11. K. Clark, 'Spellbinder. Review of *Letters of Roger Fry*, Edited by Denys Sutton', *New York Review of Books*, 2 May 1974, pp.13–14.

12. For an account of Fry's influence on Clark, see C. Elam, *Roger Fry and Italian Art* (forthcoming).

13. K. Clark, 'Introduction', *Last Lectures by Roger Fry*, Cambridge 1939, pp.ix–xxix, here p.ix.

14. K. Clark, 'Mr. Roger Fry. An Appreciation', *The Times*, 11 September 1934, p.14.

15. Clark, 'Introduction', *Last Lectures by Roger Fry*, pp.ix–xxix, here p.xiii.

16. K. Clark to Edith Wharton, Paris, 13 December 1933. Wharton Papers, Lilly Library, Indiana University.

17. Clark, 'Introduction', *Last Lectures by Roger Fry*, p.xvii.

18. Clark, *Another Part of the Wood*, p.129. For the impact on Fry of Berenson, who he met in the 1890s, see Francis Spalding, *Roger Fry: Art and Life*, London 1980.

19. K. Clark, *The Gothic Revival: An Essay in the History of Taste*, Harmondsworth 1962 [1928], p.xx.

20. Ibid.

21. Bowra continues: 'though I myself remained unable to distinguish between Gaddi and Daddi'. C.M. Bowra, *Memories 1898–1939*, London 1966, p.162.

22. Clark, *Another Part of the Wood*, p.151.

23. K. Clark, 'A Note on Leonardo da Vinci', *Life and Letters*, 1929, pp.311–26.

24. See Martin Kemp's excellent introduction to K. Clark, *Leonardo da Vinci*, London 1993.

25. 'I have described elsewhere the reason why I accepted this offer, the chief of which was that it gave my Mother an answer to those of her friends who said "But what does your son do, Mrs. Clark?"'; K. Clark, 'An Aesthete's Progress', unpublished typescript, Tate Archive 8812.2.2.10.

26. K. Clark to Edith Wharton, 6 April 1933. Wharton Papers, Lilly Library, Indiana University.

27. Clark had previously lectured on Leonardo at the Courtauld Institute, and gave a series of lectures on the same subject at the Royal Institution earlier in 1936.

28. Clark, *Another Part of the Wood*, p.189.

29. For a brief account of Clark and the Warburg Institute, see: B. Sears, 'Kenneth Clark and Gertrude Bing: Letters on "The Nude"', *Burlington Magazine*, no.1301, August 2011, pp.530–1.

30. G.M. Richter, 'Four Giorgionesque Panels', *Burlington Magazine*, 406, January 1937, pp.32–4. Clark redeemed himself with an important discovery after the war. His article reconstructing Piero della Francesca's St Augustine Altarpiece published the identification of a panel by Piero in Lisbon, showing St Augustine, as one of the main panels of the dispersed altarpiece, and the last to be discovered. K. Clark, 'Piero della Francesca's St. Augustine Altarpiece', *Burlington Magazine*, no.533, August 1947, pp.204–9.

31. See K. Clark to Edgar Wind, 10 August 1937, and K. Clark to Fritz Saxl, 22 September 1937, Warburg Institute Archive.

32. K. Clark to Ernst Gombrich, 12 July 1937, Warburg Institute Archive.

33. K. Clark, 'The Future of Painting', *Listener*, no.351, 2 October 1935, p.543.

34. K. Clark, 'A Rembrandt on View', letter to *The Times*, 19 January 1942, p.5. See also: N. MacGregor, '*To the Happier Carpenter*': Rembrandt's War-Heroine Margaretha de Geer, the London Public and the Right to Pictures', The Eighth Gerson Lecture, Groningen 1995.

35. K. Clark, 'Concerts at the National Gallery', *Listener*, no.564, 2 November 1939, p.884.

36. K. Clark, *Civilisation*, London 1973, p.300; K. Clark, 'The Artist in Wartime', *Listener*, no.563, 26 October 1939, p.810.

37. K. Clark, 'War Artists at the National Gallery', *Studio*, no.123, January 1942, pp.2–12.

38. K. Clark, 'Art and Democracy', *Magazine of Art*, vol.40, February 1947, pp.74–9.

39. Ibid.

40. K. Clark, *The Other Half: A Self-Portrait*, London 1977, p.77.

41. K. Clark, *Landscape into Art*, London 1949, p.16.

42. K. Clark, 'Thoughts of a Great Humanist', *Burlington Magazine*, no.554, May 1949, pp.144–5, here p.144.

43. K. Clark, *The Nude*, London 1956.

44. See Sears, 'Kenneth Clark and Gertrude Bing, pp.530–31.

45. K. Clark, *Rembrandt and the Italian Renaissance*, London 1966; the book was based on a series of lectures that Clark gave in New York in 1964.

46. K. Clark, *An Introduction to Rembrandt*, London 1978.

47. K. Clark, 'A Masterpiece Revived: *The Civilisation of the Renaissance* by Jacob Burckhardt', *Sunday Times*, 7 January 1945, p.3.

48. K. Clark, 'Looking for Civilisation'. Virginia Woolf once remarked that Bell's account of civilisation bore all the hallmarks of a lunch party at 46 Gordon Square, where Bell lived.

49. S. Freud, *The Future of an Illusion, Civilisation and its Discontents and Other Works*, translated by James Strachey, London 1964, p.96.

50. Clark, *Civilisation*, p.320.

51. K. Clark, 'TV is Civilisation', *Look*, 9 September 1971, p.50. The article is a fabricated interview, written by Clark himself.

52. K. Clark, 'Television', The Royal Institution Richard Bradford Lecture, 24 October 1975. Unpublished typescript, Tate Archive 8812.2.2.1023, pp.29–30.

53. Sutherland's biographer Roger Berthoud reports Clark as saying to Sutherland: 'You and I may be in a minority of two, but we may still be right in thinking that Francis Bacon has genius.' See R. Berthoud, *Graham Sutherland: A Biography*, London 1982, p.130.

54. 'In the morning we went to the Jewish Museum & saw a very good exhibition of a very modern (but not pop) artist [*sic*] by an artist called Johns – very impressive quality of paint and drawing. But in the afternoon to a <u>pop</u> artist's studio – exactly like a Pinter play. K was so upset he had a sneezing fit! Andy Warhol the name. It has <u>no</u> relation to art – he paints rows and rows of boxes Heinz soup boxes etc <u>exactly</u> like the containers and meant to be – he has an exhibition next week! We then cheered ourselves up by going to the Frick.' Jane Clark to Margaret and David Finley, April 1964, David Finley Papers, National Gallery of Art, Washington, D.C., 28A1 Box 4, Personal Correspondence, 1925–1976, 'Clark, Lord Kenneth of Saltwood [*sic*] [1948–1969] 4–6'.

55. K. Clark, *What is a Masterpiece?* London 1979, p.36.

3. PATRON AND COLLECTOR

Much of this essay draws upon my 1992 MA dissertation (University of Sussex), which was based on research in the then newly available and as yet uncatalogued Clark papers at the Tate Archive. I would like to thank the archive staff of that time for their great help, as well as their successors. More recently, I am extremely grateful to Jane Clark for allowing me access to a cache of Clark's papers unknown at the time of the Tate acquisition and to Lady Clark's papers also. I would also like to thank Peter Rumley for his help and guidance through these new sources. I have also benefited greatly from conversations with Colette Clark, James Stourton, John-Paul Stonard, David Alan Mellor, John Wyver and those who kindly attended my presentation of an early draft of this essay at the Paul Mellon Centre.

1. Clark, *Another Part of the Wood*, p.193.

2. Clark, 'Upper Terrace House: An Attempt to Keep Alive a Tradition in English Art', *House and Garden*, vol.2, no.4, winter 1947, p.27, Tate Archive 8812.2.2.1075.

3. Clark, *Another Part of the Wood*, p.47; it was, to be fair, a selection of images that would suit a lover of country sports.

4. Clark to Hugh Brigstocke, no date, Tate Archive 8812.1.4.104. Many of these, removed from the album, were sold in the second part of Clark's estate sale at Sotheby's, 3 July 1984, lots 77–117.

5. The Cézannnes included an early copy of Delacroix's *Barque of Dante* and a *View of Estaque through the Pines*.

6. Typed notes, Kenneth Clark Papers, Saltwood Castle; Kenneth Clark on the Tintoretto, *Another Part of the Wood*, p.195.

7. He noted that only one Matisse had stayed long in his possession.

8. K. Clark to David Somerset, 30 November 1966, copy in Tate Archive 8812.1.4.104.

9. 'Personal Choice', lecture notes, Tate Archive 8812/2/2/740

10. Clark, 'Upper Terrace House'.

11. Ibid.

12. Ibid.

13. I am grateful to Lee Beard for this information.

14. K. Clark, 'The Future of Painting', pp.543–4, 578.

15. K. Clark, speech at the opening of the exhibition *Pictures in Advertising*, New Burlington Galleries, London, 20 June 1934, published as 'Painters Turn to Posters', *Commercial Art*, vol.17, August 1934, p.65.

16. Ibid.

17. Clark, *Another Part of the Wood*, p.211.

18. Ibid., p.187.

19. See David Alan Mellor, 'British Art in the 1930s: Some Economic, Political and Cultural Structures', in Frank Gloversmith (ed.), *Class, Culture and Social Change: A New View of the 1930s*, London 1980, and Andrew Stephenson, 'Strategies of Situation: British Modernism and the Slump c.1929–34', *Oxford Art Journal*, no.2, 1991.

20. It is hard to be certain, as there is a thin line between a salaried artist who allows his paymaster to keep the occasional painting and a painter whose patron buys pictures regularly enough to ensure a consistent income.

21. William Coldstream, letter to K. Clark, 15 July 1939, Tate Archive 8812.1.3.753; Sutherland also benefited from Clark's link to the Massey Foundation.

22. K. Clark, 'The Artist and the Patron', *Listener*, no.580, 22 February 1940, p.380.

23. Graham Bell, letter to K. Clark, no date, Kenneth Clark Papers, Saltwood Castle.

24. V. Pasmore, letter to K. Clark, 14 March [1940], Tate Archive 8812.1.3.2402; letter to Jane Clark, [early summer 1940], Jane Clark Papers, Saltwood Castle.

25. V. Pasmore, letter to K. Clark, 11 June 1941, Tate Archive 8812.1.1.6.

26. K. Clark to Anne Olivier Popham, 4 March 1947, Tate Archive 8812.1.3.2586.

27. V. Pasmore, letter to K. Clark, 19 May 1941 (117 Ebury Street), Tate Archive 8812.1.1.6.

28. On Pasmore: Clark, *Another Part of the Wood*, p.251.

29. Ibid., p.254.

30. For a detailed account of Piper's commission see Susan Owens, 'Evocation or Topography: John Piper's Watercolours of Windsor Castle 1941–1944', *Burlington Magazine*, no.1230, September 2005, pp.598–605.

31. Though the painting from the Louvre that Degas reinterpreted is now attributed to Giovanni Cariani, in Degas's time it was given to Giovanni Bellini.

32. Quoted by Lawrence Gowing in *Victor Pasmore*, exh. cat., Yale Center for British Art, New Haven 1988, p.8; http://www.tate.org.uk/art/artworks/pasmore-nude-t00152/text-catalogue-entry - fnB12#fnB12.

33. Ibid.

34. K. Clark to Graham Sutherland, 25 February 1938, microfiche copy at Tate Archive TAM 67/3.

35. G. Sutherland to K. Clark, 7 September 1938, Tate Archive 8812/1/3/3116.

36. See Roger Berthoud, *Graham Sutherland*, London 1982, p.119.

37. L. Feigel (ed.), *Stephen Spender: New Selected Journals, 1939–1995*, London 2012, p.229. I am grateful to John-Paul Stonard for alerting me to this comment and for James Stourton's warning that, given the extent of the Ford Foundation's philanthropy, the comparison may indicate the extent of Clark's support as much as anything else.

38. K. Clark to John Betjeman, 20 September 1939, Tate Archive 8812/441a–c; Among his papers is a list of 'artists worth saving', with two supplementary lists of those worth saving but not physically fit and those worth saving but over forty. Almost all of the names on the lists are of artists supported or collected by Clark, and none was an abstract artist. Main list of artists worth saving: Edward Ardizzone, Edward Bawden, Graham Bell, William Coldstream, Lawrence Gowing, Lynton Lamb, Robert Medley, Rodrigo Moynihan, Victor Pasmore, Eric Ravilious, Kenneth Rowntree, Graham Sutherland, Geoffrey Tibble. Artists worth saving but not physically fit: Francis Bacon, Edward Burra, Barnett Freedman. Artists worth saving but over forty: John Armstrong, Raymond Coxon, John Farleigh, Ivon Hitchens, David Jones, Henry Moore, John Piper, Roland Pitchforth, William Roberts, John Skeaping, Leon Underwood.

39. Herbert Read to Ben Nicholson, [c.Christmas 1939], copy in the Ben Nicholson archive. Tate Archive 8717.1.2.3650

40. K. Clark, lecture on Henry Moore, Oxford, 8 May 1950, Clark Papers, Tate Archive 8812.2.2.604 (16/3 M–N).

41. K. Clark, 'War Artists', undated lecture, Clark Papers, Tate Archive 8812.2.2.112-3 (8/1 R–Z).

42. Robin Ironside, *Painting since 1939*, London 1947, p.23.

43. The Penguin Modern Painters had been anticipated by a special art issue of *Horizon* that Clark was to guest-edit. When his new job at the Ministry of Information forced him to pull out, the editors Cyril Connolly and Peter Watson agreed that without Clark's involvement such a venture was pointless. Instead the money he had promised to the project would be used for the reproduction of works that he liked in successive issues of the magazine; of course, Connolly assured him, he would have a veto on which artists would be illustrated with his money (Cyril Connolly, undated letter to K. Clark, [spring 1940], Tate Archive 8812.1.3.769).

44. Clark was one of two buyers for the Felton bequest at the National Gallery of Victoria from 1945 to 1947, remaining as an adviser until 1952, and advised the Art Gallery of South Australia from 1949 to 1954.

45. K. Clark, 'Constable: Prophet of Impressionism', *Listener*, no.430, 7 April 1937.

46. K. Clark, 'Is the Artist Ever Free?', lecture for Columbia University, undated, Tate Archive 8812.2.2.61.

47. See K. Clark, Colin MacInnes and Bryan Robertson, *Sidney Nolan*, London 1961; and Simon Pierse, *Australian Art and Artists in London, 1950–1965: An Antipodean Summer*, Farnham 2012, pp.1–16.

48. K. Clark, 'War Artists at the National Gallery', *Studio*, no.123, January 1942, pp.2–12.

4. SECOND WORLD WAR

1. For an exhaustive study of the WAAC, see Brian Foss, *War Paint: Art, War, State and Identity in Britain, 1939–45*, London 2007.

2. Later in life Clark gave an account of Moore's transition from modernist abstraction to a style more fit for national record: 'we watched with infinite admiration how the abstract-looking style of the 1930s was modified, without any loss of completeness, by his observation of sleepers in the tube shelters'. Clark, *The Other Half*, p.42.

3. Cecil Beaton, another MoI employee, prefaced a 1943 collection of WAAC paintings and drawings: 'Many of their new pictures, because they are created out of an experience common to us all, speak with the immediate appeal of popular art.' Cecil Beaton, 'Introduction', *Production/War Pictures by British Artists*, 2nd series, London 1943.

4. E.M.O'R. Dickey, MoI memoranda, 30 November 1939 and 5 December 1939. Imperial War Museum, GP 55/1.

5. K. Clark, 'Scheme for Recording Changing Aspects of Britain', typescript, Victoria and Albert Museum, Pilgrim Trust Archive. For a full account of Recording Britain, see David Alan Mellor, 'Recording Britain: A History and Outline', in D.A. Mellor, Gill Saunders and Patrick Wright (eds), *Recording Britain: A Pictorial Domesday of Pre-War Britain*, London 1990, pp.9–24.

6. 'Preserving Records of Ancient Buildings', *Municipal Journal*, 22 November 1940.

7. Harold Nicolson, 'Marginal Comments', *Spectator*, 16 June 1944, p.154.

8. Richard Eurich to WAAC, 10 June 1940, cited in *The Edge of All the Land: Richard Eurich, 1903–1992*, Southampton 1994, cat. entry no.28.

9. Paul Delany, *Bill Brandt: A Life*, London 2002, p.169.

10. K. Clark, 'The Warburg Institute', Tate Archive 8812.1.1.10 Misc S 1940–2, pt 1.

11. K. Clark, 'Memorandum', Tate Archive 8812.1.1.10 Misc S 1940–2, pt 1 of 2.

12. See Raphael Samuel, *Theatres of Memory/ Past and Present in Contemporary Culture* vol.1, London 1996, pp.233–4.

13. K. Clark to Clifford Ellis, 11 July 1943, Tate Archive 8812.1.1.20.

14. K. Clark to Sir Ronald Storrs, 19 March 1941, Tate Archive 8812.1.1.10 Misc S 1940–2, pt 2 of 2.

15. K. Clark 'The Weather in Our Souls', *Listener*, no.642, 1 May 1941, pp.620–1.

16. Ibid.

17. John Piper to K. Clark, 28 May 1941, Tate Archive 8812.3.2503.

18. See Rolant Pyrs Gruffudd, 'Reach for the Sky: The Air and English Cultural Nationalism', Department of Geography Working Paper no.4, University of Nottingham, 1990. Nash's pictorial vocabulary – in *Battle of Britain* – of military aircraft vapour trails arranged in 'decorative' patterns should be considered in relation to press reports during the Battle of Britain which tried to explain the spectacle of man-made clouds and vapour trails. The journal *Flight* reported and speculated about

condensation ('con') trails in July 1940, when the early skirmishes of the aerial battle were being fought: 'Visible Vortices? White Sky Trails: A Possible Explanation' (18 July 1940, p.51). Just after the climax of the battle, *Flight* ran a photograph emblematising 'War in the Air/Dog-Fight Doodle: The Trails Left in the Sky after an Air Fight' (19 September 1940, p.221).

19. Clark, 'The Weather in Our Souls', pp.620–1.

20. Paul Nash, *Outline: An Autobiography and Other Writings*, London 1949, p.264.

21. E.M.O'R. Dickey to Paul Nash, 18 September 1941, Clark Papers, Tate Archive.

22. 'Art is not "Cissy": Civil Defence Artists 3rd Show at Cooling Galleries', *Evening News*, 6 January 1942.

23. L.S. Collingage of Harpenden to K. Clark, 14 June 1942, Tate Archive 8812.1.3.765.

24. K. Clark to Edward Wadsworth, 20 April 1941, Tate Archive.

25. Signatories included D.Y. Cameron, Alfred Munnings, Frank O. Salisbury and nine others. Tate Archive 7050.414.33.

26. 'CEMA and Modern Art', *The Times*, 11 March 1944.

27. Paul Nash to *The Times*, 12 March 1944, Tate Archive 7050.414.33.

28. K. Clark, 'The State and Art: A "First Instalment" of Patronage', *Birmingham Post*, 12 May 1943. For the contemporary ferment over state patronage, and the debate that developed in 1942–3 over the extent and use of state patronage in the arts, see Raymond Mortimer, 'CEMA', *New Statesman*, 3 October 1942, pp.219–20, 229.

29. E.M.O'R. Dickey, 21 November 1941, Imperial War Museum, GP/55/104.

30. Voice-over commentary, Jill Craigie, *Out of Chaos*, 1944.

31. K. Clark to John Piper, 15 August 1941: 'This is to confirm our conversation yesterday in which I told you of the Queen's commission to paint a series of watercolours of Windsor Castle and Great Park. We agreed that you would do 15 watercolours for £150, this sum to include expenses. I have written to the

Librarian, Owen Morshead, telling him about the commission and that you will be calling on him soon.' Tate Archive 8812.1.3.2504.

32. Raymond Mortimer, *New Statesman*, 27 June 1942.

33. Eric Newton, 'Pictures While You Eat', BBC Forces Network, 22 October 1942.

34. 'Lady Clark is leading spirit in the enterprise which is snatching art and the artist from the sleepy seclusion of the picture gallery and thrusting them into those lively arenas of everyday thought and opinion, the feeding centres of the community.' Anne Robertson Cougar, 'Art Study in British Restaurants: The King's Pictures', *Manchester Evening News*, 25 November 1942.

35. K. Clark, 'Art in War Time', *Listener*, 5 November 1942, p.598.

36. K. Clark, 'Essex Town Gives a Lead: Decorating British Restaurants', *Essex Weekly News*, 25 December 1942.

37. R.A. Butler, 'Music and Art in Wartime', *Glasgow Herald*, 25 June 1942.

38. 'Art Advisor to Brighten British Restaurants', *Daily Mirror*, 2 November 1942.

39. Raymond Mortimer, *New Statesman*, 8 August 1941, p.174. Similarly Herbert Furst wrote, '[I feel] uneasy … I feel as if I have awakened in Valhalla'; Herbert Furst, *Apollo*, October 1942, p.97. Cited in Jonathan Black, *The Face of Courage*, London 2011, p.103, n.338.

40. The most telling contemporary imaginative attempt to discuss RAF Bomber Command's calibrations of planified ground targets and visual display, in the spectacular language of detonating flares (nicknamed by aircrew as 'pink pansies') like those in Nash's painting, is to be found in Guy Gibson's posthumously published *Enemy Coast Ahead*, London 1946.

41. Denis Cosgrove has written about the context of journalistic graphics illustrating the USAAF offensive against Japan in 1943–5, which constituted the figuring of 'high-angle, oblique pictorial maps … The new spatial perspectives introduced by powered flight, the scale and logic of contemporary spaces which

are comprehensible only from above.' Denis Cosgrove, 'Maps, Mapping and Modernity: Art and Cartography in the 20th Century', *Imago Mundi*, no.1, 2005, pp.50–1.

42. 'The Battle of Germany: From the Heavens', *Picture Post*, 24 March 1945, p.7.

43. K. Clark to Paul Nash, 3 October 1944, Tate Archive 8812.7050.361.

44. K. Clark to Jim Ede, 10 May 1943, Tate Archive 8812.1.1.20.4.

45. Cyril Connolly, 'Writers and Society 1940–3', *The Condemned Playground*, London 1945, p.281.

46. K. Clark to Paul Nash, 22 October 1941, Imperial War Museum file.

5. SALTWOOD

1. Ben Snook has researched Saltwood's early charters, some of which have proved to be later medieval copies, e.g. the 1026 charter granting the manor Saltwood to the see of Canterbury: British Museum, Cotton MSS, CH X II. Despite the importance of the castle there has been no extensive history written, although Anthony Emery's *Greater Medieval Houses of England and Wales*, vol.3: *Southern England*, Cambridge 2006, pp.400–4, provides an engaging analysis. All other historians, however, have relied exclusively on Edward Hasted's *The History and Topographical Survey of the County of Kent*, 1st edn, Canterbury 1790, vol.3, pp.404–10.

2. See Susan Pittman, 'Elizabethan and Jacobean Deer Parks in Kent', unpublished Ph.D thesis, Christ Church Canterbury University, 2011; for challenging theories on the symbolic nature of medieval castles, see Charles Coulson, *Castles in Medieval Society*, Oxford 2003, and Robert Liddiard, *Castles in Context*, Bollington 2005.

3. J.M.W. Turner completed eight pencil sketches of Saltwood Castle from various angles c.1816–19, suggesting a close interest in the castle and its setting (Tate Archive D10481–D10491). A watercolour of the main gatehouse, c.1795, is held by the Ashmolean Museum, Oxford.

4. Frederick Beeston, *An Archaeological Description of Saltwood Castle*, c.1890, is the only record of the excavations: no context section drawings, photographs or location plans of the archaeological excavation have been located. Saltwood Castle also features in Amicia de Moubray, *Twentieth Century Castles in Britain*, London 2013, pp.144–51; this book has merit, but the author has relied heavily on Clark's inaccurate autobiography, *The Other Half*, as well as other secondary sources, thereby perpetuating incorrect information.

5. Herbert Deedes was the father of Bill Deedes, who had a distinguished career as a politician, journalist and editor of the *Daily Telegraph*. Saltwood was his boyhood home. See Stephen Robinson, *The Remarkable Lives of Bill Deedes*, London 2008, pp.1–16.

6. According to Ann Felce, née Simmons, of Grange Farm, Saltwood.

7. Lord Conway of Allington, *Episodes in a Varied Life*, London 1932, pp.93–104. Also Joan Evans, *The Conways: A History of Three Generations*, London 1966.

8. See Philip Tilden, *True Remembrances: The Memoirs of an Architect*, London 1954, for a detailed account of his work at Saltwood and elsewhere.

9. Clark, *The Other Half*, p.158. A letter in the Tate Archive (8812.1.2) is dated 24 April (no year) from Lady Conway to Lady Clark, thanking her for returning the *Country Life* copies. This certainly refers to Christopher Hussey's article in *Country Life*, 20 November–4 December 1944, which happens to be retained in a leather folder at Saltwood. Lady Conway died on 14 March 1953 (announced in the *London Gazette*, 28 July 1953), so Lady Conway's letter is most likely to have been written in April 1952, proving that the Clarks were negotiating to purchase the castle earlier than previously thought.

10. Cash statement from Bird & Bird, solicitors, 24 February 1954. Saltwood Castle purchase files, Saltwood Castle Archive.

11. Hatch & Waterman, *Saltwood Castle Sales Catalogue*, 8 December 1953.

Saltwood Castle Archive.

12. William Shawcross, *Queen Elizabeth, The Queen Mother*, London 2009, p.710.

13. The Queen Mother to Lord and Lady Clark, 1 July 1957, Saltwood Castle Archive.

14. Personal communication with Jane Clark.

6. TELEVISION

1. Anon., 'How Like an Angel', *The Times*, 17 May 1969, p.9.

2. 'Critics' Poll: Best of a Decade', *Contrast*, no.4, Autumn 1965, pp.98–9. *Contrast* was published by the British Film Institute between the autumn of 1961 and spring of 1966.

3. 'Our Special Correspondent', 'When Television Turns to the Arts', *The Times*, 11 April 1964, p.5.

4. Clark, *The Other Half*, p.208.

5. Maurice Wiggin, 'Over the Hills and Away', *Sunday Times*, 19 May 1963, p.40.

6. K. Clark, *Rediscovering the Image: Gauguin*, broadcast 1 February 1965; *Picasso: Sir Kenneth Clark at the Tate Gallery*, broadcast 8 August 1960.

7. *Five Revolutionary Painters: Goya*, broadcast 19 October 1959; the following four films in the series looked at Brueghel, Caravaggio, Rembrandt and Van Gogh.

8. 13 April 1937, minutes of the National Gallery Board Meetings, vol.11, 13 January 1931–12 December 1939, NG 1/11; thanks to John-Paul Stonard for this reference.

9. *Radio Times*, 10 December 1937, p.21. The programme broadcast on 17 December was the third in a series titled *Artists and Their Work*, contradicting Clark's later assertion that the *Sight and Sound* panel show with poets and painters, broadcast on 26 February 1939 with Clark in the chair, was 'the first "art" programme to appear on the new medium' (Clark, *The Other Half*, p.206).

10. 'It was an inexplicable choice, and was commonly attributed to the fact that in those days films were spoken of as "pictures", and I was believed to be an

authority on pictures.' Clark, *The Other Half*, p.10.

11. Clark, *The Other Half*, p.138.

12. *Television Act 1954*, section 3, London 1954.

13. ITA Paper 47(55), quoted in Bernard Sendall, *Independent Television in Britain*, vol.1, *Origin and Foundation, 1946–62*, London 1982, p.112.

14. Contract draft with ATV (later signed without amendment to this passage), 7 November 1957, Tate Archive 8812.1.4.32.

15. Robert Heller to K. Clark, 19 September 1957, Tate Archive 8812.1.4.32. In the same letter Heller confirmed ATV's interest in entering into a separate agreement to produce a series of programmes based on *The Nude*, although this never came to fruition.

16. 'Richard Bradford Lecture: Television', given on 24 October 1975; corrected typescript, Tate Archive 8812.2.2.1023.

17. ATV press statement draft, [early November 1957], Tate Archive 8812.1.4.32.

18. 'Sir Kenneth Clark's Next Work for Television', *The Times*, 13 November 1957, p.3.

19. *Should Every Picture Tell a Story?*, broadcast on 14 April 1958, includes Clark and Berger discussing Picasso's *Guernica* and the paintings of Renato Guttuso.

20. *Encounters in the Dark* was broadcast on 17 March 1958. Only brief sequences from the programme appear to survive.

21. *Are They Worth It?*, broadcast 17 November 1958; by this point ATV had dropped the title *Is Art Necessary?*

22. *Can Art Be Democratic?*, broadcast 15 December 1958.

23. *What is Good Taste?*, broadcast 1 December 1958.

24. Unpublished transcript in author's papers of interview recorded in 1993 for the television programme *K: Kenneth Clark 1903–1983*, broadcast 10 October 1993, BBC2.

25. *Five Revolutionary Painters: Goya*, broadcast 19 October 1959.

26. *Five Revolutionary Painters: Caravaggio*, broadcast 30 November 1959.

27. K. Clark to Robert Heller, 30 December 1959, Tate Archive 8812.1.4.32.

28. K. Clark to Val Parnell, 1 November 1960, Tate Archive 8812.1.4.32.

29. Robert Heller to K. Clark, 27 March 1960, Tate Archive 8812.1.4.32.

30. K. Clark, 'Temple of the "Terrible Toughs"', *TV Times*, 12 December 1964, p.6.

31. *Great Temples of the World: Chartres Cathedral*, broadcast 15 December 1965.

32. *Royal Palaces of Britain*, broadcast on both BBC and ITV, 25 December 1966.

33. First broadcast in Britain from 23 February to 18 May 1969; the immensely successful book of the series was published by the BBC and John Murray in 1969.

34. First broadcast in Britain from 8 to 29 January 1972; the book *Ways of Seeing*, by Berger, Mike Dibb, Sven Blomberg, Chris Fox and Richard Hollis, was published by the BBC and Penguin in 1972.

35. Interviewed in 1993 for *K: Kenneth Clark, 1903–1983*, broadcast 10 October 1993, BBC2; the production of *Civilisation* is chronicled by Marcus Hearn in *Viewing Notes*, a booklet accompanying the DVD release of *Civilisation*, London 2005, and in Jonathan Conlin, *BFI TV Classics: Civilisation*, London 2009.

36. Speech reprinted as the Appendix to Clark, *The Other Half*, p.248.

Kenneth Clark Bibliography

JOHN-PAUL STONARD

While not exhaustive, this bibliography lists most of Clark's published books, articles, lectures and letters to newspapers and magazines. It does not list reprints, further editions or translations.

BOOKS AND CATALOGUES

The Gothic Revival, London 1928.

A Commemorative Catalogue of the Exhibition of Italian Art, exh. cat., ed. by K. Clark and Lord Balniel, Royal Academy of Arts, London 1931.

A Catalogue of the Drawings of Leonardo da Vinci in the Collection of His Majesty the King at Windsor Castle, 2 vols, Cambridge 1935.

On the Painting of English Landscape, Annual Lecture on Aspects of Art, British Academy, London 1935.

One Hundred Details from Pictures in the National Gallery, London, London 1938.

Recent Works of Graham Sutherland, exh. cat., with an introduction by K. Clark, Rosenberg and Helft, London 1938.

Last Lectures by Roger Fry, with a preface and introduction by K. Clark, Cambridge 1939.

Leonardo da Vinci: An Account of His Development as an Artist, Cambridge 1939.

More Details from Pictures in the National Gallery, London, London 1941.

An Exhibition of Paintings by Members of the Euston Road Group Organised by the Contemporary Art Society, exh. cat., with an introduction by K. Clark, Ashmolean Museum, Oxford 1941.

Exhibition of Paintings by Sir William Nicholson and Jack B. Yeats, exh. cat., with an introduction by K. Clark, National Gallery, London 1942.

Paul Cézanne: An Exhibition of Watercolours, exh. cat., with an introduction by K. Clark, Arts Council, London 1946.

Paintings of Graham Bell, with an introduction by K. Clark, London 1947.

Praeterita: Outlines of Scenes and Thoughts Perhaps Worthy of Memory in My Past Life, by John Ruskin, with an introduction by K. Clark, London 1949.

Landscape into Art, London 1949.

Piero della Francesca, Oxford 1951.

Drawings by Charles Keene 1823–1891, exh. cat., with an introduction by K. Clark, Arts Council, London 1952.

J.M.W. Turner, RA, 1775–1851: A Selection of Twenty-Four Oil Paintings from the Tate Gallery, exh. cat., with a text by K. Clark, Tate Gallery, London 1952.

Leonardo da Vinci: Selected Drawings from Windsor Castle, edited by K. Clark, London 1954.

The Nude, London 1956.

Drawings by Jean-François Millet, exh. cat., with an introduction by K. Clark, Arts Council, London 1956.

The Romantic Movement: Fifth Exhibition to Celebrate the Tenth Anniversary of the Council of Europe, exh. cat., with a foreword and introduction by K. Clark, Tate Gallery and Arts Council Gallery, London 1959.

Reynolds Stone: An Exhibition of Engravings and Designs, exh. cat., with an introduction by K. Clark, Arts Council, London 1959.

Drawings by John Ruskin, exh. cat., with an introduction by K. Clark, Arts Council, London 1960.

Looking at Pictures, London 1960.

Sidney Nolan, by K. Clark, C. MacInnes and B. Robertson, London 1961.

The Renaissance: Studies in Art and Poetry. To Which is Added the Essay on Raphael from 'Miscellaneous Studies', by Walter Pater, with an introduction and notes by K. Clark, London 1961.

The Other Side of the Alde, London 1963.

Ruskin Today, chosen and annotated by K. Clark, London 1964.

Ruskin and His Circle, exh. cat., with an introduction by K. Clark, Arts Council, London 1964.

Rembrandt and the Italian Renaissance, London 1966.

A Catalogue of the Drawings of Leonardo da Vinci in the Collection of Her Majesty the Queen at Windsor Castle, with C. Pedretti, Oxford 1968.

The Artist Grows Old, Cambridge 1972.

Moments of Vision, London 1973.

Civilisation: A Personal View, London 1973.

Henry Moore Drawings, compiled and with a text by K. Clark, London 1974.

Another Part of the Wood: A Self-Portrait, London 1974.

The Drawings by Sandro Botticelli for Dante's 'Divine Comedy': After the Originals in the Berlin Museums and Vatican, introductory text by K. Clark, London 1976.

Animals and Men, London 1977.

Introduction to Rembrandt, London 1978.

The Other Half: A Self-Portrait, London 1977.

The Best of Aubrey Beardsley, London 1978.

What is a Masterpiece?, Walter Neurath memorial lectures, London 1979.

Henry Moore's Sheep Sketchbook, comments by Henry Moore and Kenneth Clark, London 1980.

Feminine Beauty, London 1980.

The Art of Humanism, London 1983.

ARTICLES / CHAPTERS / PUBLISHED LECTURES

'A Note on Leonardo da Vinci', *Life and Letters*, 1929, pp.122–32.

'The "Bizarie" of Giovanbatista Braccelli', *Print Collector's Quarterly*, no.4, 1929, pp.311–26.

'Italian Drawings at Burlington House', *Burlington Magazine*, no.325, April 1930, pp.174–7, 180–3, 187.

'Venetian Drawings in Windsor Castle Library', *Old Master Drawings*, March 1931, pp.63–5.

'Alberti and Shakespeare', letter, *Times Literary Supplement*, no.1521, 26 March 1931, p.252.

'Michelangelo', review of E. Steinmann, *Michelangelo im Spiegel seiner Zeit*, *Times Literary Supplement*, no.1522, 21 April 1932, p.285.

'*The Quattro Cento. Part I. Florence and Verona*, by A. Stokes', review, *Criterion*, no. 12, October 1932, pp.147–8.

'Giovanni Bellini or Mantegna', *Burlington Magazine*, no.356, November 1932, pp.232, 235.

'Leonardo's Adoration of the Shepherds and Dragon Fight', *Burlington Magazine*, no.358, January 1933, pp.20–3, 25–6.

'A Ferrarese Pupil of Piero della Francesca', *Burlington Magazine*, no.360, March 1933, pp.142–3.

'The Madonna in Profile; Studies by Leonardo for the Madonna', *Burlington*

Magazine, no.360, March 1933, pp.136–7, 139–40.

'English Painting', *Listener*, no.258, 20 December 1933, p.947.

'What I Like in Art', *Listener*, no.285, 27 June 1934, p.1068.

'Mr. Roger Fry. An Appreciation', *The Times*, 11 September 1934, p.14.

'Seven Sassettas for the National Gallery', *Burlington Magazine*, no.385, April 1935, pp.152–5, 158.

'On the Painting of English Landscape', Annual Lecture on Aspects of Art, 19 June 1935, in *Proceedings of the British Academy*, London 1935, pp.185–200.

'A Renoir Exhibition', *Burlington Magazine*, no.388, July 1935, pp.2–4, 7.

'The Future of Painting', *Listener*, no.351, 2 October 1935, p.543.

'The Art of Rouault', *Listener*, no.354, 23 October 1935, p.706.

'A Western Criticism of Chinese Painting', *Listener*, no.367, 22 January 1936, p.151.

'Loan exhibition at the National Gallery', letter, *The Times*, 5 August 1936, p.8.

'The Cleaning of Pictures. National Gallery Precautions: A Word on Glazes', letter, *The Times*, 23 December 1936, p.11.

'Leonardo da Vinci: Study of a Bear Walking, from the Collection of Herr Ludwig Rosenthal', *Old Master Drawings*, March 1937, pp.66–7.

'Constable, Prophet of Impressionism', *Listener*, no.430, 7 April 1937, p.634.

'Four Giorgionesque Panels', *Burlington Magazine*, no.416, November 1937, pp.198, 201, 204–7.

'Seventeenth-Century Painting', *Listener*, no.469, 5 January 1938, p.5.

'The National Gallery. Growth of a Great Collection. A Struggle for Space', *The Times*, 8 April 1938, pp.17–18.

'The Aesthetics of Restoration', Royal Institution of Great Britain, weekly evening meeting, 20 May 1938, *Proceedings of the Royal Institution*, no.141, 1938, pp.382–97.

'Recent Paintings by Picasso', *Listener*, 530, 9 March 1939, p.517.

'National Gallery Pictures. None are in Cellars. Loans to Provincial Collections', letter, *The Times*, 29 March 1939, p.17.

'Art at the Fair: Great Britain', *Art News*, no.37, 27 May 1939, p.15.

'Artists in War. A Central Institute', letter, *The Times*, 21 October 1939, p.4.

'The Artist in Wartime', *Listener*, no.563, 26 October 1939, p.810.

'Concerts in the National Gallery', *Listener*, no.564, 2 November 1939, p.884.

'The National Gallery Concerts', letter, *The Times*, 11 November 1939, p.7.

'Art for the People', *Listener*, no.567, 23 November 1939, p.999.

'Dessins de Leonardo da Vinci, 1513–1515', *Cahiers d'Art*, no.14, 1939, pp.40–6.

'The Artist and the Patron: A Discussion between Eric Newton and Sir Kenneth Clark', *Listener*, no.580, 22 February 1940, p.380.

'A Thousand Shows a Week', *Listener*, no.613, 10 October 1940, p.509.

'Eclipse of the Highbrow', letter, *The Times*, 27 March 1941, p.5.

'Eclipse of the Highbrow', letter, *The Times*, 7 April 1941, p.5.

'The Weather in Our Souls', *Listener*, no.642, 1 May 1941, p.620.

'Sir Hugh Walpole', letter, *The Times*, 4 June 1941, p.7.

'War Artists at the National Gallery', *Studio*, no.123, January 1942, pp.2–12.

'Pictures at Hampton Court', letter, *The Times*, 13 June 1942, p.5.

'A Rembrandt on View. National Gallery's Decision. Pictures in War-Time', letter, *The Times*, 19 January 1942, p.5.

'English Romantic Poets and Landscape Painting', *Memoirs and Proceedings of the Manchester Library and Philosophical Society, Session 1941–43*, March 1943, pp.103–20.

'Baroque and the National Shrine', *Architectural Review*, no.559, July 1943, pp.2–12.

'Ornament in Modern Architecture', *Architectural Review*, no.564, December 1943, pp.147–50.

'HR. Edvard Munch', letter, *The Times*, 31 January 1944, p.6.

'Artist and Patron', *Sunday Times*, 2 April 1944, p.4.

'A C.E.M.A. Exhibition. Sir Kenneth Clark's

Comment', letter, *The Times*, 25 November 1944, p.5.

'C.E.M.A. Pictures. Disputed French Paintings', letter, *The Times*, 1 December 1944, p.5.

'A Masterpiece Revived', review of new edition of *The Civilisation of the Renaissance*, by Jacob Burckhardt, *Sunday Times*, 7 January 1945, p.3.

'Art in a Distracted World', *Listener*, no.836, 18 January 1945, p.67.

'The National Gallery', letter, *The Times*, 5 July 1945, p.5.

'The Arts Council', letter, *The Times*, 10 October 1945, p.5.

'The Ruskin Revival', review of *Ruskin*, by R.W. Livingstone, *Sunday Times*, 24 February 1946, p.3.

'Art and Democracy', *Cornhill Magazine*, no.965, 22 May 1945, p.370.

'The New Romanticism in British Painting', *Art News*, February 1947, pp.24–9, 56–8.

'Piero della Francesca's St Augustine Altarpiece', *Burlington Magazine*, no.533, August 1947, pp.204–9.

'Lord Lee of Fareham', *Burlington Magazine*, no.534, September 1947, p.259.

'International Gothic and Italian Painting: Selwyn Brinton Lecture', *Journal of the Royal Society of Arts*, no.4753, 10 October 1947, pp.757–70.

'Thoughts of a Great Humanist', *Burlington Magazine*, no.554, May 1949, pp.144–5.

'Appreciating Uccello', review of *The Complete Work of Paulo Uccello*, by J. Pope-Hennessy, *Times Literary Supplement*, no.2546, 17 November 1950, p.722.

'Humanism and Architecture', *Architectural Review*, February 1951, pp.65–9.

'Henry Moore's Metal Sculpture', *Magazine of Art*, May 1951, pp.171–4.

'Apologia of an Art Historian', lecture, *University of Edinburgh Journal*, Summer 1951, p.234.

'An Early Quattrocento Triptych from Santa Maria Maggiore, Rome', *Burlington Magazine*, no.584, November 1951, pp.339–47.

'Sir Muirhead Bone', letter, *The Times*, 29 October 1953, p.10.

'Lord Queensberry', letter, *The Times*, 30

April 1954, p.10.

'The Transformations of Nereids in the Renaissance', *Burlington Magazine*, no.628, July 1955, pp.214–17, 219.

'The Study of Art History', *Universities Quarterly*, no.3, May 1956, pp.223–38.

'On Looking at Pictures', *Sunday Times*, 12 May 1957, p.14.

'Six Great Pictures. 1: *The Entombment*, by Titian', *Sunday Times*, 19 May 1957, p.9.

'Six Great Pictures. 2: *Virgin with St Anne*, by Leonardo da Vinci', *Sunday Times*, 26 May 1957, p.9.

'Six Great Pictures. 3: *Las Meninas*, by Velasquez [*sic*]', *Sunday Times*, 2 June 1957, p.9.

'Six Great Pictures. 4: *The Crusaders Entering Constantinople*, by Delacroix', *Sunday Times*, 9 June 1957, p.9.

'Six Great Pictures. 5: *Une Baignade*, by Seurat', *Sunday Times*, 16 June 1957, p.9.

'Six Great Pictures. 6: *Self-Portrait*, by Rembrandt', *Sunday Times*, 23 June 1957, p.9.

'*Lorenzo Ghiberti*, by Richard Krautheimer', review, *Burlington Magazine*, no.662, May 1958, pp.174–8.

'More Great Pictures', *Sunday Times*, 28 September 1958, p.22.

'The Miraculous Draught of Fishes', *Sunday Times*, 5 October 1958, p.15.

'The Leaping Horse', *Sunday Times*, 12 October 1958, p.15.

'The Nativity by Botticelli', *Sunday Times*, 19 October 1958, p.15.

'Watteau's *L'Enseigne de Gersaint*', *Sunday Times*, 26 October 1958, p.15.

'Medieval Gospel Pictures', *Sunday Times*, 21 December 1958, p.10.

'More Great Paintings', *Sunday Times*, 27 September 1959, p.11.

'The Eye of Vermeer', *Sunday Times*, 4 October 1959, p.11.

'The Sage of Art', *Sunday Times*, 11 October 1959, p.15.

'A Flemish Artist's View of Life', *Sunday Times*, 18 October 1959, p.15.

'Bernard Berenson', *Burlington Magazine*, no.690, September 1960, pp.381–6.

'Turner's "Look at Nature"', *Sunday Times*, 25 October 1959, p.17.

'Johannes Wilde', *Burlington Magazine*, no.699, special issue in honour of Professor Johannes Wilde, June 1961, p.205.

'Mr. R.W. Bliss', letter, *The Times*, 26 April 1962, p.21.

'The Blot and the Diagram', *Art News*, December 1962, pp.28–31.

'Michelangelo Pittore', *Apollo*, no.34, December 1964, pp.436–45.

'The Authentic Sibylline Voice', *Sunday Times*, 13 December 1964, p.27.

'The Painter as Scholar–Poet', *Sunday Times*, 10 October 1965, p.51.

'The Value of Art in an Expanding World', *Hudson Review*, no.1, Spring 1966, pp.11–23.

'Out of the Black Lake', *Sunday Times*, 8 May 1966, p.39.

'Obituary. Viscount Lee of Fareham', letter, *The Times*, 8 July 1966, p.14.

'M. Georges Salles. Former Director of the Louvre', letter, *The Times*, 27 October 1966, p.14.

'Mr. Oliver Brown', letter, *The Times*, 23 December 1966, p.10.

'Henry Moore's Gift', letter, *The Times*, 2 June 1967, p.11.

'Miss Nicky Mariano', letter, *The Times*, 14 June 1968, p.5.

'Leonardo and the Antique', in *Leonardo's Legacy*, ed. C. O'Malley, Berkeley and Los Angeles 1969, pp.1–34.

'Bryan Robertson and the Whitechapel', letter, *The Times*, 22 January 1969, p.7.

'London's Debt to Labour', letter, *The Times*, 20 April 1967, p.11.

'Enthusiastic Support', letter, *The Times*, 20 February 1969, p.11.

'The Genesis of Italian Drawing', *Apollo*, 98, April 1970, pp.260–5.

'Ingres: Peintre de la Vie Moderne', *Apollo*, no.111, May 1971, pp.357–65.

'TV is Civilisation', *Look*, 7 September 1971, p.50.

'Mona Lisa', *Burlington Magazine*, no.840, March 1973, pp.144–51.

'Conversation with Kenneth Clark: The Museum's Duty, the Uses of Art History, the Education of the Eye', *ARTnews*, October 1973, pp.13–16.

'Helmut Ruehmann', obituary, *Burlington Magazine*, no.849, December 1973, p.810.

'Spellbinder (Review of Sutton, *Letters of Roger Fry*)', *New York Review of Books*, no.7, 2 May 1974, p.13–14.

'A Peer Gynt from the Slade', review of *Augustus John: A Biography*, by M. Holroyd, and *The Art of Augustus John*, M. Easton and M. Holroyd, *Times Literary Supplement*, no.3789, 18 October 1974, pp.1149–50.

'Julien Cain', letter, *Times Literary Supplement*, no.3809, 7 March 1975, p.253.

'Yukio Yashiro', letter, *Times Literary Supplement*, no.3832, 22 August 1975, p.946.

'David Crawford: The Earl of Crawford and Balcarres', obituary, *Burlington Magazine*, no.877, April 1976, pp.231–2.

'Big Brother', letter, *The Times*, 1 May 1976, p.15.

'Ending of Sunday Postal Collections', letter, *The Times*, 6 May 1976, p.17.

'A Full-Length Portrait', review of *Edith Wharton*, R.W.B. Lewis, *Times Literary Supplement*, no.3849, 19 December 1976, pp.1502–3.

'Rembrandt's *Good Samaritan* in the Wallace Collection', *Burlington Magazine*, no.885, December 1976, pp.806–7, 809.

'The Hapsburgs as Patrons', review of *Princes and Artists*, by H. Trevor-Roper, *Times Literary Supplement*, no.3906, 21 January 1977, pp.46–7.

'Elderly Travellers', letter, *The Times*, 15 April 1977, p.13.

'Seven Centuries of Colour', *Sunday Times*, 9 December 1979, p.34.

Kenneth Clark Selected Filmography

JOHN WYVER

Programme descriptions are from *TV Times* unless otherwise indicated

Artists and their Work No. 3
17 December 1937, 21:05 (15 mins), BBC
'Florentine paintings from the National Gallery, described by Kenneth Clark, Director of the National Gallery.' (*Radio Times*)

Sight and Sound
26 February 1939, 21:55 (30 mins), BBC
'Sir Kenneth Clark, Director of the National Gallery, will act as Master of the Ceremonies in a test of skill ... artists will be asked to spot quotations and the poets will be shown well-known pictures and asked their authorship.' (*Radio Times*)

Out of Chaos
1944 (30 mins), Two Cities Films
Documentary about artists during wartime directed by Jill Craigie, featuring an interview with Kenneth Clark.

For Schools
13 May 1957, 14.45 (30 mins), A-R for ITV
'Sir Kenneth Clark, Chairman of Independent Television Authority, and Sir John Wolfenden, Chairman of Associated-Rediffusion's Education Advisory Council, open the first schools television service'

Television Tomorrow: Discussion
1 November 1957 (32 mins), BBC

Is Art Necessary? Isn't He Beautiful?
16 February 1958, Sunday 14.30 (Midlands) (26 mins), ATV for ITV

Is Art Necessary? Encounters in the Dark
17 March 1958, Monday 21.00 (30 mins) ATV for ITV
'Sir Kenneth Clark in company with Henry Moore ... invites viewers to share their experiences on a unique midnight visit to the British Museum'.

Is Art Necessary? Should Every Picture Tell a Story?
14 April 1958, 21:00 (30 mins) ATV for ITV
'Here is your chance to compare your ideas with those of master storyteller Somerset Maugham, controversial artist Graham Sutherland and dynamic art critic John Berger, who join Sir Kenneth Clark in the third of his present series'.

Is Art Necessary? Do We Want Public Figures?
19 May 1958, 21:00 (30 mins) ATV for ITV
'Are they worth looking at? Will they be seen in the cities of the future? Sir Kenneth Clark is joined by Osbert Lancaster and Sir Hugh Casson on a treasure hunt among the pieces of public sculpture, old and new, familiar and little-known, that adorn our buildings, parks and streets'.

Is Art Necessary? Do Fakes Matter?
23 June 1958, 21:00 (30 mins), ATV for ITV

Are They Worth It?
17 November 1958, 22:15 (30 mins) ATV for ITV

What is Good Taste?
1 December 1958, 22:15 (30 mins) ATV for ITV

Can Art Be Democratic?
15 December 1958, 22:15 (30 mins) ATV for ITV

Can Photography Be An Art?
9 March 1959, 22:15 (30 mins) ATV for ITV
'Can the photograph, whether taken by a professional, a Press photographer, or an amateur, ever be considered a form of art? Does the photograph contain the qualities which we recognise in all the great works of art? Sir Kenneth Clark will examine the path photography has taken since its early days, and will talk of its possibilities, values and pleasures'.

Should We Have Him Painted?
23 March 1959, 22:15 (30 mins) ATV for ITV
'If a likeness can be shown in a photograph, why should a person have his portrait painted? Are there values created by a painting that cannot be attained by any other medium? Sir Kenneth Clark, in his answer to these questions, will discuss the qualities that have made certain portrait paintings rank among the great masterpieces of art, and will assess the importance of some portrait paintings of today.'

What is Sculpture?
6 April 1959, 22:15 (30 mins) ATV for ITV

For Schools: The Artist in the Modern World. No 1
30 September 1959, 15:23 (27 mins) ATV for ITV

Five Revolutionary Painters: Goya
19 October 1959, 22:30 (30 mins) ATV for ITV
'In this series Sir Kenneth Clark talks about five painters who found that the traditional modes of picture making prevented them from using the materials of life to appeal directly to human emotions.'

Five Revolutionary Painters: Peter Breugel
16 November 1959, 22:30 (30 mins) ATV for ITV

Five Revolutionary Painters: Caravaggio
30 November 1959, 22:30 (30 mins) ATV for ITV

Five Revolutionary Painters: Rembrandt
14 December 1959, 22:30 (30 mins) ATV for ITV

Five Revolutionary Painters: Van Gogh
28 December 1959, 22:30 (30 mins) ATV for ITV

The Art of Architecture: No 1: The Good Old Rules
21 March 1960, 22:30 (30 mins) ATV for ITV
'Reyner Banham, in the first of three fortnightly programmes suggested and prefaced by Sir Kenneth Clark, begins by searching for some basic principles inherited from the past which persist in the most daring, imaginative and great buildings of our time'.

The Art of Architecture: No 2: The Age of the Spaceman
4 April 1960, 22:55 (30 mins) ATV for ITV

The Art of Architecture: No 3: The Architecture We Deserve
18 April 1960, 22:30 (30 mins) ATV for ITV
'Reyner Banham ... inquires how far the present state of British architecture is the fault of the architects, and how far it is the fault of the public for whom architects have to build.'

Picasso: Sir Kenneth Clark at the Tate Gallery
8 August 1960, 22:35 (30 mins) ATV for ITV

Shapes and Sounds: Shape of Cars to Come
23 October 1960, 17:40 (25 mins) ATV for ITV (not transmitted)
'A fortnightly programme of current events in the arts'.

Shapes and Sounds: A Conversation with Sir William Walton
6 November 1960, 17:40 (25 mins) ATV for ITV
'Sir William Walton's *2nd Symphony* is to be performed in London for the first time at the Royal Festival Hall on November 23. In this programme Sir Kenneth Clark talks to Sir William about his new work, his ceremonial and choral music and, with an illustration from *Henry V*, his film music.'

Shapes and Sounds: The Realistic Cinema
20 November 1960, 17:20 (25 mins) ATV for ITV

Shapes and Sounds: Design in a Great Liner
4 December 1960, 17:20 (25 mins) ATV for ITV
'Yesterday, the SS Oriana sailed on her maiden voyage ... Sir Kenneth Clark discusses with Sir Colin Anderson, Director of the Orient Line, the problems involved in designing a modern liner.'

Shapes and Sounds: The Sound of Words
18 December 1960, 17:40 (25 mins) ATV for ITV
'A discussion about the poet and poetry with Sir Kenneth Clark and John Betjeman.'

Landscape into Art: No 1: Backgrounds
29 May 1961, 22.30 (30 mins) ATV for ITV
'In his first talk of this series Sir Kenneth Clark discusses the birth of landscape painting as we know it today and shows that appreciation of nature for its own sake has not always been practised.'

Landscape into Art: No 2: Friendly Nature
5 June 1961, 22.30 (25 mins) ATV for ITV
'Sir Kenneth Clark looks at painters inspired by a vision of the Golden Age where nature is always harmonious and friendly.'

Landscape into Art: No 3: Unfriendly Nature
12 June 1961, 22.30 (25 mins) ATV for ITV
'Sir Kenneth Clark discusses painters who have depicted nature as being violent and hostile to man.'

Landscape into Art: No 4: The Natural Vision
19 June 1961, time? (25 mins) ATV for ITV
'Sir Kenneth Clark discusses landscape painters who have portrayed nature in a realistic and unprejudiced manner.'

Landscape into Art: No 5: The Two Paths
26 June 1961, time? (25 mins) ATV for ITV

'Sir Kenneth Clark discusses the two major directions taken by landscape painters of the 19th century.'

Leonardo da Vinci's 'The Virgin and St. Anne'
29 April 1962, 14:35 (20 mins) ATV for ITV
'The full title of this world-famous cartoon – or preparatory drawing for an oil painting – is "The Virgin and Child with St. John the Baptist and St. Anne". It was drawn by Leonardo in about the year 1500 ... Since the Royal Academy announced its intention of selling it ... a campaign has been launched to keep it in the country'.

Rembrandt: No. 1: Success Story 1625–1642
21 May 1962, 22:40 (30 mins) ATV for ITV

Out of Burning: The Rebirth of Coventry Cathedral
23 May 1962, 21:45 (60 mins) ATV for ITV
'Ruined by enemy action on the night of November 14th–15th, 1940. Now rebuilt, and to be consecrated on Friday, May 25th, 1962. An artistic appraisal by Sir Kenneth Clark'.

Rembrandt: No. 2: Life and Art 1642–1656
28 May 1962, 22:40 (30 mins) ATV for ITV

Rembrandt: No. 3: Beyond Art 1656–1669
4 June 1962, 22:40 (30 mins) ATV for ITV

Michelangelo: No 1: The Artist as Hero
16 April 1963, 22:45 (30 mins) ATV for ITV

Michelangelo: No 2: The Summit of Achievement
30 April 1963, 22:45 (30 mins) ATV for ITV

Michelangelo: No 3: Lord, What Is Man?
14 May 1963, 22:45 (30 mins) ATV for ITV

Discovering Japanese Art: The Shadow of China
2 December 1963, 22:32 (30 mins) ATV for ITV

Discovering Japanese Art: Friendly Nature
9 December 1963, 22:40 (30 mins) ATV for ITV

Discovering Japanese Art: Ritual Simplicity Crude Vitality
16 December 1963, 22:40 (30 mins) ATV for ITV

Great Temples of the World: No 1: San Marco, Venice
16 December 1964, 21:40 (45 mins) ATV for ITV

Rediscovering the Image: Paul Gaugin
1 February 1965, 23:00 (32 mins) ATV for ITV

Rediscovering the Image: Henri Rousseau
8 February 1965, 23:00 (32 mins) ATV for ITV

Rediscovering the Image: Edvard Munch
15 Feb 1965, 23:02 (30 mins) ATV for ITV

Great Temples of the World: Chartres Cathedral
15 December 1965, 21:48 (52 mins) ATV for ITV
'In another of the special programmes in which he interprets past cultures and civilisations by "reading" their most significant buildings like books Sir Kenneth Clark takes us tonight to France to explore the setting, the history and the artistic treasures of Chartres Cathedral.'

Three Faces of France
18 April 1966, 23:10 (30 mins) ATV for ITV
'Sir Kenneth Clark talks about three 19th century painters – Courbet, Manet and Degas – from a particular point of view, as interpreters of French life. Between them they cover French Society during the 50 years where France was the centre of the civilised world. But they represented three very different aspects of that society'.

Three Faces of France: Manet
25 April 1966, 23:00 (30 mins) ATV for ITV

Three Faces of France: Degas
1 (or 2) May 1966, 23:00 (30 mins) ATV for ITV

Great Temples of the World: Karnak
3 August 1966, 21:40 (45 mins) ATV for ITV

The Royal Palaces of Britain
12.10/14.00, 25 December 1966, BBC and ITV
60 mins
'Sir Kenneth Clark conducts a tour of Windsor Castle, Buckingham Palace and Holyrood house.'

Civilisation – A Personal View: The Skin of Our Teeth
23 February 1969, 20.15 (50 mins) BBC2

Late Night Line-Up
28 February 1969, 23.40 (24 mins)
'Joan Bakewell interviews writer and historian Sir Kenneth Clark at his home in Saltwood Castle, Kent'. (*Radio Times*)

Civilisation – A Personal View: The Great Thaw
2 March 1969, 20.15 (48 mins) BBC2

Civilisation – A Personal View: Romance and Reality
9 March 1969, 20.15 (50 mins) BBC2

Civilisation – A Personal View: Man: The Measure of All Things
16 March 1969, 20.15 (49 mins) BBC2

Civilisation – A Personal View: The Hero as Artist
23 March 1969, 20.15 (49 mins) BBC2

Civilisation – A Personal View: Protest and Communication
30 March 1969, 20.15 (50 mins) BBC2

Civilisation – A Personal View: Grandeur and Obedience
6 April 1969, 20.15 (49 mins) BBC2
Civilisation - A Personal View: The Light of Experience
13 April 1969, 20.15 (49 mins) BBC2

Civilisation - A Personal View: The Pursuit of Happiness
20 April 1969, 20.15 (50 mins) BBC2

Civilisation - A Personal View: The Smile of Reason
27 April 1969, 20.15 (49 mins) BBC2

Civilisation - A Personal View: Man: The Worship of Nature
4 May 1969, 20.15 (50 mins) BBC2

Civilisation - A Personal View: Man: The Fallacies of Hope
11 May 1969, 20.15 (48 mins) BBC2

Civilisation - A Personal View: Man: Heroic Materialism
18 May 1969, 20.15 (51 mins) BBC2

Bernard Berenson
13 March 1971, 20.00 (53 mins) BBC2
'A profile by Kenneth Clark of Bernard Berenson, one of the most influential art critics & art historians of his time. For several decades his word on who painted what amongst the Italian painters of the Renaissance dominated the art market. Kenneth Clark talks about Bernard

Berenson, whom he knew, and talks to other people who knew him including Iris Origo, Alda Anrep, Hanna Kiel'. (*Radio Times*)

Pioneers of Modern Painting: Edouard Manet
13 November 1971, 22.40 (30 mins) ITC/ATV for ITV

Pioneers of Modern Painting: Paul Cezanne
20 November 1971, 22.40 (30 mins) ITC/ATV for ITV

Pioneers of Modern Painting: Claude Monet
27 November 1971, 22.40 (30 mins) ITC/ATV for ITV

Pioneers of Modern Painting: Georges Seurat
4 December 1971, 22.40 (30 mins) ITC/ATV for ITV

Pioneers of Modern Painting: Henri Rousseau
11 December 1971, 22.40 (30 mins) ITC/ATV for ITV

Pioneers of Modern Painting: Edvard Munch
18 December 1971, 22.40 (30 mins) ITC/ATV for ITV

Romantic versus Classic Art
16 April 1973 and following weeks, 22:30 (30 mins) Visual Programmes System Ltd for ATV
Thirteen-part series: Rodin, David, Delacroix, Goya, Piranesi, Millet, Blake, Constable, Turner (two programmes), Degas, Ingres (two programmes).

Aquarius: Kenneth Clark on the Mona Lisa
23 September 1973, 17:20 (45 mins) LWT for ITV

An Edwardian Childhood: Lord Kenneth Clark
24 September 1975, 20.30 (27 mins), Visual Programmes System Ltd for BBC
'Lord Clark looks back on his childhood in the early 1900s talking about the leisurely life of the aristocracy into which he was born. House parties, shooting, yachting and gambling, and the family's houses in Suffolk, London, Scotland and the Riviera.' (*Radio Times*)

Rembrandt 1: The Self Portraits
29 June 1976, 19.40 (28 mins), Ashwood Educational Productions for BBC.

Rembrandt 2: The Rebel
6 July 1976, 19.40 (28 mins), Ashwood Educational Productions for BBC.

Rembrandt 3: The Success
13 July 1976, 19.40 (28 mins), Ashwood Educational Productions for BBC

Rembrandt 4: The Withdrawal
20 July 1976, 19.40 (28 mins), Ashwood Educational Productions for BBC

Rembrandt 5: The Bible
27 July 1976, 19.40 (28 mins), Ashwood Educational Productions for BBC.

Carved in Ivory
1976 (24 mins), produced by the Arts Council of Great Britain

The Lively Arts: Animals and Men
18 September 1977, 21.05 (45 mins), BBC2
'Kenneth Clark examines the changing relations between animals and men. He traces the different roles in which man has cast himself from worshipper to destroyer to guardian of animals'. (*Radio Times*)

The Lively Arts: Nolan at Sixty
11 December 1977, 21.00 (53 mins), BBC2
A documentary portrait narrated by Kenneth Clark.

Poverty and Oysters
17 August 1979, 22.30, BBC
'Profile of Charles Ricketts, engraver, painter, designer, book collector, critic, costume designer and sculptor, who was also a patron and friend of the most distinguished writers and artists in London in the early twentieth century'. (*Radio Times*)

List of Exhibited Works

Note: Information in this listing was correct at the time of going to press. Measurements are in centimetres (height before width). A figure or plate reference is included where an image of the work is reproduced in this volume

ROOM 1: FROM CHILDHOOD TO THE 'GREAT CLARK BOOM'

1. Graham Sutherland (1903–80)
Study for Portrait of Lord Clark 1963
Pencil on paper
20.3 × 12.7
Private Collection

2. Graham Sutherland (1903–80)
Kenneth Clark, Baron Clark 1963–4 (page 6)
Oil on canvas
54.6 × 45.7
National Portrait Gallery, London

3. Edwin Landseer (1802–73)
The Otter c.1842 (fig.3)
Oil on canvas
45.5 × 60.5
Private Collection

4. William Quiller Orchardson (1832–1910)
Venetian Lagoon 1870s (fig.17)
Oil on canvas
62 × 104
Private Collection

5. John Lavery (1856–1941)
Portrait of Kenneth Clark as a Young Boy c.1910
Oil on canvas
172.7 × 88.9
Private Collection

6. Charles Sims (1873–1928)
Portrait of Lord Clark as a Young Boy c.1911 (fig.4)
Oil on canvas
91.4 × 71
Private Collection

7. Charles Keene (1823–91)
Collection of eighty-six drawings in a book, late 19th century (pl.9)
50 × 35 × 2.5
Private Collection

8. Aubrey Beardsley (1872–98)
The Fat Woman 1894
Ink on paper
17.8 × 16.2
Tate: Presented by Colonel James Lister Melvill at the request of his brother, Harry Edward Melvill 1931

9. School of Kanō Toun Masunobu (1625–94)
Winter Landscape 17th century (pl.2)
Six-fold screen, ink and gold on paper
170 × 365
Victoria and Albert Museum, London

10. Utagawa Hiroshige (1797–1858)
Pilgrims Visiting the Shrine of Benten at Enoshima in Sagami Province c.1850 (pl.50)
Woodblock print triptych
55.9 × 91.4
Private Collection

11. Katsushika Hokusai (1760–1849)
A Journey to the Waterfalls in All the Provinces: Aoigaoka Waterfall in Edo c.1832
Woodblock print
57 × 41
Private Collection

12. Kitagawa Utamaro (1753–1806)
Hour of the Cock, Servant from a Samurai Mansion 1798–1804 (fig.5)
Woodblock print
37 × 24.7
Victoria and Albert Museum, London

13. Kitagawa Utamaro (1753–1806)
Kitchen Scene c.1794–5

Diptych of polychrome wood-block prints; ink and colour on paper
37 × 25
Lent by The Metropolitan Museum of Art, Rogers Fund, 1922 (JP1369a, b)

14. *Bombola decorated with figs, lemons, vine, persimmons and apples*
Faenza or Venice c.1530
Tin-glazed earthenware (maiolica)
32 × 32 × 32
Private Collection

15. *Plate*
Castel Durante c.1540–50
Tin-glazed earthenware (maiolica)
25.5 × 25.5 × 5
Private Collection

16. Giovanni Bellini (c.1430–1516)
The Virgin and Child c. 1470
Tempera and gilding on panel
33.5 × 27.2
The Ashmolean Museum, Oxford. Accepted by HM Government in lieu of Inheritance Tax from the estate of Lord Clark of Saltwood and allocated to the Ashmolean Museum, 1987.

17. Venetian School
A Pagan Rite c.1500
Oil on panel
33 × 63.5
Private Collection

18. Leonardo da Vinci (1452–1519)
A Nude Man from the Front c.1504–6 (fig.9)
Red chalk and pen and ink on pale red prepared paper
23.7 × 14.6
The Royal Collection/HM Queen Elizabeth II

19. After Leonardo da Vinci (1452–1519)
A Standing Male Nude c.1504–6 (fig.10)

Black and red chalk with touches of pen and ink on pale red prepared paper
25.8 × 15.3
The Royal Collection/HM Queen Elizabeth II

20. Leonardo da Vinci (1452–1519)
A Deluge c.1517–8 (fig.11)
Black chalk on paper
16.3 × 21
The Royal Collection/HM Queen Elizabeth II

21. Attributed to Benozzo Gozzoli (1421–97)
Virgin and Child with Angels 1447–50
Egg tempera on wood
29.2 × 21.6 cm
The National Gallery, London

22. Paolo de San Leocadio (1447–1520)
Virgin and Child with Saints c.1495
Oil on oak
43.5 × 23.3 cm
The National Gallery, London

23. Follower of Filippino Lippi (1457–1504)
Moses brings forth Water out of the Rock c.1500
Oil and egg on canvas, transferred from wood
78.1 × 137.8 cm
The National Gallery, London

24. Andrea Previtali c.1480–1528
Scenes from Tebaldeo's Eclogues 1505 (fig.12)
Tempera with oil glazes on wood
45.2 × 20
The National Gallery, London

25. John Constable (1776–1837)
Sketch for 'Hadleigh Castle' c.1828–9 (fig.13)
Oil on canvas
122.6 × 167.3
Tate: Purchased 1935

26. **Samuel Palmer (1805–81)**
A Cornfield by Moonlight with the Evening Star c.1830 (pl.37)
watercolour with bodycolour and pen and ink
19.7 × 29.8
On loan from The British Museum PD 1985,0504.1

27. **Duncan Grant (1885–1978)**
Study for a Portrait of Lady Clark c.1932
Pencil on paper
61 × 53
Private Collection

28. **Hugh Cecil (1892–1974)**
Four portraits of Lady Clark c.1930–5
Photograph, gelatin silver print on paper
Each 34.5 × 24.5
Private Collection

29. **Man Ray (1890–1976)**
Solarised Portrait of Lady Clark c.1933 (fig.23)
Photograph, gelatin silver print on paper
23.5 × 18
Private Collection

ROOM 2: COLLECTOR

30. *The Martyrdom of St. Agatha* c.1300–50
Historiated initial on vellum
23.5 × 18.3
Richard Deutsch

31. *David lamenting the death of Saul (2 Samuel 1:17–27)* Tuscany c.1400
Historiated initial on vellum
24.4 × 17.8
Richard Deutsch

32. *Saint George* Venice late 14th/early 15th century
Egg tempera and gold leaf on wood
40.5 × 32
Private Collection

33. **Master of the Fiesole Epiphany (15th century)**
Head of an angel late 15th century
Oil on wood
29 × 20.5
Private Collection

34. **Francesco Bertos (1678–1741)**
Summer early 18th century
Bronze with marble base
42.5 × 18 × 15

35. **Francesco Bertos (1678–1741)**
Spring early 18th century
Bronze with marble base
40 × 15 × 15

36. Bow Factory
Pair of white busts of Mongolians c.1750 (pl.43)
Porcelain ware
male: 25.5 × 10.7 × 8.4
female: 28.5 × 12.5 × 9.5
Pallant House Gallery, Chichester

37. **Attributed to Charles Catton (1728–98)**
Duke of Cumberland c.1747
Pencil and gouache on paper
35.5 × 25.6
Private Collection

38. **Attributed to Charles Catton (1728–98)**
Three Mariners c.1747
Pencil and gouache on paper
25.6 × 35.5
Private Collection

39. **Attributed to Charles Catton (1728–98)**
Black Boy and Hat c.1747
Pencil and gouache on paper
35.5 × 25.6
Private Collection

40. **Attributed to Charles Catton (1728–98)**
Three Jolly Butchers c.1747
Pencil and gouache on paper
25.6 × 35.5
Private Collection

41. **Paul Cézanne (1839–1906)**
The Back of a Chair 1879–82 (fig.8)
Watercolour, wash and crayon on paper
17.5 × 11.5
Private Collection

42. **Paul Cézanne (1839–1906)**
Apple Tree 1885–7
Graphite on paper
31.4 × 47.8
The Samuel Courtauld Trust, The Courtauld Gallery, London

43. **Paul Cézanne (1839–1906)**
The Young Paul Asleep 1878–80 (pl.18)
Pencil on paper
35.6 × 49.2
Private Collection

44. **Paul Cézanne (1839–1906)**
Portrait of Cézanne's son asleep c.1880
Pencil on paper
16 × 23.5
Private Collection

45. **Paul Cézanne (1839–1906)**
The Entombment, after the painting by Delacroix in Saint-Denis du Saint Sacrement, Paris c.1866–72
Pencil on paper
16 × 24
On loan from The British Museum PD 1980,0726.12

46. **Paul Cézanne (1839–1906)**
View of a house through bare trees c.1885–7
Pencil on paper
34.6 × 52.3
On loan from The British Museum PD 1952,0405.11

47. **Paul Cézanne (1839–1906)**
Still Life: 'Pain Sans Mie' (pl.46) c.1887–90
Pencil on paper
31.8 × 49.2
Private Collection

48. **Paul Cézanne (1839–1906)**
Bathers (Esquisse de baigneurs)
c.1900–2 (pl.31)
Oil on canvas
20.5 × 33.4
Private Collection

49. **Paul Cézanne (1839–1906)**
Turning Road (Route Tournante) c.1905
Oil on canvas
73 × 92
The Samuel Courtauld Trust, The Courtauld Gallery, London

50. **Edgar Degas (1834–1917)**
Dancer looking at the sole of her foot 1900, cast 1928
Bronze
47 × 23.5 × 17
Private Collection

51. **Edgar Degas (1834–1917)**
Two Heads of Men, after Giovanni Cariani (formerly attributed to Gentile Bellini) c.1854 (pl.45)
Oil on canvas
40 × 60 mm
Private Collection

52. **Edgar Degas (1834–1917)**
Two Horses, From Behind undated
Pencil on paper
24.5 × 17 mm
Private Collection

53. **Eugène Delacroix (1798–1863)**
Study of a Lionness undated
Brown pen and ink on paper
13 × 18.5 mm
Private Collection

54. **Follower of Adam Elsheimer (1578–1610)**
Tobias and the Angel after 1613 (pl.44)
Oil on panel
9.5 × 12.5
Private Collection

55. **Thomas Gainsborough (1727–88)**
A Peasant Family Going to Market 1771–4 (pl.41)
Chalk and wash on paper
41.4 × 53.8

Gainsborough's House, Sudbury, Suffolk

56. Giambologna (1577–1640)
Two reclining female figures
c.1560–70 (pl.7)
Bronze
25 × 34 × 15
Private Collection

57. Attributed to Giorgio Barbarelli da Castelfranco, known as 'Giorgione' (c.1477–1510)
A Winged Putto Gathering Fruit
c.1500 (pl.21)
Fresco fragment, transferred to linen
144 × 81 × 11
Private Collection

58. Giovanni Martini da Udine (1470/5 –1535)
Trompe l'Oeil with Two Quails and a Lute c.1515–20 (pl.5)
Ink and watercolour with collage on paper
43 × 32
Private Collection

59. Michel Larionov (1881–1964)
Design for Reynard 1922
Gouache and ink on card
26.5 × 37.5
Private Collection

60. Attributed to Bernardino Luini (c.1480–1532)
Madonna and Child c.1500
Pen and ink on paper
22.3 × 22.3
Private Collection

61. William MacQuitty (1905–2004)
Portrait of Kenneth Clark (1944)
Photograph
22.5 × 16.5
Private Collection

62. Aristide Maillol (1861–1944)
Bust of Renoir 1907
Terracotta
40 × 16 × 18.5
Private Collection

63. Follower of Michelangelo Buonarroti (1475–1564)
Sheet of figure studies, with the Madonna and Child 16th century (pl.17)
Black chalk on paper
21 × 26.5
Private Collection

64. Antonio Pisanello (1395–1455)
Portrait medal of Filippo Maria Visconti, duke of Milan 1440
Lead
10 × 10.5
Private Collection

65. Rembrandt van Rijn (1606–69)
The Three Crosses 1653
Etching on paper
39 × 45
Private Collection

66. Auguste Renoir (1841–1919)
Study for Acrobats at the Cirque Fernando c.1879
Pencil and crayon on paper
51.5 × 41.5 × 4
Private Collection

67. Auguste Renoir (1841–1919)
Mother and Child (Mère et enfant) c.1916, cast 1927 (fig.16)
Bronze
53.3 × 23.5 × 31.8
Tate: Presented by Sir Thomas D. Barlow 1929

68. Joshua Reynolds (1723–92)
Portrait of Marie Countess of Schaumburg-Lippe c.1759
Oil on canvas
49 × 40 mm
Private Collection

69. Lucca della Robbia (1399/1400–1482)
Christ Before Pilate 15th century (pl.32)
White-glazed maiolica with blue pigment
33 × 58 mm
Private Collection

70. Auguste Rodin (1840–1917)
Eve 1881 (pl.15)
Bronze, cast by Alexis Rudier
76 × 23 × 29
Private Collection

71. Circle of Jacopo Carucci, known as Pontormo (1494–1557)
Madonna and Child c.1520 (pl.19)
Oil on panel
73.5 × 53.5
Cartwright Hall Art Gallery, Bradford

72. Thomas Rowlandson (1756–1827)
The Midday Rest 1784–91
Pen, ink and watercolour on paper
38 × 26
Private Collection

73. John Ruskin (1819–1900)
Study of a Window Near Madonna dell'Orto, Venice c.1849 (fig.7)
Ink and watercolour on paper
33.7 × 25.4
Private Collection

74. Georges Seurat (1859–91)
The Forest at Pontaubert 1881 (pl.47)
Oil on canvas
79 × 62.5
Lent by The Metropolitan Museum of Art, Purchase, Gift of Raymonde Paul, in memory of her brother C. Michael Paul, by exchange, 1985 (1985.237)

75. Georges Seurat (1859–91)
Le Bec du Hoc, Grandcamp 1885
Oil on canvas
64.8 × 81.6
Tate: Purchased 1952

76. Circle of Alessandro Turchi 1578–1649
The Madonna and Child with St John the Baptist and a Guardian Angel 17th century
Oil on amethestine quartz
27 × 37 mm
Private Collection

77. John Wootton (?1682–1764)
A Landscape c.1700s
Oil on canvas
94 × 121.3
Private Collection

78. Plate depicting the goddess Diana Italy c.1550
Tin-glazed earthenware (maiolica)
27.5 × 26.5
Private Collection

79. Lustred dish with 'peacock's feather eye' decoration
Deruta 1520–40 (fig.16)
Tin-glazed earthenware (maiolica)
40 × 40
Private Collection

80. Table Fountain Group: Orpheus playing his lyre
Urbino 1561 (pl.26)
Tin-glazed earthenware (maiolica)
48 × 44 × 34
Private Collection

81. Venus and Cupid Venice c.1600 (pl.29)
Bronze
22.5 × 6 × 6
Private Collection

82. An allegory of vigilence
France c.1600 (pl.29)
Ivory
17 × 6 × 5
Private Collection

83. Triumph of Death
Italy c.1420–50
Ivory relief
23 × 34 × 2
Private Collection

84. Pair of blue and white albarelli
Venice c.1520–40 (fig.18)
Tin-glazed earthenware (maiolica)
33.5 × 23.5 × 23.5
Private Collection

85. Charity
Italy c.17th century (pl.29)

Gilt bronze
33 × 15 × 10
Private Collection

86. *North Italian roundel of Tomyris on a horse cutting off the head of Cyrus* c.1500
Bronze
18 × 18 × 2
Private Collection

87. *North Italian roundel with a king crowning his queen* c.1500
Bronze
18 × 18 × 2
Private Collection

88. *Christ and the Apostles, and a miracle (perhaps The Feeding of the Five Thousand)* late 13th century
Historiated initial in a decorative setting
11.4 × 7.6
Private Collection

89. *Augsburg silver gilt and enamel casket* 17th and 18th century (pl.30)
Set with agate intaglios and mother of pearl cameo portraits
9 × 12 × 8
Private Collection

90. *Pair of Coptic textile roundels* 3rd/5th century AD
Textile
59.5 × 47.5
53 × 47
Private Collection

91. *Portrait head of a Roman Empress: probably Agrippina the Elder* 1st Century AD (pl.40)
Greywacke (Greenschist)
54 × 23 × 26
Private Collection

92. *Hadrianic Panel of Two Masks* c.125 AD (pl.49)
Marble
31 × 48 × 10
Private Collection

ROOM 3: PATRON

93. **Vanessa Bell (1879–1961)**
Design for a plate: Queen Christina of Sweden 1932
Pencil and watercolour on paper
25.5 × 25.5 × 2
Victoria and Albert Museum, London

94. **Vanessa Bell (1879–1961)**
Mme la Marquise de Caux, Adelina Patti 1932
Plate from 'Famous Ladies' set
Ceramic
25.5 × 25.5 × 2
The Charleston Trust

95. **Vanessa Bell (1879–1961)**
S.A.I. La Princess Mathilda 1932
Plate from 'Famous Ladies' set
Ceramic
25.5 × 25.5 × 2
The Charleston Trust

96. **Vanessa Bell (1879–1961)**
Queen Mary 1932
Plate from 'Famous Ladies' set
Ceramic
25.5 × 25.5 × 2
The Charleston Trust

97. **Duncan Grant (1885–1978)**
Design for Plate: Virginia Woolf c.1932
Pencil, ink, wash on paper
42.7 × 39
Private Collection

98. **Duncan Grant (1885–1978)**
Design for Plate: Sarah Churchill c.1932 (fig.24)
Ink and wash on paper
43 × 39
Private Collection

99. **Duncan Grant (1885–1978)**
Unidentified subject
Plate from 'Famous Ladies' set
Ceramic
25.5 × 25.5 × 2
The Charleston Trust

100. **Duncan Grant (1885–1978)**
Four designs for plates: Sarah Bernhardt, Eleanora Duse, Greta Garbo and Mrs Patrick Campbell c.1932
Pencil, ink and wash on paper
58 × 56.5
Private Collection

101. **Duncan Grant (1885–1978)**
Rug c.1932
Wool
180 × 127
Private Collection

102. **Duncan Grant (1885–1978)**
Three-Fold Screen c.1930
Painted wood
133 × 190 × 2 (each: 61 cm wide)
Private Collection

103. **Duncan Grant (1885–1978)**
Wedgwood creamware jug incorporating portraits of Kenneth and Jane Clark 1932
Ceramic
27 × 24.5 × 20
Private Collection

104. **Duncan Grant (1885–1978)**
Wedgwood creamware jug incorporating a childhood portrait of Alan Clark 1932
Ceramic
22 × 20.5 × 16
Private Collection

105. **Marion Dorn (1896–1964)**
Study of Four Shells c.1930
Gouache on paper
44.5 × 58.4
Private Collection

106. **Marion Dorn (1896–1964)**
Fire Screen Depicting Four Shells c.1930
Embroidered textile
84 × 67.5 × 25
Private Collection

107. **Bernard Leach (1887–1979)**
Fish tile c.1930
Ceramic
22.5 × 22.5 × 2
Potteries Museum and Art Gallery, Stoke-on-Trent

108. **Duncan Grant (1885–1978)**
Self-Portrait 1925 (pl.8)

Oil on canvas
46 × 38
Private Collection

109. **Duncan Grant (1885–1978)**
After Zurbarán c.1928 (fig.32)
Oil on canvas
62 × 15.3
Private Collection

110. **Vanessa Bell (1879–1961)**
Portrait of Angelica as a Russian Princess (pl.35)
Oil on canvas
59 × 39
Private Collection

111. **Vanessa Bell (1879–1961)**
Self Portrait c.1958
Oil on canvas
48.3 × 39.4 × 2
The Charleston Trust

112. **Pavel Tchelitchew (1898–1957)**
Apple Tree 1931 (pl.33)
Oil on canvas
78 × 100
Private Collection

113. **Ben Nicholson (1894–1982)**
1934 (white relief – AS) 1934 (fig.20)
Painted wood relief
70.5 × 47.5 × 3
Annely Juda Fine Art, London / Mitchell Innes & Nash, New York

114. **William Coldstream (1908–87)**
Mrs Auden 1936–7
Oil on canvas
74 × 55
Potteries Museum and Art Gallery, Stoke-on-Trent

115. **William Coldstream (1908–87)**
On the Map 1937 (fig.26)
Oil on canvas
50.8 × 50.8
Tate: Purchased 1980

116. **Graham Bell (1910–43)**
Suffolk Landscape with Train 1937 (fig.27)

Oil on canvas
71 × 91.5
Private Collection

117. Graham Bell (1910–43)
Mont St Victoire
Oil on canvas
63.5 × 80
Private Collection

118. Graham Bell (1910–43)
Imogen c.1938
Oil on canvas
45.7 × 35.6
Derby Museums

119. Graham Bell (1910–43)
Brunswick Square, London 1940
(fig.27)
Oil on canvas
34.7 × 39.8
Museums Sheffield

120. Victor Pasmore (1908–98)
The Red Tablecloth 1936 (fig.28)
Oil on canvas
60.5 × 73
Private Collection

121. Victor Pasmore (1908–98)
The Striped Dress 1939
Oil on canvas
50.8 × 61
Private Collection

122. Victor Pasmore (1908–98)
Head of a Girl 1940
Oil on canvas
40.7 × 30.5
Derby Museums

123. Victor Pasmore (1908–98)
Nude 1941
Oil on canvas
61 × 50.8
Tate: Presented by Sir Kenneth
Clark (later Lord Clark of
Saltwood) 1957

124. Victor Pasmore (1908–98)
The Wounded Bird 1944 (pl.3)
Oil on canvas
51 × 76
Private Collection

125. Victor Pasmore (1908–98)
Evening Star 1945–1947
Oil on canvas
76 × 101.5
Private Collection

126. Victor Pasmore (1908–98)
The Studio of Ingres 1947
Oil on canvas
76.5 × 101.5
Private Collection

127. Stanley Spencer (1891–1959)
White Lilacs 1932
Oil on canvas
45.7 × 35.6
Private Collection

128. Edward Ardizzone (1900–79)
The Tart c.1940
Watercolour on paper
40.5 × 45
Private Collection

129. Barnett Freedman (1901–58)
Fourteen drawings for Jane Eyre
c.1940
Ink and watercolour on paper
56 × 100 × 4
Private Collection

130. Eric Gill (1882–1940)
Divine Lovers 1923
Pewter
11 × 7.5 × 3
Private Collection

131. David Jones (1895–1974)
Petra im Rosenhag 1931 (pl.13)
Watercolour, gouache and pencil
on paper
100 × 77.5
Amgueddfa Cymru – National
Museum of Wales

132. David Jones (1895–1974)
Flowers in a Chalice 1955
Watercolour, gouache and pencil
on paper
56 × 70
Private Collection

133. Frances Hodgkins (1869–1947)
Church and Castle, Corfe 1942
Gouache on paper

66.5 × 78
Ferens Art Gallery, Hull
Museums

134. Paul Nash (1889–1946)
Image of the Stag 1938
Watercolour on paper
29.2 × 39.4
Private Collection

**135. Graham Sutherland
(1903–80)**
Pastoral 1930
Etching on paper
13 × 19
Tate: Purchased 1970

**136. Graham Sutherland
(1903–80)**
Pembrokeshire Landscape 1935
Mixed media on paper
55 × 72.7 × 2
Amgueddfa Cymru – National
Museum of Wales

137. Henry Moore (1898–1986)
Head 1930
Ironstone
7 × 7 × 3
Private Collection

Room 4: New romantics

138. Henry Moore (1898–1986)
Standing Female Nude c.1923
(pl.25)
Pen and black ink, black wash
and coloured chalks on buff
paper
42.3 × 25.2
On loan from The British
Museum PD 1988,0305.1

139. Henry Moore (1898–1986)
Mask 1929
Lead
15 × 19 × 12
Private Collection

140. Henry Moore (1898–1986)
*Drawing 1936: Two Studies of a
Sarcophagus* 1936
Pen and black ink, black chalk
and grey wash on paper

35.8 × 44.7
On loan from The British
Museum PD 1988,0305.4

141. Henry Moore (1898–1986)
Recumbent Figure 1938 (fig.30)
Green Hornton stone
88.9 × 132.7 × 73.7, 520 kg
Tate: Presented by the
Contemporary Art Society 1939

142. Henry Moore (1898–1986)
Reclining Figure 1938
Pencil, charcoal, chalk, pen
and ink on paper
38 × 56
Private Collection

143. Henry Moore (1898–1986)
*Heads: Drawings for Metal
Sculpture* 1939
Coloured chalks and grey wash
on paper
21.3 × 25.5
On loan from The British
Museum PD 1988,0305.6

144. Henry Moore (1898–1986)
Reclining Figure 1939 (fig.22)
Lead
18 × 29.5 × 10.5
Private Collection

145. Henry Moore (1898–1986)
*Ideas for metal sculpture: studies
for reclining figures; abstract
forms* 1939 (fig.21)
Coloured chalks on paper
38 × 55.5
On loan from The British
Museum PD 1988,0305.4

146. Henry Moore (1898–1986)
Studies of Mothers and Children
1940
Pen and chalk on paper
17 × 26
Private Collection

147. John Piper (1903–92)
Ruined Cottage, Llanthony
1939–40
Oil on canvas
39.4 × 49.7
Birmingham Museum and Art
Gallery

148. John Piper (1903–92)
Seaton Delaval 1941
Oil on canvas on wood
71 × 88.3
Tate: Presented by Sir Kenneth
Clark (later Lord Clark of
Saltwood) through the
Contemporary Art Society 1946

149. John Piper (1903–92)
The Middle Ward, Windsor Castle
1941–2
Pencil, pen and ink, watercolour
and bodycolour
41.6 × 54.6
The Royal Collection/HM Queen
Elizabeth II

150. John Piper (1903–92)
*The Quadrangle from Engine
Court, Windsor Castle* 1941-2
Pencil, pen and ink, watercolour
and bodycolour
40 × 53.2
The Royal Collection/HM Queen
Elizabeth II

151. John Piper (1903–1992)
*The Round Tower from the roof of
St George's Chapel* 1941–2 (fig.31)
Pencil, pen and ink, watercolour
and bodycolour
37.4 × 51
The Royal Collection/HM Queen
Elizabeth II

152. John Piper (1903–92)
Gordale Scar 1943
Oil on canvas
76.2 × 61
Private Collection

153. John Piper (1903–92)
*Slopes of Glyder Fawr, Llyn Adwal,
Caernarvonshire, Wales* 1947
Pen, ink and watercolour on paper
55 × 70
The Whitworth Art Gallery,
The University of Manchester

**154. Graham Sutherland
(1903–80)**
Red Tree 1936
Oil on canvas
55.9 × 91.4
Private Collection

155. Graham Sutherland (1903–1980)
Landscape with Black Rock c.1938
Gouache
36 × 52
Private Collection

**156. Graham Sutherland
(1903–80)**
Sun Setting Between Two Hills
1938 (fig.29)
Watercolour on paper
26.5 × 36
Private Collection

**157. Graham Sutherland
(1903–80)**
Sheet of Four Studies 1939
Pen and watercolour on paper
29.8 × 22.4
Higgins Art Gallery and
Museum, Bedford

**158. Graham Sutherland
(1903–80)**
Roots of a Tree c.1939
Pencil, ink and gouache on
paper, squared for transfer
10.5 × 18.5

**159. Graham Sutherland
(1903–80)**
Rocky Landscape with Sullen Sky
1940
Watercolour and gouache on
paper
49.3 × 69.5
Harris Museum and Art Gallery,
Preston

**160. Graham Sutherland
(1903–80)**
Midsummer Landscape 1940
Gouache on paper
68 × 47
Birmingham Museum and Art
Gallery

161. Graham Sutherland (1903–1980)
Two designs for The Wanderer
1940
Watercolour on paper
Each 42 × 45
James L. Gordon Collection

**162. Graham Sutherland
(1903–1980)**
Sunset, Red Blobs with Grey
c.1938
Oil on canvas
33 × 24
Private Collection

163. Graham Sutherland (1903–1980)
*Four scenes with text from
Ecclesiastes* 1942
Watercolour on paper
45.5 × 34
Private Collection

**164. Graham Sutherland
(1903–1980)**
*Design for the cover of 'Landscape
into Art'* 1940 (pl.34)
Watercolour and ink on paper
41 × 34.5
Private Collection

ROOM 5: WARTIME

165. Louisa Puller (1884–1967)
Church Farm, Sudbourne 1942
Watercolour on paper
35 × 46.25
Victoria and Abert Museum,
given by the Pilgrim Trust

166. Louisa Puller (1884–1967)
Wedgwood Works, Etruria 1943
Watercolour and bodycolour
painting on paper
39 × 54
Victoria and Abert Museum,
given by the Pilgrim Trust

167. Olive Cook (1912–2002)
*The Yard of the Abbey Arms
Hotel, Festiniog, Merionethshire*
1940
Watercolour on paper
43.2 × 53.3
Victoria and Abert Museum,
given by the Pilgrim Trust

168. Clifford Ellis (1907–85)
3 Bathwick Hill, Bath 1943
Watercolour on paper
44 × 45.4

Victoria and Abert Museum,
given by the Pilgrim Trust

169. Thomas Hennell (1903–45)
Scythe Smithy, Weybridge 1941
Watercolour on paper
31.8 × 47.9
Victoria and Abert Museum,
given by the Pilgrim Trust

170. Barbara Jones (1912–78)
The Black Bear, Wareham, Dorset
1942
Watercolour with white
heightening on paper
55.2 × 37
Victoria and Abert Museum,
given by the Pilgrim Trust

171. Barbara Jones (1912–78)
*Doric Arch, Euston Station,
London NW1* 1943
Watercolour and body colour
on paper
55.2 × 36.8
Victoria and Abert Museum,
given by the Pilgrim Trust

172. John Piper (1903–92)
The Tithe Barn, Coxwell c.1940
Watercolour on paper
38 × 52
Victoria and Abert Museum,
given by the Pilgrim Trust

**173. Kenneth Rowntree
(1915–97)**
*The Bell Ringers' Chamber, SS
Peter & Paul Church, Clare,
Suffolk* c.1940 (fig.37)
Watercolour and body colour
on paper
30 × 47.5
Victoria and Abert Museum,
given by the Pilgrim Trust

174. Henry Moore (1898–86)
*Six seated figures wrapped in
blankets* 1940–1
Pen and black ink, graphite,
white wax crayon and
watercolour on paper
18.7 × 16.5
On loan from the British
Museum PD 1977,0402.13.61

175. Henry Moore (1898–86)
Three compositions 1940–1
Pen and black ink and graphite, with green and grey wax crayon and watercolour on paper
18.7 × 16.4
On loan from the British Museum PD 1977,0402.13.12

176. Henry Moore (1898–86)
Seated figure with hands in lap 1940–1
Pen and black ink and graphite, with pink, yellow and brown wax crayon and watercolour on paper, squared for transfer
18.8 × 16.6
On loan from the British Museum PD 1977,0402.13.44

177. Henry Moore (1898–86)
Two seated women, one holding a child 1940–1
Pen and black ink, wax crayons and watercolour on paper, squared for transfer
18.7 × 16.5
On loan from the British Museum PD 1977,0402.13.46

178. Henry Moore (1898–86)
Woman sleeping with child, bombed houses in the background 1940–1
Pen and black ink and graphite, with yellow wax crayon and watercolour on paper
18.8 × 16.6
On loan from the British Museum PD 1977,0402.13.65

179. Henry Moore (1898–86)
Sketches with barbed wire 1940–1
Pen and black ink, watercolour, wax crayons on paper
18.7 × 16.6
On loan from the British Museum PD 1977, 0402.13.15

180. Henry Moore (1898–86)
A Tilbury Shelter Scene 1941
Ink, watercolour, crayon and gouache on paper
41.9 × 38
Tate: Presented by the War Artist's Advisory Committee 1946

181. Henry Moore (1898–86)
Pink and Green Sleepers 1941 (fig.36)
Graphite, ink, gouache and wax on paper
38 × 55.9
Tate: Presented by the War Artist's Advisory Committee 1946

182. John Piper (1903–92)
Coventry Cathedral 1940
Oil on plywood
76.2 × 63.4
Manchester City Galleries. Presented by H.M. Government War Artist's Advisory Commitee, 1947

183. John Piper (1903–92)
St Mary le Port, Bristol 1940
Oil paint and graphite on canvas on wood
76.2 × 63.5
Tate: Presented by the War Artist's Advisory Committee 1946

184. John Piper (1903–92)
The Ruined Council Chamber, House of Commons, May 1941 1941
Oil on canvas
105.3 × 138
Palace of Westminster

185. Graham Sutherland (1903–80)
The City: A fallen lift shaft 1941
Gouache on paper
85.6 × 134.8
IWM (Imperial War Museums)

186. Graham Sutherland (1903–80)
Devastation 1941: City, Twisted Girders 1941
Gouache, charcoal and ink on paper
55.4 × 112.3
Ferens Art Gallery, Hull Museums

187. Graham Sutherland (1903–80)
Kenneth Clark's House in Gray's Inn Square, after Bombing c.1942
Gouache on paper
31 × 42
Private Collection

188. John Piper (1903–92)
All Saints Chapel, Bath 1942
Ink, chalk, gouache and watercolour on paper
42.5 × 55.9
Tate: Presented by the War Artist's Advisory Committee 1946

189. John Piper (1903–92)
Somerset Place, Bath 1942
Graphite, ink and gouache on paper
48.9 × 76.2
Tate: Presented by the War Artist's Advisory Committee 1946

190. Graham Sutherland (1903–80)
A Foundry: Hot Metal has been Poured into a Mould and Inflammable Gas is Rising 1941–2 (fig.35)
Crayon and gouache on paper
91.8 × 109.2
Tate: Presented by the War Artist's Advisory Committee 1946

191. Graham Sutherland (1903–80)
Slag-ladles 1942
Gouache on paper
51.4 × 37.7
IWM (Imperial War Museums)

192. Graham Sutherland (1903–80)
The Teeming-pit: Tapping a Steel-furnace 1942
Gouache on paper
49.5 × 38.3
IWM (Imperial War Museums)

193. Henry Moore (1898–86)
Miner at Work at the Coal Face 1942
Pencil, wax crayon, watercolour wash, pen and ink on paper
33.3 × 54.9
The Whitworth Art Gallery, The University of Manchester

194. Graham Sutherland (1903–80)
Miner Probing a Drill Hole 1942
Gouache, wax crayon and ink on paper on hardboard
56 × 51.2

Tate: Presented by the War Artist's Advisory Committee 1946

195. Graham Sutherland (1903–80)
Tin Mine: A Declivity 1942
Pen, chalk and watercolour on paper, mounted on board
47.5 × 94.5
Leeds Museums and Galleries (Leeds Art Gallery)

196. Graham Sutherland (1903–80)
Tin Mine: Emerging Miner 1942
Gouache on paper mounted on board
116.8 × 73
Leeds Museums and Galleries (Leeds Art Gallery)

197. Paul Nash (1889–46)
Bomber in the Corn 1940
Graphite and watercolour on paper
39.4 × 57.8
Tate: Presented by the War Artist's Advisory Committee 1946

198. Paul Nash (1889–46)
Battle of Britain 1941 (fig.39)
Oil on canvas
122.6 × 183.5
IWM (Imperial War Museums)

199. Edward Ardizzone (1900–79)
On a Fortified Island, the Night Watch 1941
Watercolour and ink on paper
27.3 × 34.9
Tate: Presented by the War Artist's Advisory Committee 1946

200. Edward Ardizzone (1900–79)
Soldiers Holding Up Rosaries to be Blessed at a Papal Audience 1944
Watercolour and ink on paper
18 × 18.7
Tate: Presented by the War Artist's Advisory Committee 1946

201. Barnett Freedman (1901–58)
Interior of a Submarine 1943
Ink and watercolour on paper
60 × 94
Tate: Presented by the War

Artist's Advisory Committee 1946

202. Edward Bawden (1903–89)
The Catholic Church, Addis Ababa 1941
Ink, watercolour and crayon on paper
45.7 × 57.8
Tate: Presented by the War Artist's Advisory Committee 1946

203. Edward Bawden (1903–89)
Cairo, the Citadel: Mohammed Ali Mosque c.1941
Graphite and watercolour on paper
47 × 59.7
Tate: Presented by the War Artist's Advisory Committee 1946

204. Thomas Hennell (1903–45)
Slipway, Reykjavik Harbour. August 12, 1943 1943
Watercolour on paper
47.9 × 63.5
Tate: Presented by the War Artist's Advisory Committee 1946

205. Eric Ravilious (1903–42)
Midnight Sun 1940
Watercolour and graphite on paper
47 × 59
Tate: Presented by the War Artist's Advisory Committee 1946

206. Eric Ravilious (1903–42)
Shelling by Night 1941
Graphite and watercolour on paper
44.5 × 54.6
Tate: Presented by the War Artist's Advisory Committee 1946

207. Albert Richards (1919–45)
The Landing: H Hour minus 6. In the Distance Glow of the Lancasters Bombing Battery to be Attacked 1944
Graphite, crayon, gouache, watercolour and wax on paper
54 × 73.7
Tate: Presented by the War Artist's Advisory Committee 1946

208. Mary Kessell (1914–77)
Notes from Belsen Camp 1945
Sanguine crayon on paper
10.7 × 15.2
IWM (Imperial War Museums)

209. Mary Kessell (1914–77)
Notes from Belsen Camp 1945
Sanguine crayon on paper
10.7 × 10.7
IWM (Imperial War Museums)

210. Mary Kessell (1914–77)
Waiting for the Train on the Anhalter Bahnhof, Berlin, December 1945 1945
Charcoal on paper
48.8 × 61.8
IWM (Imperial War Museums)

211. Mary Kessell (1914–77)
Refugees: '...pray ye that your fight be not in the winter...' Matt XXIV 20 1945 (fig.41)
Oil on canvas
50.8 × 70.9
IWM (Imperial War Museums)

212. Mary Kessell (1914–77)
The Exodus c.1953
Oil on panel
37 × 83
Private Collection

ROOM 6: TELEVISION

213. *Allegorical tapestry* Brussels, c.1530 (fig.49)
220 × 210

214. Circle of Giusto le Corte (1627–79)
Madonna and Child c.1660
Marble
98 × 76 × 36.5
Private Collection

215. Cecil Beaton (1904–80)
Kenneth Clark 1955
Bromide print
23.8 × 24
National Portrait Gallery, London

216. David Des Granges (1611 or 13–?75)
The Saltonstall Family c.1636–7 (pl.28)
Oil on canvas
214 × 276.2
Tate: Purchased with assistance from the Friends of the Tate Gallery, the Art Fund and the Pilgrim Trust 1976

217. Robin Ironside (1912–65)
Saltwood Castle c.1955 (fig.46)
Ink and watercolour on paper
22.9 × 13.3
Private Collection

218. Robin Ironside (1912–65)
Saltwood Window c.1955
Ink and watercolour on paper
16 × 17
Private Collection

219. Robin Ironside (1912–65)
Courtyard at Saltwood with family dogs beneath c.1955
Ink and watercolour on paper
27 × 27.5
Private Collection

220. Henry Moore (1898–86)
Madonna and Child 1943 (fig.19)
Terracotta
19 × 15 × 15
Daniel Katz Gallery, London

221. Henry Moore (1898–86)
Maquette for Family Group 1945
Bronze
17.8 × 10.2 × 6
Tate: Purchased 1945

222. Graham Sutherland (1903–80)
Thorn Tree 1945
Oil on canvas
66 × 51.2
Private Collection

223. John Craxton (1922–2009)
Dark Landscape 1943
Oil on card
37.5 × 55.2
Southampton City Art Gallery

224. Lucian Freud (1922–2011)
Balcony Still Life 1951 (pl.51)
Oil on copper
14.5 × 19.5
Private Collection

225. Sidney Nolan (1917–92)
Central Australia 1950 (pl.39)
Ripolin paint on board
121 × 90
University of York

226. Sidney Nolan (1917–92)
Convict and Billabong c.1960
PVA paint on board
121 × 151
University of York

227. Tang Dynasty
Lion 618-907 AD (pl.23)
Black stone
40 × 28 × 27.5
Private Collection

228. Paul Cézanne (1839–1906)
Le Chateau Noir c.1904
Oil on canvas
69.2 × 82.7
Private Collection

229. Henry Moore (1898–86)
Composition 1932 (pl.24)
Dark African wood
40.6 × 38 × 26.7
Private Collection c/o Thomas Gibson Fine Art Ltd.

230. Francisco Zurbarán (1598–1664)
A Cup of Water and a Rose c.1630 (pl.48)
Oil on canvas
21.2 × 30
National Gallery, London

Picture Credits

COPYRIGHT CREDITS

© BBC: figs 15, 52, 56

© Estate of Vanessa Bell, courtesy Henrietta Garnett: plate 27; figs 24, 25

© The estate of Sir William Coldstream. All Rights Reserved 2014 / Bridgeman Art Library: fig.26

Anthony Denney / Vogue © The Condé Nast Publications Ltd. Loelia, Duchess of Westminster / Vogue © The Condé Nast Publications Ltd: figs 48, 49

© Lucian Freud/ The Bridgeman Art Library: plate 51

© Estate of Duncan Grant. All rights reserved, DACS 2014: plate 8; figs 24, 25, 32

© Hulton-Deutsch Collection/ CORBIS: front cover

© ITV: figs 53, 54, 55

© Estate of Felix H. Man: figs 16, 17, 18

© Man Ray Trust/ADAGP, Paris and DACS, London 2014: fig.23

© Reproduced by permission of The Henry Moore Foundation: plates 16, 25, 26, 38; figs 19, 21, 22, 30, 36, 50, 55

© 1941 The Museum of Modern Art, New York: fig.38

Ben Nicholson © Angela Verren Taunt 2014. All rights reserved, DACS: fig.20

© Sidney Nolan/The Bridgeman Art Library: plate 39

© Estate of Victor Pasmore. All Rights Reserved, DACS 2014: plate 3; figs 28, 33

© The Piper Estate: plate 38; fig.31

© The Estate of Graham Sutherland: plate 34; fig.29

© Pavel Tchelitchew

© Two Cities Films: fig.51

PHOTOGRAPHIC CREDITS

akg-images: plate 10

Annely Juda Fine Art, London: fig.20

Ashmolean Museum, University of Oxford: plate 4; fig.47

BBC Photo Library: fig. 52

BBC Motion Gallery / Getty Images: figs 15, 56

Courtesy of the Cecil Beaton Studio Archive at Sotheby's: frontispiece

Copyright © 2014 Bonhams & Butterfields Auctioneers Corp. All Rights Reserved: plate 2

© Bradford Museums and Galleries: plate 19

Daniel Katz Gallery, London: fig.19

Anthony Denney / Vogue © The Condé Nast Publications Ltd: figs 48, 49

Sam Drake & Lucy Dawkins / Tate Photography: plates 24, 33; figs 3, 24, 29

Howard Grey: fig.25

© Imperial War Museums: figs 39, 41, 45

© ITV/REX: figs 53, 54, 55

Dave Lambert & Rod Tidnam / Tate Photography: plates 3, 32, 34; fig.32

Marcus Leith & Andrew Dunkley / Tate Photography: plates 5, 7, 9, 11, 12, 15, 17, 21, 23, 26, 27, 29, 30, 38, 40, 42, 44, 45, 49, 50; figs 4, 7, 8, 27, 28, 46

Private Collection / The Bridgeman Art Library: plate 1

Private Collection / Photo © Christie's Images / The Bridgeman Art Library: plate 41

Private Collection / Photo © Lefevre Fine Art Ltd., London / The Bridgeman Art Library: plate 31, back cover

Private Collection / © The Lucian Freud Archive / The Bridgeman Art Library: plate 51

© The Trustees of the British Museum: plates 16, 25, 37; fig.21

Felix H. Man: figs 16, 17, 18

© Manchester City Galleries: fig.35

© 2014 The Metropolitan Museum of Art / Art Resource / Scala, Florence: plate 47

William McQuitty: fig.51

© Museums Sheffield: plate 35

Nahmad Collection, Switzerland: plate 6

National Gallery, London: plate 48; figs 12, 14

© National Museum of Wales: plate 13

© National Portrait Gallery, London: Foreword

© Pallant House Gallery, Chichester, UK: plate 43

The Pierpont Morgan Library, New York: plate 20

Man Ray: fig.23

Royal Collection Trust /© Her Majesty Queen Elizabeth II 2014: figs 9, 10, 11, 31

Gerty Simon: fig.2

© Sotheby›s / akg-images: plate 8

© Tate Photography: plates 23, 28; figs 13, 30, 34, 36

Rod Tidnam / Tate photography: figs 37, 40, 43

University of York Art Collection: plate 39

© Victoria and Albert Museum, London: figs 5, 6, 38

Index

Supporting Tate

Tate relies on a large number of supporters – individuals, foundations, companies and public sector sources – to enable it to deliver its programme of activities, both on and off its gallery sites. This support is essential in order for Tate to acquire works of art for the Collection, run education, outreach and exhibition programmes, care for the Collection in storage and enable art to be displayed, both digitally and physically, inside and outside Tate. Your donation will make a real difference and enable others to enjoy Tate and its Collection both now and in the future. There are a variety of ways in which you can help support Tate and also benefit as a UK or US taxpayer. Please contact us at:

Development Office
Tate
Millbank
London SW1P 4RG

Tel: +44 (0)20 7887 4900
Fax: +44 (0)20 7887 8098

Tate Americas Foundation
520 West 27th Street, Unit 404
New York, NY 10001-5548
USA

Tel: (001) 212 643 2818
Fax: (001) 212 643 1001

Donations, no matter the size, are gratefully received, either to support particular areas of interest, or to contribute to general activity costs.

Gifts of Shares
We can accept gifts of quoted shares and securities. All gifts of shares to Tate are exempt from capital gains tax, and higher rate taxpayers enjoy additional tax efficiencies. For further information please contact the Development Office.

Gift Aid
Through Gift Aid you can increase the value of your donation to Tate as we are able to reclaim the tax on your gift. Gift Aid applies to gifts of any size, whether regular or a one-off gift. Higher rate taxpayers are also able to claim additional personal tax relief. Contact us for further information and to make a Gift Aid Declaration.

Legacies
A legacy to Tate may take the form of a residual share of an estate, a specific cash sum or item of property such as a work of art. Legacies to Tate are free of inheritance tax, and help to secure a strong future for the Collection and galleries. For further information please contact the Development Office.

Offers in Lieu of Tax
Inheritance Tax can be satisfied by transferring to the Government a work of art of outstanding importance. In this case the amount of tax is reduced, and it can be made a condition of the offer that the work of art is allocated to Tate. Please contact us for details.

Tate Members
Tate Members enjoy unlimited free admission throughout the year to all exhibitions at Tate, as well as a number of other benefits such as exclusive use of our Members' Rooms and a free annual subscription to *Tate Etc*. Whilst enjoying the exclusive privileges of membership, you are also helping secure Tate's position at the very heart of British and modern art. Your support actively contributes to new purchases of important art, ensuring that Tate's collection continues to be relevant and comprehensive, as well as funding projects in London, Liverpool and St Ives that increase access and understanding for everyone.

Tate Patrons
Tate Patrons share a passion for art and are committed to supporting Tate on an annual basis. The Patrons help enable the acquisition of works across Tate's broad collecting remit and also give their support to vital conservation, learning and research projects. The scheme provides a forum for Patrons to share their interest in art and meet curators, artists and one another in an enjoyable environment through a regular programme of events. These events take place both at Tate and beyond and encompass curator-led exhibition tours, visits to artists' studios and private collections, art trips both in the UK and abroad, and access to art fairs. The scheme welcomes supporters from outside the UK, giving the programme a truly international scope. For more information, please contact the Patrons Office on +44(0)20 7887 8740 or at patrons.office@tate.org.uk.

Corporate Membership
Corporate Membership at Tate Modern, Tate Britain and Tate Liverpool offers companies opportunities for corporate entertaining and the chance for a wide variety of employee benefits. These include special private views, special access to paying exhibitions, out-of-hours visits and tours, invitations to VIP events and talks at members' offices.

Corporate Investment
Tate has developed a range of imaginative partnerships with the corporate sector, ranging from international interpretation and exhibition programmes to local outreach and staff development programmes. We are particularly known for high-profile business-to-business marketing initiatives and employee benefit packages. Please contact the Corporate Fundraising team for further details.

Charity Details
The Tate Gallery is an exempt charity; the Museums & Galleries Act 1992 added the Tate Gallery to the list of exempt charities defined in the 1960 Charities Act. Tate Members is a registered charity (number 313021). Tate Foundation is a registered charity (number 1085314).

Tate Americas Foundation
Tate Americas Foundation is an independent charity based in New York that supports the work of Tate in the United Kingdom. It receives full tax exempt status from the IRS under section 501(c)(3) allowing United States taxpayers to receive tax deductions on gifts towards annual membership programmes, exhibitions, scholarship and capital projects. For more information contact the Tate Americas Foundation office.

Mrs Coral Samuel, CBE
David and Sophie Shalit
Mr and Mrs Sven Skarendahl
Pauline Denyer-Smith and Paul Smith
Mr and Mrs Nicholas Stanley
The Jack Steinberg Foundation
Charlotte Stevenson
Tate Gallery Centenary Gala
Carter and Mary Thacher
Mr and Mrs John L. Thornton
The Trusthouse Charitable Foundation
David and Emma Verey
Dinah Verey
Clodagh and Leslie Waddington
Gordon D Watson
Mr and Mrs Anthony Weldon
The Duke of Westminster, OBE TD DL
Sam Whitbread
Mr and Mrs Stephen Wilberding
Michael S. Wilson
The Wolfson Foundation
and those who wish to remain anonymous

**Donors to The Tate Britain
Millbank Project**
The Deborah Loeb Brice Foundation
Clore Duffield Foundation
The Alan Cristea Gallery
Sir Harry and Lady Djanogly
The Gatsby Charitable Foundation
J. Paul Getty Jr Charitable Trust
Paul Green, Halcyon Gallery
Heritage Lottery Fund
The Hiscox Foundation
James and Clare Kirkman
The Linbury Trust and The Monument Trust
The Manton Foundation
The Mayor Gallery
Ronald and Rita McAulay
Midge and Simon Palley
PF Charitable Trust
The Porter Foundation
The Dr Mortimer and Theresa Sackler
 Foundation
Mrs Coral Samuel, CBE
Tate Members
The Taylor Family Foundation
David and Emma Verey
Sir Siegmund Warburg's Voluntary
 Settlement
Garfield Weston Foundation
The Wolfson Foundation
and who wish to remain anonymous

**Tate Britain Benefactors
and Major Donors**
*We would like to acknowledge and thank
the following benefactors who have
supported Tate Britain prior to 16 December
2013*

The Ahmanson Foundation
The Ampersand Foundation
Annenberg Foundation
The Art Fund
Arts & Humanities Research Council
Arts Council England
Artworkers Retirement Society
Charles Asprey
Gillian Ayres
John Baldessari
Lionel Barber
The Estate of Peter and Caroline Barker-
 Mill
The Barns-Graham Charitable Trust
Billstone Foundation
Maria Rus Bojan

The Charlotte Bonham-Carter Charitable
 Trust
Charles Booth-Clibborn
Louise Bourgeois
Frank Bowling
Sir Alan and Sarah Bowness
Bowness, Hepworth Estate
Pierre Brahm
The Estate of Dr Marcella Louis Brenner
British Council
The Estate of Joseph and Ruth Bromberg
Elizabeth and Rory Brooks
The Estate of Mrs Kathleen Bush
The Trustees of the Chantrey Bequest
The Clore Duffield Foundation
The Clothworkers' Foundation
Contemporary Art Society
Sonia and Giles Coode-Adams
Isabelle and John Corbani
Douglas S. Cramer
Alan Cristea Gallery
The Estate of William Crozier
Bilge Ogut-Cumbusyan and Haro
 Cumbusyan
Thomas Dane
Alex Davids
Ago Demirdjian and Tiqui Atencio
 Demirdjian
Department for Business, Innovation
 and Skills
Department for Culture, Media and Sport
Jonathan Djanogly
Anthony and Anne d'Offay
Peter Doig
Jytte Dresing, The Merla Art Foundation,
 Dresing Collection
EDP – Energias de Portugal, S.A.
Maryam and Edward Eisler
The John Ellerman Foundation
Ibrahim El-Salahi
European Commission
European Union
Esmée Fairbairn Collections Fund
The Estate of Maurice Farquharson
HRH Princess Firyal of Jordan
Wendy Fisher
David Fitzsimons
Eric and Louise Franck
The Getty Foundation
Ida Gianelli
Liam Gillick
Milly and Arne Glimcher
Nicholas and Judith Goodison
Douglas Gordon and Artangel
Richard Green
Konstantin Grigorishin
Guaranty Trust Bank Plc
Calouste Gulbenkian Foundation
The Haberdashers' Company
Paul Hamlyn Foundation
Viscount and Viscountess Hampden and
 Family
Noriyuki Haraguchi
Hauser & Wirth
Heritage Lottery Fund
Friends of Heritage Preservation
The Hintze Family Charitable Foundation
Damien Hirst
Robert Hiscox
David Hockney
The Estate of Mrs Mimi Hodgkin
Maja Hoffmann/LUMA Foundation
Vicky Hughes and John A. Smith
Fady Jameel
Amrita Jhaveri
Karpidas Family
J. Patrick Kennedy and Patricia A. Kennedy

Bharti Kher
KMG Independent Limited
Leon Kossoff
The Kreitman Foundation
Samuel H. Kress Foundation, administered
 by the Foundation of the American
 Institute for Conservation
Andreas Kurtz
Kirby Laing Foundation
David and Amanda Leathers
The Leathersellers' Company Charitable
 Fund
The Leche Trust
Agnes and Edward Lee
Legacy Trust UK
The Leverhulme Trust
Lisson Gallery
The Loveday Charitable Trust
John Lyon's Charity
The Estate of Sir Edwin Manton
The Manton Foundation
Fergus McCaffrey
The Paul Mellon Centre for Studies in
 British Art
The Andrew W. Mellon Foundation
Sir Geoffroy Millais
Jean-Yves Mock
The Modern Institute
The Henry Moore Foundation
Daido Moriyama
The Estate of Mrs Jenifer Ann Murray
NADFAS
National Heritage Memorial Fund
The Netherlands Organisation for
 Scientific Research (NWO)
Tony Oursler and Artangel
Outset Contemporary Art Fund
The Paolozzi Foundation
The Estate of Mr Brian and Mrs Nancy
 Pattenden
Stephen and Yana Peel
Stanley Picker Trust
The Porter Foundation
Gilberto Pozzi
Oliver Prenn
Laura Rapp and Jay Smith
The Reed Foundation
Sir John Richardson, KBE
Yvonne Robinson
Barrie and Emmanuel Roman
Mr and Mrs Richard Rose
Helen and Ken Rowe
Edward Ruscha
The Estate of Simon Sainsbury
Sir Anthony and Lady Salz
James Scott
Robert Scott
Candida and Rebecca Smith
The Estate of Mrs Freda Mary Snadow
Nicholas and Elodie Stanley
Mercedes and Ian Stoutzker
The Estate of Iiro Takamatsu
Tate 1897 Circle
Tate Africa Acquisitions Committee
Tate Americas Foundation
Tate Asia-Pacific Acquisitions Committee
Tate International Council
Tate Latin American Acquisitions
 Committee
Tate Members
Tate Middle East and North Africa
 Acquisitions Committee
Tate North American Acquisitions
 Committee
Tate Patrons
Tate Photography Acquisitions Committee
Tate Russia and Eastern Europe

Acquisitions Committee
Tate South Asia Acquisitions Committee
Taylor Family Foundation
Melissa Tecklenberg
Terra Foundation for American Art
The Estate of Mr Nicholas Themans
Luis Tomasello
Russell Tovey
The Tretyakov Family Collection
Petri and Jolana Vainio
The Vandervell Foundation
Waddington Custot Galleries Ltd
Offer Waterman & Co
Wellcome Trust
Welton Foundation
The Estate of Fred Williams
Jane and Michael Wilson
Samuel and Nina Wisnia
The Lord Leonard and Lady Estelle
 Wolfson Foundation
Poju and Anita Zabludowicz
Ms Silke Ziehl
and those who wish to remain anonymous

Platinum Patrons
Mr Alireza Abrishamchi
Ghazwa Mayassi Abu-Suud
Mr Shane Akeroyd
Basil Alkazzi
Ryan Allen and Caleb Kramer
Mr and Mrs Edward Atkin CBE
Rhona Beck
Beecroft Charitable Trust
Mr Harry Blain
Rory and Elizabeth Brooks (Chair)
The Lord Browne of Madingley, FRS,
 FREng
Karen Cawthorn Argenio
Mr Stephane Custot
Ms Miel de Botton
Ms Sophie Diedrichs-Cox
Elizabeth Esteve
Mr David Fitzsimons
The Flow Foundation
Mr Michael Foster
Edwin Fox Foundation
Mrs Lisa Garrison
Hugh Gibson
The Goss-Michael Foundation
Ms Nathalie Guiot
Mr and Mrs Yan Huo
Mr Phillip Hylander
Anne-Marie and Geoffrey Isaac
Mrs Gabrielle Jungels-Winkler
Maria and Peter Kellner
Esperanza Koren
Mr and Mrs Eskandar Maleki
Scott and Suling Mead
Gabriela Mendoza and Rodrigo Marquez
Pierre Tollis and Alexandra Mollof
Mr Donald Moore
Mary Moore
Mr and Mrs Paul Phillips
Mariela Pissioti
Maya and Ramzy Rasamny
Frances Reynolds
Simon and Virginia Robertson
Mr and Mrs Richard Rose
Claudia Ruimy
Vipin Sareen and Rebecca Mitchell
Hakon Runer and Ulrike Schwarz-Runer
Mr and Mrs J. Shafran
Mrs Andrée Shore
Maria and Malek Sukkar
Mr Vladimir Tsarenkov and Ms Irina
 Kargina
Mr and Mrs Petri Vainio

Michael and Jane Wilson
Poju and Anita Zabludowicz
and those who wish to remain anonymous

Gold Patrons
Eric Abraham
The Anson Charitable Trust
Katrina Barter
Jenny and Robert Borgerhoff Mulder
Elena Bowes
Broeksmit Family Foundation
Ben and Louisa Brown
Nicolò Cardi
Melanie Clore
Beth and Michele Colocci
Bilge Ogut-Cumbusyan and Haro
 Cumbusyan
Mr Dónall Curtin
Mrs Robin D'Alessandro
Harry G. David
Mr Frank Destribats
Mrs Maryam Eisler
Mala Gaonkar
Kate Groes
Mrs Helene Guerin-Llamas
Ms Natascha Jakobs
Tiina Lee
Paul and Alison Myners
Reem Nassar
Mr Francis Outred
Simon and Midge Palley
Mathew Prichard
Valerie Rademacher
Carol Sellars
Mrs Dana Sheves
Mr and Mrs Stanley S. Tollman
Emily Tsingou and Henry Bond
Mrs Celia Forner Venturi
Rebecca Wang
Manuela and Iwan Wirth
Barbara Yerolemou
 and those who wish to remain anonymous

Silver Patrons
Allahyar Afshar
Agnew's
Sharis Alexandrian
Ms Maria Allen
Mrs Malgosia Alterman
Toby and Kate Anstruther
Mr and Mrs Zeev Aram
Mrs Charlotte Artus
Tim Attias
Miss Silvia Badiali
Mrs Jane Barker
Mr Edward Barlow
Victoria Barnsley, OBE
Jim Bartos
Alex Beard
Mrs Cynthia Lewis Beck
Mr Harold Berg
Lady Angela Bernstein
Madeleine Bessborough
Ms Karen Bizon
Janice Blackburn
Shoshana Bloch
David Blood and Beth Bisso
Mrs Sofia Bogolyubov
Nathalie and Daniel Boulakia
Helen Boyan
Mr Brian Boylan
Ivor Braka
Alex Branczik
Viscountess Bridgeman
The Broere Charitable Foundation
Mr Dan Brooke
Michael Burrell

Mrs Marlene Burston
Mrs Aisha Caan
Timothy and Elizabeth Capon
Mr Francis Carnwath and Ms Caroline
 Wiseman
Lord and Lady Charles Cecil
Dr Peter Chocian
Frank Cohen
Nicola Collard
Mrs Jane Collins
Dr Judith Collins
Terrence Collis
Mr and Mrs Oliver Colman
Carole and Neville Conrad
Giles and Sonia Coode-Adams
Alastair Cookson
Cynthia Corbett
Mark and Cathy Corbett
Tommaso Corvi-Mora
Mr and Mrs Bertrand Coste
Kathleen Crook and James Penturn
James Curtis
Loraine da Costa
Sir Howard Davies
Mr and Mrs Roger de Haan
Giles de la Mare
Maria de Madariaga
Mr Jean-Evrard Dominicé and Mrs
 Stephanie de Preux Dominicé
Anne Chantal Defay Sheridan
Marco di Cesaria
Simon C. Dickinson Ltd
James Diner
Liz and Simon Dingemans
Ms Charlotte Ransom and Mr Tim Dye
Rafe Eddington
Joan Edlis
Lord and Lady Egremont
Jeffrey and Jennifer Eldredge
John Erle-Drax
Dr Nigel Evans
Stuart and Margaret Evans
Eykyn Maclean LLC
Gerard Faggionato
Ms Rose Fajardo
Richard Farleigh
Mrs Heather Farrar
David Fawkes
Mrs Margy Fenwick
Mr Bryan Ferry, CBE
The Sylvie Fleming Collection
Mrs Jean Fletcher
Lt Commander Paul Fletcher
Steve Fletcher
Katherine Francey Stables
Elizabeth Freeman
Stephen Friedman
Mr Mark Glatman
Ms Emily Goldner and Mr Michael
 Humphries
Mr Jonathan Goodman
Kate Gordon
Mr and Mrs Paul Goswell
Penelope Govett
Martyn Gregory
Sir Ronald Grierson
Mrs Kate Grimond
Richard and Odile Grogan
Michael and Morven Heller
Richard and Sophia Herman
Mrs Patsy Hickman
Robert Holden
James Holland-Hibbert
Lady Hollick, OBE
Holtermann Fine Art
John Huntingford
Mr Alex Ionides
Maxine Isaacs

Helen Janecek
Sarah Jennings
Mr Haydn John
Mr Michael Johnson
Jay Jopling
Mrs Marcelle Joseph and Mr Paolo
 Cicchiné
Mrs Brenda Josephs
Tracey Josephs
Mr Joseph Kaempfer
Andrew Kalman
Ghislaine Kane
Jag-Preet Kaur
Dr Martin Kenig
Simon and Jeannette Kenny
Mr David Ker
Nicola Kerr
Mr and Mrs Simon Keswick
Richard and Helen Keys
Mrs Mae Khouri
David Killick
Mr and Mrs James Kirkman
Brian and Lesley Knox
The Kotick Family
Kowitz Trust
Mr and Mrs Herbert Kretzmer
Linda Lakhdhir
Mrs Julie Lee
Simon Lee
Mr Gerald Levin
Leonard Lewis
Sophia and Mark Lewisohn
Mr Gilbert Lloyd
George Loudon
Mrs Elizabeth Louis
Mark and Liza Loveday
Catherine Lovell
Daniella Luxembourg Art
Kate MacGarry
Anthony Mackintosh
Fiona Mactaggart
The Mactaggart Third Fund
Mrs Jane Maitland Hudson
Lord and Lady Marks
Marsh Christian Trust
David McCleave
Mrs Anne-Sophie McGrath
Ms Fiona Mellish
Mr Martin Mellish
Mrs R.W.P. Mellish
Professor Rob Melville
Mr Alfred Mignano
Victoria Miro
Ms Milica Mitrovich
Jan Mol
Lulette Monbiot
Mrs Bona Montagu
Mr Ricardo Mora
Mrs William Morrison
Richard Nagy
Julian Opie
Pilar Ordovás
Isabelle Paagman
Desmond Page
Maureen Paley
Dominic Palfreyman
Michael Palin
Mrs Adelaida Palm
Stephen and Clare Pardy
Mrs Véronique Parke
Mr Sanjay Parthasarathy
Frans Pettinga
Trevor Pickett
Mr Oliver Prenn
Susan Prevezer, QC
Mr Adam Prideaux
Mr and Mrs Ryan Prince
James Pyner

Ivetta Rabinovich
Patricia Ranken
Mrs Phyllis Rapp
Ms Victoria Reanney
Dr Laurence Reed
The Reuben Foundation
Sir Tim Rice
Lady Ritblat
Ms Chao Roberts
David Rocklin
Frankie Rossi
Mr David V. Rouch
Mr James Roundell
Mr Charles Roxburgh
Naomi Russell
Mr Alex Sainsbury and Ms Elinor Jansz
Mr Richard Saltoun
Mrs Amanda Sater
Mrs Cecilia Scarpa
Cherrill and Ian Scheer
Sylvia Scheuer
The Schneer Foundation
Mrs Cara Schulze
Deborah Scott
The Hon. Richard Sharp
Neville Shulman, CBE
Ms Julia Simmonds
Paul and Marcia Soldatos
Mr George Soros
Louise Spence
Mr and Mrs Nicholas Stanley
Mr Nicos Steratzias
Mrs Patricia Swannell
Mr James Swartz
The Lady Juliet Tadgell
Tot Taylor
Christopher and Sally Tennant
Anthony Thornton
Britt Tidelius
Mr Henry Tinsley
Karen Townshend
Andrew Tseng
Melissa Ulfane
Mrs Cecilia Versteegh
Mr Jorge Villon
Gisela von Sanden
Audrey Wallrock
Sam Walsh, AO
Stephen and Linda Waterhouse
Offer Waterman
Terry Watkins
Lisa West
Miss Cheyenne Westphal
Walter H. White Jr
Sue Whiteley
Mr David Wood
Mr Douglas Woolf
Anthony Zboralski
and those who wish to remain anonymous

Young Patrons
Vinita Agarwal
Stephanie Alameida
HH Princess Nauf AlBendar Al-Saud
Jonathan Algar
Miss Noor Al-Rahim
HRH Princess Alia Al-Senussi (Chair,
 Young Patrons Ambassador Group)
Miss Sharifa Alsudairi
Sigurdur Arngrimsson
Miss Katharine Arnold
Maria and Errikos Arones
Miss Joy Asfar
Ms Mila Askarova
Miss Olivia Aubry
Flavie Audi
Sarah Bejerano
Josh Bell and Jsen Wintle

Miss Marisa Bellani
Mr Erik Belz
Mr Edouard Benveniste-Schuler
Miss Margherita Berloni
William Bertagna
Mrs Sofia Bocca
Roberto Boghossian
Alina Boyko
Johan Bryssinck
Miss Verena Butt
Miss May Calil
Miss Sarah Calodney
Matt Carey-Williams and Donnie Roark
Georgina Casals
Alexandra and Kabir Chhatwani
Miss Katya Chitova
Arthur Chow
Bianca Chu
Mrs Mona Collins
Mrs Laura Comfort
Alicia Corbin
Thamara Corm
Daphné Cramer
Miss Amanda C. Cronin
Mr Theo Danjuma
Mr Joshua Davis
Ms Lora de Felice
Countess Charlotte de la Rochefoucauld
Emilie De Pauw
Agnes de Royere
Federico Martin Castro Debernardi
Carine Decroi
Mira Dimitrova
Ms Michelle D'Souza
Indira Dyussebayeva
Alexandra Economou
Miss Roxanna Farboud
Emilie Faure
Jane and Richard Found
Mr Andreas Gegner
Mrs Benedetta Ghione-Webb
Miss Dori Gilinski
Georgia Griffiths
Jessica Grosman
Olga Grotova and Oleksiy Osnach
Mr Nick Hackworth
Alex Haidas
Ms Michelle Harari
Sara Harrison
Kira Allegra Heller
Christoph Hett
Mrs Samantha Heyworth
Andrew Honan
Katherine Ireland
Miss Eloise Isaac
Kamel Jaber
Scott Jacobson
Mr Christopher Jones
Ms Melek Huma Kabakci
Sophie Kainradl
Miss Meruyert Kaliyeva
Efe and Aysun Kapanci
Nicole Karlisch
Philipp Keller
Miss Tamila Kerimova
Ms Chloe Kinsman
Ms Marijana Kolak
Zeynep Korutürk
Alkistis Koukouliou
Miss Marina Kurikhina
Mr Jimmy Lahoud
Ms Aliki Lampropoulos
Ms Anna Lapshina
Isabella Lauder-Frost
Mrs Julie Lawson
Lin Lei
Karen Levy
Miss M.C. Llamas

Mr Justin Lobo
Alex Logsdail
Mr John Madden
Ms Sonia Mak
Mr Jean-David Malat
Kamiar Maleki
Zoe Marden
Rebecca Marques
Dr F. Mattison Thompson
Ms Clémence Mauchamp
Miss Nina Moaddel
Mr Fernando Moncho Lobo
Ms Michelle Morphew
Erin Morris
Ali Munir
Katia Nounou
Mrs Annette Nygren
Katharina Ottmann
Christine Chungwon Park
Ms Camilla Paul
Alexander V. Petalas
Mrs Stephanie Petit
The Piper Gallery
Mr Eugenio Re Rebaudengo
Mr Bruce Ritchie and Mrs Shadi Ritchie
Mr Simon Sakhai
Miss Tatiana Sapegina
Olga Savchenko
Elena Scarpa
Franz Schwarz
Alex Seddon
Count Indoo Sella Di Monteluce
James Sevier
Robert Sheffield
Henrietta Shields
Mr Paul Shin
Ms Marie-Anya Shriro
Laura Simkins
Jag Singh
Tammy Smulders
Miss Jelena Spasojevic
Thomas Stauffer and Katya Garcia-Anton
Alexandra Sterling
Gemma Stewart-Richardson
Mr Dominic Stolerman
Gerald Tan
Mr Edward Tang
Nayrouz Tatanaki
Miss Georgiana Teodorescu
Miss Inge Theron
Soren S.K. Tholstrup
Hannah Tjaden
Mr Giancarlo Trinca
Mrs Padideh Trojanow
Mr Philippos Tsangrides
Ms Navann Ty
Angus Walker
Mr Neil Wenman
Ms Hailey Widrig Ritcheson
Lars N. Wogen
Miss Julia Wright
Ms Seda Yalcinkaya
Arani Yogadeva
Daniel Zarchan
Alma Zevi
and those who wish to remain anonymous

International Council Members
Mr Segun Agbaje
Staffan Ahrenberg, Editions Cahiers d'Art
Doris Ammann
Mr Plácido Arango
Gabrielle Bacon
Anne H. Bass
Cristina Bechtler
Nicolas Berggruen
Olivier and Desiree Berggruen
Baron Berghmans

Mr Pontus Bonnier
Frances Bowes
Ivor Braka
The Deborah Loeb Brice Foundation
The Broad Art Foundation
Bettina and Donald L Bryant Jr
Melva Bucksbaum and Raymond Learsy
Andrew Cameron AM
Fondation Cartier pour l'art contemporain
Nicolas and Celia Cattelain
Mrs Christina Chandris
Richard Chang
Pierre T.M. Chen, Yageo Foundation, Taiwan
Lord Cholmondeley
Mr Kemal Has Cingillioglu
Mr and Mrs Attilio Codognato
Sir Ronald Cohen and Lady Sharon Harel-Cohen
Mr Douglas S. Cramer and Mr Hubert S. Bush III
Mr Dimitris Daskalopoulos
Mr and Mrs Michel David-Weill
Julia W. Dayton
Ms Miel de Botton
Tiqui Atencio Demirdjian and Ago Demirdjian
Joseph and Marie Donnelly
Mrs Olga Dreesmann
Mrs Jytte Dresing
Barney A. Ebsworth
Füsun and Faruk Eczacibaşi
Stefan Edlis and Gael Neeson
Mr and Mrs Edward Eisler
Carla Emil and Rich Silverstein
Alan Faena
Harald Falckenberg
Fares and Tania Fares
HRH Princess Firyal of Jordan
Mrs Doris Fisher
Mrs Wendy Fisher
Dr Corinne M. Flick
Amanda and Glenn Fuhrman
Candida and Zak Gertler
Alan Gibbs
Lydia and Manfred Gorvy
Kenny Goss
Mr Laurence Graff
Ms Esther Grether
Konstantin Grigorishin
Mr Xavier Guerrand-Hermès
Mimi and Peter Haas Fund
Margrit and Paul Hahnloser
Andy and Christine Hall
Mr Toshio Hara
Paul Harris
Mrs Susan Hayden
Ms Ydessa Hendeles
Marlene Hess and James D. Zirin
André and Rosalie Hoffmann
Ms Maja Hoffmann (Chair)
Vicky Hughes
ITYS, Athens
Dakis and Lietta Joannou
Sir Elton John and Mr David Furnish
Pamela J. Joyner
Mr Chang-Il Kim
Jack Kirkland
C Richard and Pamela Kramlich
Bert Kreuk
Catherine Lagrange
Mr Pierre Lagrange and Mr Roubi L'Roubi
Bernard Lambilliotte
Agnès and Edward Lee
Mme RaHee Hong Lee
Jacqueline and Marc Leland
Mr and Mrs Sylvain Levy
Mr Eugenio Lopez

Mrs Fatima Maleki
Panos and Sandra Marinopoulos
Mr and Mrs Donald B. Marron
Andreas and Marina Martinos
Mr Ronald and The Hon. Mrs McAulay
Angela Westwater and David Meitus
Mr Leonid Mikhelson
Simon and Catriona Mordant
Mrs Yoshiko Mori
Mr Guy and The Hon. Mrs Naggar
Mr and Mrs Takeo Obayashi
Hideyuki Osawa
Irene Panagopoulos
Young-Ju Park
Yana and Stephen Peel
Daniel and Elizabeth Peltz
Andrea and José Olympio Pereira
Catherine and Franck Petitgas
Sydney Picasso
Mr and Mrs Jürgen Pierburg
Jean Pigozzi
Lekha Poddar
Ms Miuccia Prada and Mr Patrizio Bertelli
Laura Rapp and Jay Smith
Maya and Ramzy Rasamny
Patrizia Sandretto Re Rebaudengo and Agostino Re Rebaudengo
Robert Rennie and Carey Fouks
Sir John Richardson, KBE
Michael Ringier
Lady Ritblat
Dame Theresa Sackler
Mrs Lily Safra
Muriel and Freddy Salem
Dasha Shenkman
Uli and Rita Sigg
Michael S. Smith
Norah and Norman Stone
Julia Stoschek
John J. Studzinski, CBE
Maria and Malek Sukkar
Mrs Marjorie Susman
David Teiger
Mr Budi Tek, The Yuz Foundation
Mr Robert Tomei
The Hon. Robert H. Tuttle and Mrs Maria Hummer-Tuttle
Mr and Mrs Guy Ullens
Mrs Ninetta Vafeia
Corinne and Alexandre Van Damme
Paulo A.W.Vieira
Robert and Felicity Waley-Cohen
Diana Widmaier Picasso
Christen and Derek Wilson
Michael G. Wilson
Mrs Sylvie Winckler
The Hon. Dame Janet Wolfson de Botton, DBE
Anita and Poju Zabludowicz
Michael Zilkha
and those who wish to remain anonymous

Africa Acquisitions Committee
Tutu Agyare (Co-Chair)
Bolanle Austen-Peters
Mrs Nwakaego Boyo
Lavinia Calza
Priti Chandaria Shah
Mrs Kavita Chellaram
Salim Currimjee
Harry G. David
Mr and Mrs Michel David-Weill
Robert Devereux (Co-Chair)
Hamish Dewar
Mrs Wendy Fisher
Kari Gahiga
Andrea Kerzner
Samallie Kiyingi